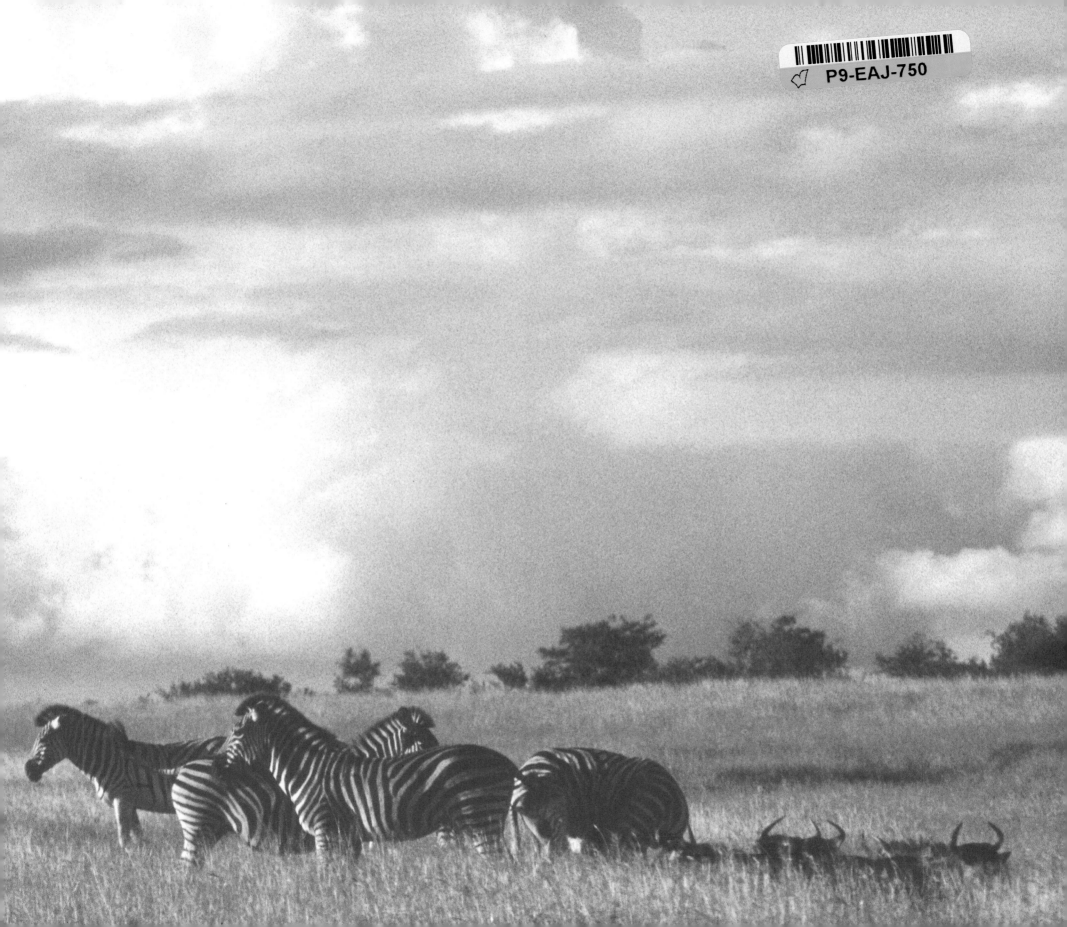

Mala Mala

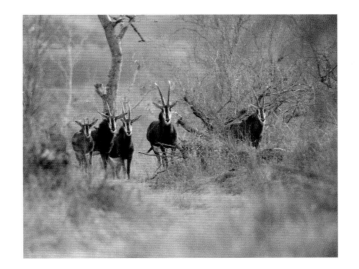

Foreword

ℱOR CENTURIES, PEOPLE HAVE TRAVELED from all over the world to experience Africa's vast panorama of wildlife. Thanks to those individuals who years ago saw the need to conserve African wildlife, reserves like South Africa's magnificent MalaMala still provide places where Africa's astounding beauty can be seen intact. More important, they provide tangible models for wildlife conservation.

The staggering diversity of Africa's natural resources is matched only by the cultural wealth of its people. Yet despite this rich heritage, the continent faces an array of daunting challenges. Tropical forests are falling to timber concessions at a devastating rate; population growth and destructive agricultural practices threaten the land; endangered species are poached and fisheries are overexploited; and plants and animals join humans as victims of civil wars. Never has the need for wildlife conservation been more urgent.

Determined to ensure that future generations can experience African wildlife firsthand, the international network of WWF organizations (known as World Wildlife Fund and World Wide Fund for Nature) and local organizations like South Africa's Endangered Wildlife Trust work tirelessly to practice sound conservation that also recognizes human needs. The MalaMala reserve succeeds in this same effort by keeping thousands of acres from development while employing many local residents. And Vista Press will help support wildlife conservation through proceeds from the sale of this book.

Together, those committed to conserving the priceless wonder of wild Africa are moving forward to meet the challenges.

Kathryn S. Fuller
PRESIDENT, WWF UNITED STATES

Dr. Ian A. W. Macdonald
CHIEF EXECUTIVE, WWF SOUTH AFRICA

Vista
Press

Mala Mala

Pathway to an African Eden

Photography by
Amanda Lumry
& Jamie Thom

Edited and designed
by Emily McGalliard

Text by Laura Hurwitz in
collaboration with Amanda Lumry

First edition published 1999 by Vista Press, LLC
20 Old Farm Road
North Haven, CT 06473
U.S.A.
info@vistapress.com
www.vistapress.com

Map of Africa by Mountain High Maps ® Copyright ©1993 Digital Wisdom, Inc.
MalaMala map reprinted with permission from MalaMala.

ISBN 0-9662257-1-6

Printed and bound in Hong Kong by C & C Offset, Ltd.

Please address inquiries about
MalaMala Game Reserve to:

MalaMala
P. O. Box 2575
Randburg 2125, South Africa
Tel: (27) (11) 789-2677
Fax: (27) (11) 886-4382
email: jhb@malamala.com
www.malamala.com

A portion of the proceeds from this book are donated to the World Wildlife Fund South
Africa, World Wildlife Fund U.S., and the Endangered Wildlife Trust. For more infor-
mation about these organizations please contact:

EWT	WWF United States	WWF South Africa
Private Bag X11	1250 24th Street N.W.	P. O. Box 456
Parkview	Washington, D.C. 20037	Stellenbosch
2122 South Africa	USA	7599 South Africa
Tel: (27) (11) 486-1102	Tel: (202) 293-4800	Tel: (27) (21) 8872801
Fax: (27) (11) 486-1506	Fax: (202) 293-9211	Fax: (27) (21) 8879517
ewtsa@global.co.za	membership@wwfus.org	imacdon%wwfsa@mhs.cstat.co.za
www.ewt.org.za	www.worldwildlife.org	www.panda.org.za

Cover and Frontmatter Captions
Cover photo: Lions, like many animals, use the roads as pathways.
Back cover photo: Mother hippos are savagely protective of their young.
Front flap: Sunset over the Sand River
Half title page: Sable antelope seen on White Cloth Road
Title page: A female cheetah surveys her surroundings from a termite mound.
Dedication: Sibuye Drive captured in the afternoon light.
Preface: A young male leopard descends from its viewpoint.
Acknowledgments: Two impala rams at the river's edge, alert to any sign of ambush.
Introduction: A matriarch elephant and some members of her herd approach the Sand River.

\mathcal{T}HIS BOOK IS DEDICATED TO THE entire Rattray family, especially to Loring, Michael, and Norma Rattray, for without their courageous vision, tenacity, and faith, MalaMala, as we know it, would not exist. Also, to Nelson Mandela, the voice and soul of the new South Africa, who sees the wisdom and importance of preserving the environment and animals of his native land for all humanity. Also, to the warm, accommodating, and eminently capable staff of MalaMala, who bring boundless energy and skill to their posts. Finally, to the people of South Africa, for sharing the unique beauty of their nation with a growing number of international tourists. May the pathway you have forged together be an inspiration to Africa, and may the entire world learn from the precedent you have set at MalaMala: that through careful preservation of natural resources, you have established a means of environmental and economic stability that, in turn, engenders a climate of harmony and prosperity.

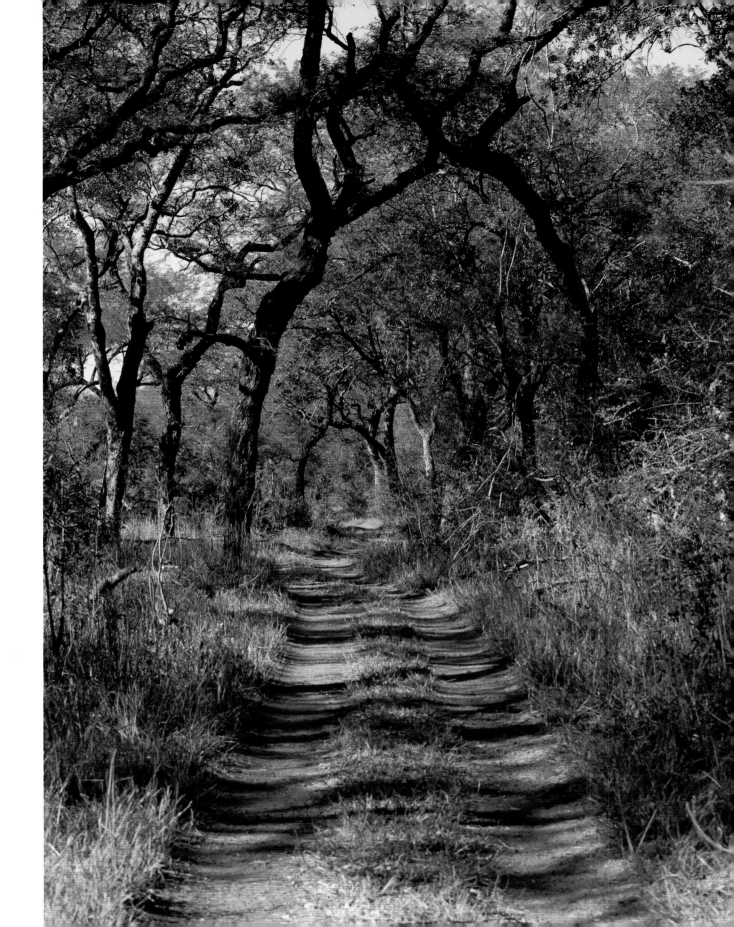

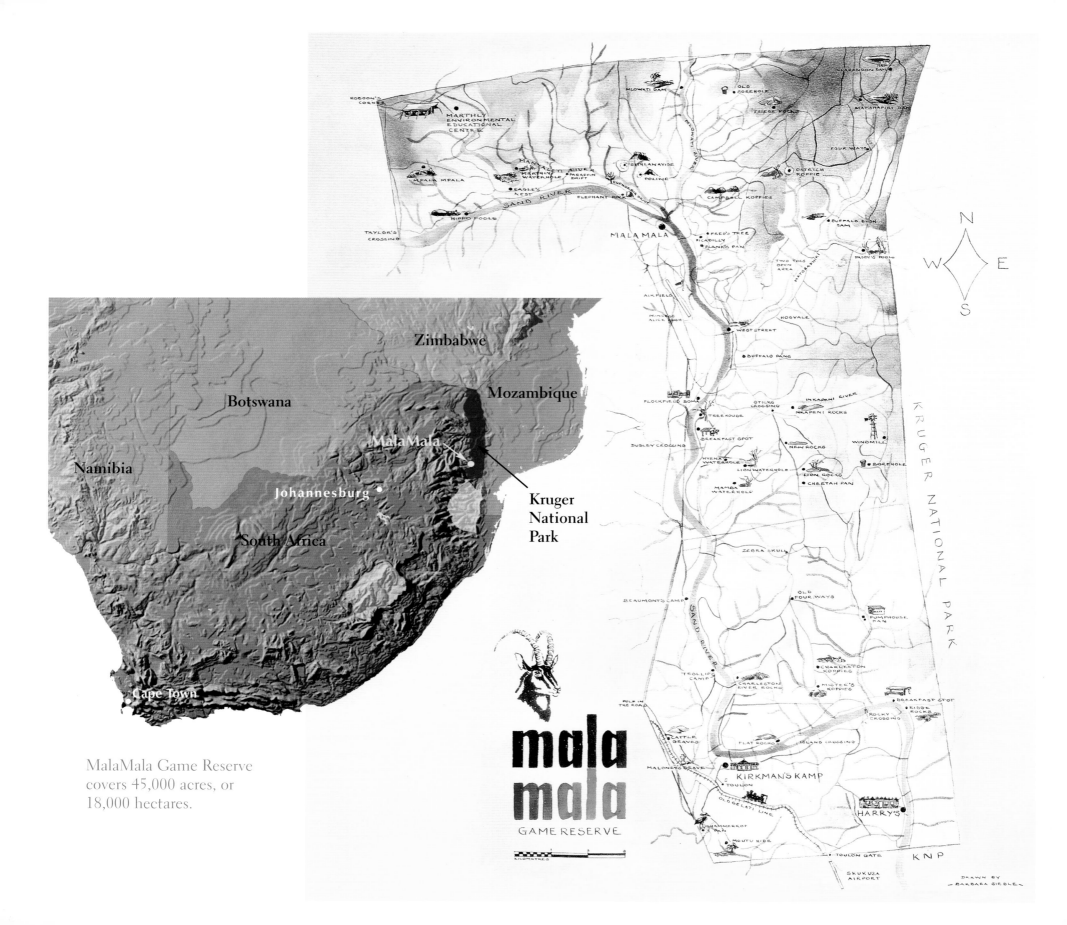

MalaMala Game Reserve
covers 45,000 acres, or
18,000 hectares.

Zimbabwe

Botswana

Mozambique

Namibia

MalaMala

Johannesburg

Kruger
National
Park

South Africa

Cape Town

**mala
mala**
GAME RESERVE

KILOMETRES

KRUGER NATIONAL PARK

KNP

DRAWN BY
BARBARA SIEDLE

Table of Contents

 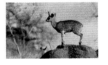

Preface

WHAT IS IT, PRECISELY, THAT MAKES MALAMALA so extraordinary? If you are unfamiliar with MalaMala, a brief description may help. MalaMala is a privately owned game reserve in the Mpumalanga region of South Africa, adjacent to Kruger National Park. It is renowned for its extravagant and varied physical beauty, traditionally inspired yet luxurious accommodations, and incredible concentration and variety of animals (including the legendary "Big Five": lion, leopard, buffalo, rhino and elephant) that can be viewed year-round, on- and off-road, day and night.

The terrain of MalaMala, as varied as the animals who inhabit it, includes gently rolling swells of the savannas, the starkly dramatic thrust of the rocky koppies, and the lush vegetation and stately towering trees surrounding the meandering Sand River. The clear skies over MalaMala provide a vast, pristine backdrop for spectacular sunsets and sunrises, which range in hue from fiery crimson to palest gold. At night, the stars, undimmed by the lights of civilization, shine with an unreal, piercing brightness.

Many animals whose populations are dwindling in other parts of Africa inhabit MalaMala. These animals, including wild dogs, cheetahs, rhinos, and African wild cats are protected at MalaMala. Poaching, grazing, and poor land management throughout other parts of Africa in years past had placed several of these creatures on the brink of extinction. In contrast, MalaMala has made every effort to conserve resources, educate visitors and employees, and manage the land intelligently and sensitively. As a direct result, these threatened animals are thriving. This emphasis on conservation is further reflected in a pervasive philosophy of MalaMala: that all wildlife and each environment is on an organic continuum. From the dung beetle to the giraffe, from the spiny thistle to the imposing umbrella thorn tree, every living thing at MalaMala is prized as an integral part of the ecosystem.

MalaMala is not only self-supporting but profitable, unlike other African game reserves, which preserve animals but for the most part operate at a financial loss. A large percentage of MalaMala's profits are invested directly back into the management of precious resources, the only way to maintain a delicate balance and preserve the existing system in this ecologically sensitive area. Simply put, tourism provides the means to pay for conservation. In addition, MalaMala helps the local economy by employing approximately two hundred people, many of whom are from the Shangaan tribe, and by purchasing neighboring farmers' products. Locally made crafts are sold in the MalaMala gift shop, and staff and their families usually are able to avail themselves of firewood, thatching materials and meat.

More importantly, MalaMala attracts visitors from all over the world. Ninety-eight percent of MalaMala's clientele is international, including many celebrities and influential world leaders. A typical international tourist coming to visit MalaMala stays two days, then spends another nine days visiting other parts of South Africa, bringing badly needed foreign currency into the country. This example underscores the fact that the influx of global interest and foreign currency have made MalaMala and other private game parks one of the most positive aspects of South Africa's current economy.

President Nelson Mandela said in a speech to the Lubumbo Spatial Development Initiative in May of 1998 that "tourism has been described as a peace industry—one that promotes contact between peoples and cultures. It has the capacity to play a strategic role in development, and therefore in entrenching the peace which we now enjoy."

Not only does MalaMala furnish an exemplary prototype for this emerging eco-tourism, but it shows by example how sensitive and intelligent development benefits animals, the environment, and the national economy. MalaMala, as it exists today, is the result of a pioneering effort by the Rattray family, who acted with remarkable courage and foresight when they made the bold decision in 1964 to ban hunting and transform MalaMala into a successful photographic game reserve. It is a testament to

the Rattrays' faith and tenacity that other private game reserves have modeled themselves after their example. Equally impressive is the Rattrays' resolve to continue funding MalaMala's development, even during the lean years of sanctions against South Africa, when very few tourists passed through their gates. Their innovative vision has not gone unnoticed or unsung: for many years, MalaMala has garnered numerous international accolades and awards. In 1997, *Travel and Leisure* magazine named MalaMala "Best Hotel in the World," "Best Small Hotel in the World," and "Best Hotel in Africa and the Middle East," and in 1998, the Travel Industry Awards named it "Top Game Lodge in South Africa," and *Conde Nast Traveller* dubbed it "Top Hotel in Africa and the Middle East."

Gillian Rattray notes in her beautiful book about MalaMala, *To Everything Its Season,*

> Not only has MalaMala put South Africa firmly on the international tourist map, but perhaps of more worth is that 50,000 acres of precious wilderness are being nurtured and preserved with expertise and dedication.
>
> Somehow Mike and Norma Rattray have struck the magical balance between a superbly-run business venture, and a scientifically conserved wilderness.

It is our sincere hope that MalaMala and other privately held game reserves continue to flourish. In general, Africa has been experiencing a difficult period of social and political upheaval. The fragile ecosystem is at risk during these turbulent times. Subsistence farming, grazing, poaching, and large-scale development of land jeopardize the well-being of animals and their environment. MalaMala and other similar reserves address these problems on a local, national, and international level in an effort to arrive at a universally beneficial solution. Seldom do enterprises founded on such altruistic principles as keen social awareness, fiscal responsibility, and dedication to the preservation of rich biological diversity, become an international success, but such is the case with MalaMala.

We invite you to share the beauty of MalaMala as recorded on these pages. Keep in mind, however, that the true beauty of MalaMala transcends the images on our pages. A brilliant and abiding love of Africa, its land, and all its wildlife is realized here, and that love and intelligence have united in a grand mission to forge a pathway to a modern-day African Eden.

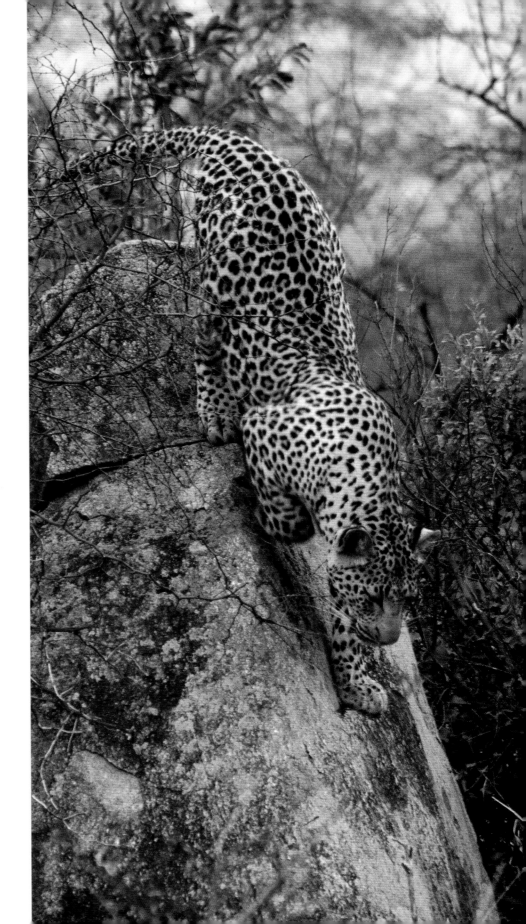

Acknowledgments

I WOULD FIRST LIKE TO THANK THE LORD for allowing us to experience His spectacular creation. On numerous occasions, we truly felt as if we were in Eden. In addition, we would like to thank the following people for their support and encouragement:

Mr. And Mrs. Michael Rattray, for allowing us to embark on this project and for opening up MalaMala to us; David Evans of MalaMala, for acting as an invaluable liaison and source of information; Nils Kure, camp manager, for his advice, assistance, and amusing anecdotes; Leon Van Wyk, MalaMala ranger, for his uncanny animal and bird imitations and his knowledge of the bush; the staff of MalaMala for their smiling faces and their gracious round-the-clock assistance and hospitality.

Professor Chris D. Killip, professor of Visual Environmental Sudies and department chairman at Harvard, for his guidance and sharpening of my photographic skills; Barbara Norfleet, curator, Photo Archives, senior lecturer emerita at Harvard, for her wisdom and instruction; Sage Sohier, lecturer of Visual and Environmental Studies, for her guidance and advice; Professor John R. Stilgoe, Robert and Lois Orchard Professor in the History of Landscape Development; Rob Moss, Kathleen Chaudhry, and other members of the Harvard University Visual Environmental Studies Department for making this project possible.

Emily McGalliard, for her patience, invaluable advice, and remarkable talent; Laura Hurwitz for her way with words.

Dad, Mom, Worth and Chris Lumry, for their continual prayers, humor, encouragment, and support; Sam, Hannah, Jake, Rachel, Sarah, Eliza, and Micah Hurwitz, for their love, patience, and support; Loren Wengerd, for his strength, organization, and calming influence; Carolyn Hague and Michael Pinkerton for their keen eyes and constructive criticism.

Additional people we would like to thank: John Robinson and everyone at GIST, Vista Press, Nanda Mehta, Acorn Ventures, Inc., Joni Bomstead, and Maryan Regan.

A.L.

Thanks to the Lumrys for the opportunity to publish this book, and to the Rattrays for the chance to work in the Eden that MalaMala is, and finally to my parents for all of their investment in me.

J.T.

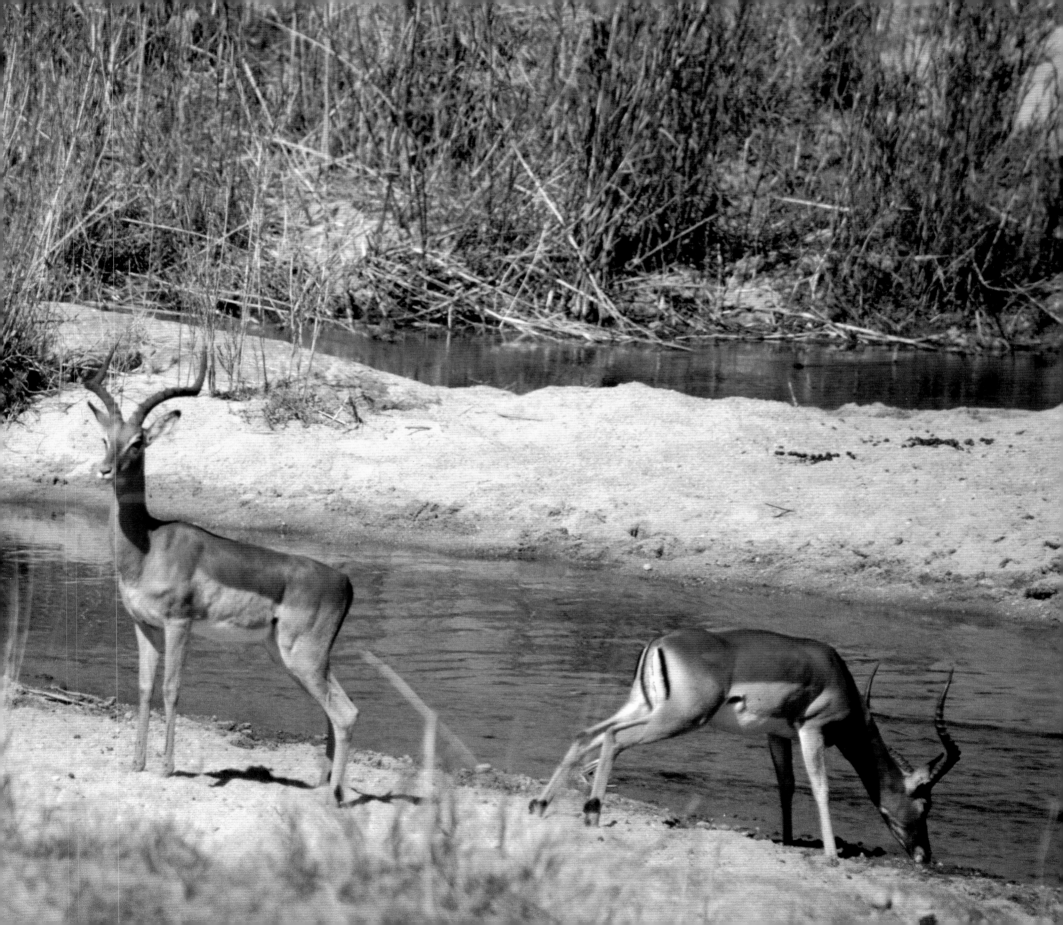

Introduction

*S*O-CALLED "CIVILIZED" MAN HAS HISTORICALLY BEEN AT ODDS with both the animal kingdom and the environment. Animals were captured, domesticated, or hunted for food. Land was cleared for planting or grazing, or mined for precious metals or fuel. Clearly, man's relationship with nature is often adversarial, and the tragic result is evident in the extinction of animal species, the obliteration of entire forests, and the pollution of water and air.

Witness, then, MalaMala, a miracle in South Africa. What was formerly a private hunting camp is now a haven where animals are not fenced or restricted in any way. The environment, from the drama of the rocky koppies to the serene expanse of the bushveld, is left pristine. Man's only intrusion is by vehicle, which the animals have learned, through careful long-term exposure, poses no threat. They seem to consider the Land Rovers some manner of large, benign creature whom they need not challenge for their supper. As passengers in those vehicles, we are given front-row seats to observe animals in their natural state, behaving as they would if they were alone in the wild.

A new visitor to MalaMala finds his jaw agape for most of the first day. From the veranda, while eating a sumptuous lunch, one sees a herd of elephants wander through the reeds by the Sand River. Is that really a baboon on the grass below, cradling her baby and screeching to her companions? There's a warthog on the path to the pool, walking on its knees, snout to the ground. It seems unbelievable that man and animal can coexist in such close proximity.

That is, in essence, the MalaMala experience. We are invited into a world that has not been artificially created, but carefully preserved. The harsh reality of survival of the fittest is played out in the kills that occur frequently. The animal prides, coalitions, families, and occasional loners make us realize that all creatures have their social groupings. We observe mating rituals, the frenzy of flight from predators, and the need to simply rest in the sun, and we feel fortunate that as visitors to Mala Mala we are privy to all this.

Enjoy this photographic journey of the MalaMala experience. From the gentle hues of the early morning sunrises to the excitement of the starkly lit night drives, from the vast expanse of the rolling savannas to the jagged drama of the ravines and koppies, this is a land of contrasts which only serve to highlight its unique beauty. Within the context of this unspoiled paradise, animals are free to exist without any concessions to man.

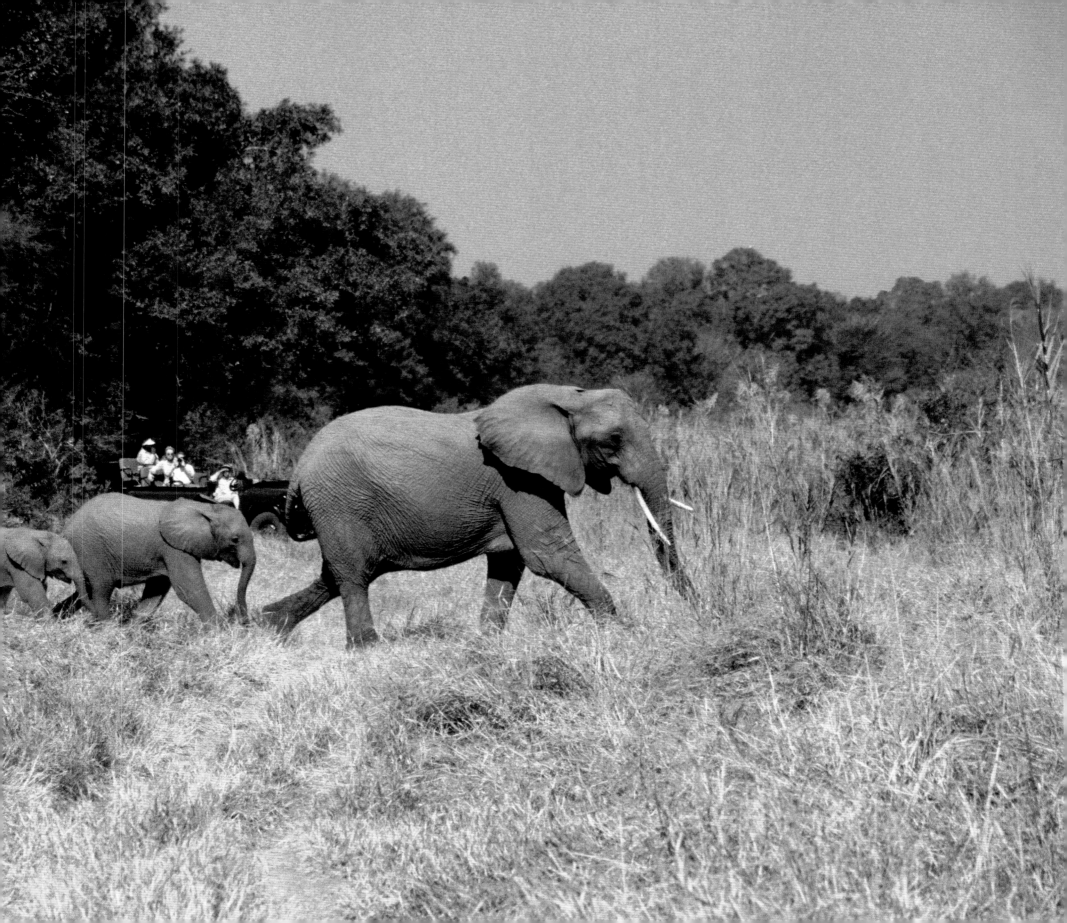

Dawn to Dusk

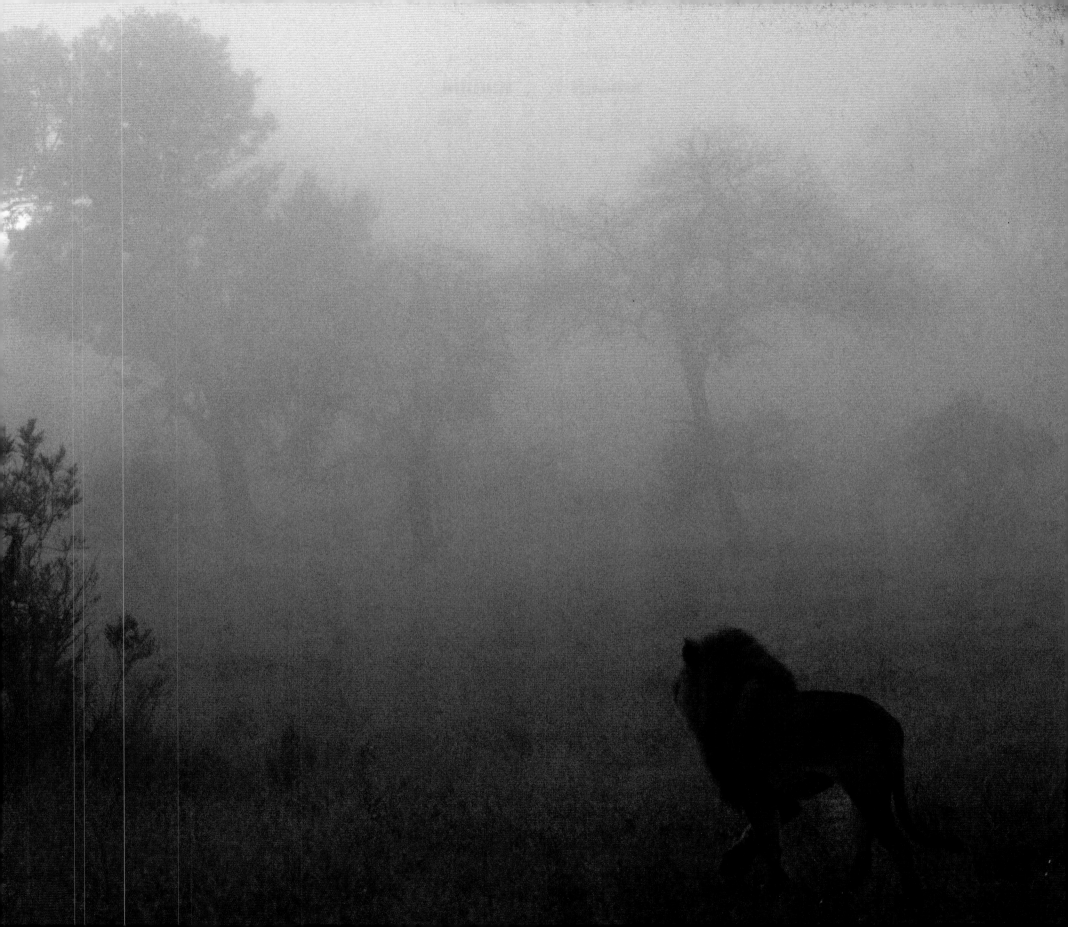

*T*HE RING OF THE TELEPHONE ROUSES YOU FROM SLEEP. GROGGILY, YOU CONSULT your bedside clock. Picking up the phone, you are greeted by the cheerful voice of your ranger, informing you that it's time to rise for your early-morning drive. Pulling on jeans, sweater, and jacket, you wonder if perhaps you should have slept a bit later and ambled over to the delectable breakfast buffet in the dining room. However, when you think about the wildlife you may chance upon in the early morning hours, excitement swiftly takes the place of languor. You emerge into the cool winter pre-sunrise gray, join your travelling party, and climb into the Land Rover.

As you leave camp, you take the Old Bridge crossing and drive toward the Piccadilly Open Area, where you are confronted by the eerily beautiful sight of a solitary male lion, walking majestically through the mist. The sun has begun to rise, glowing soft pink and red over the Sand River. You proceed to Campbell Koppies, an elevated site famous for optimal viewing of spectacular sunrises. Your entourage arrives just in time to see the sun burst through in a blaze of gold, highlighting the waves of diaphanous mist which roll across the treetops. In the distance, Sithlawayise (also known as Stwise), the most majestic of the koppies, slices starkly through the soft sea of white. You are reduced to silent awe by the beauty that unfolds below. Your group pauses, prolonging the moment with a steaming mug of coffee and freshly baked muffin, courtesy of your ranger and ever helpful tracker. Taking one last look before driving on, you then head to the Hippo Pools, just in time to catch a robust hippo, grazing placidly on the riverbank before lumbering into the water to join his comrades. You watch as they surface and submerge with seeming delight as the deep water ripples around their rotund bodies. One thing is clear: these are creatures happy with their lot in life. Upon leaving the hippos, you happen upon a herd of Cape buffalo lolling about, chewing their cuds, considering the possibility of getting up to start their day. You notice that the sun is fully up now. You can remove your first layer of outer clothing, and you find yourself searching for your brimmed hat. Look up! In the branch of a nearby tree a leopard is taking a mid-morning siesta. The sounds of birds and insects fill the air as the sun rises yet higher in the sky.

Your ranger inquires if you all might like to head back for lunch. This sounds like an excellent suggestion. You proceed towards Camp, only to encounter an elephant sauntering down a path, showering himself with dust. Passing by the high wall outside the Main Camp entrance, you spot two comical vervet monkeys. Their chattering acrobatic antics seem deliberate, as if it is their intent to charm and amuse.

You decide to spend the warmest part of the day enjoying a sumptuous lunch on the shaded deck overlooking the river, then going for a swim in the pool. After three o'clock tea, you are sufficiently fortified to embark on your after-noon-into-evening game drive. You take along your sweater and jacket in preparation for doing the reverse of what you did in the morning—adding layers, rather than removing them.

The first sighting of the afternoon is a stately male kudu, standing at almost military attention. He stops, allowing you to photograph him, then darts off into the bush. A bit further down the road, near Campbell Koppies, are four

RIGHT: Sunrise over the Sand River.
PREVIOUS PAGE: One of the West Street males crosses the Piccadilly open area at dawn.

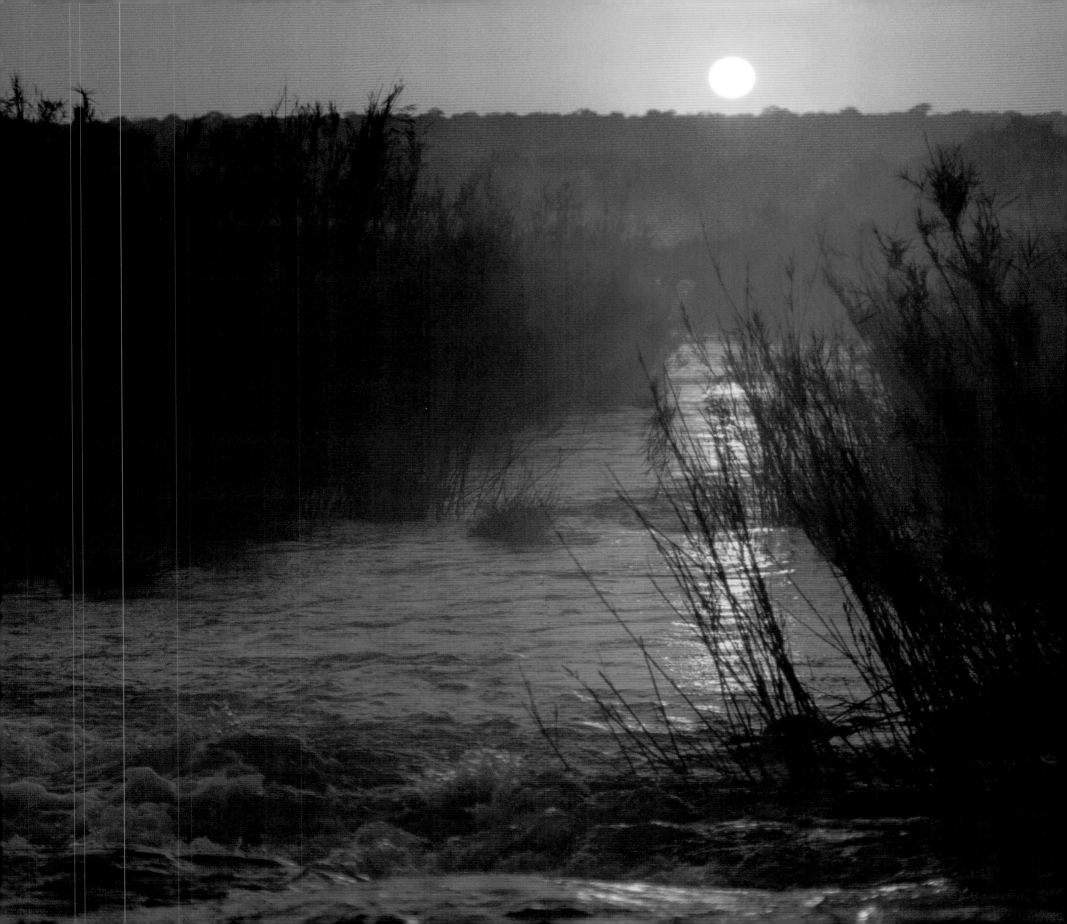

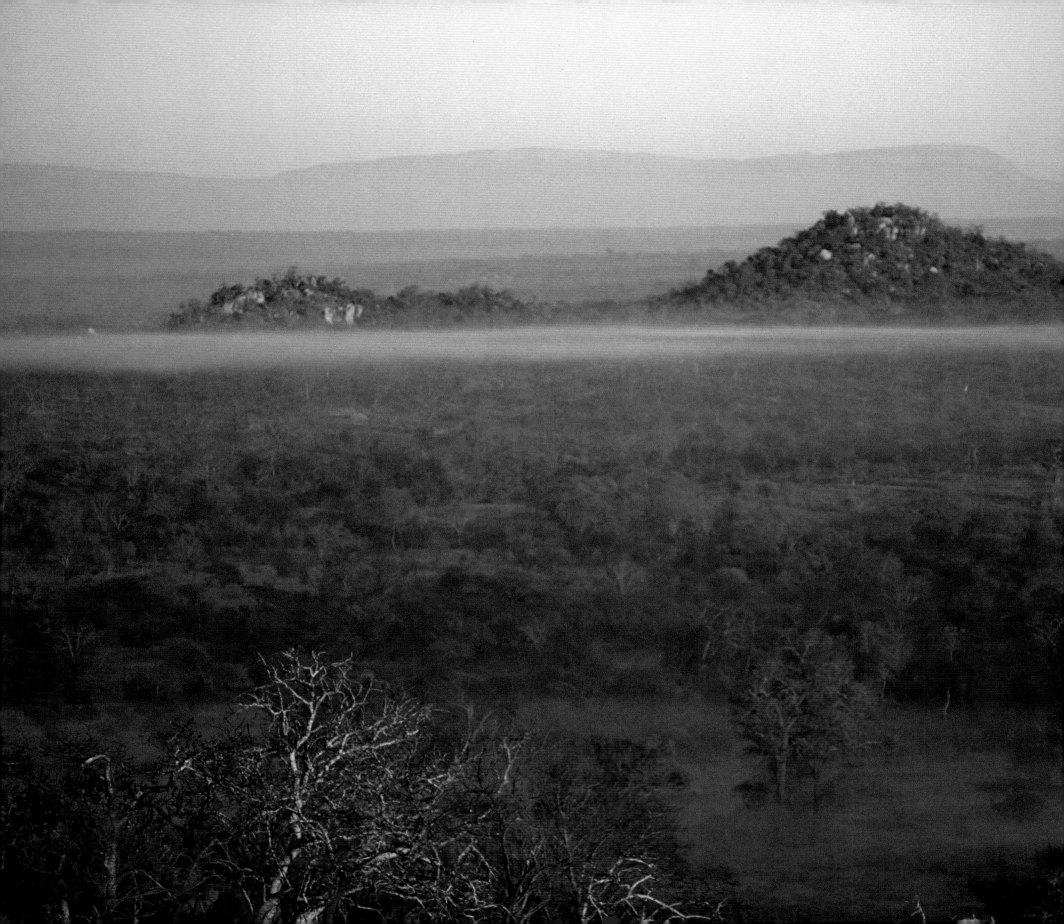

elegant impala, who seem to be listening intently for any signs of danger. Proceeding down a rutted dirt path framed by graceful bushwillow trees, you are startled by the sight of two enormous rhinos reveling in the muck of a mud hole. You begin to notice that the sun is sinking in the sky, and the afternoon light takes on a golden glow. You pass a huge termite mound, from which two playful mongooses seem to be conducting a game of hide and seek. Down another quiet path, through a grove of umbrella thorn trees, a limpid-eyed female bush buck stands and browses. The late-day light fades and gradually deepens into dusk, when the waning sun finally sinks in a burst of vivid color, dramatically silhouetting the trees and koppies. It is only after the sun has set that your tracker takes out the spotlight, which he uses to facilitate night viewing. You pull on your jacket to ward off the slight chill in the air and drive over in the direction of the windmill. There, you chance upon an amazing spectacle: a pride of nine lions, drinking en masse from a watering hole. They are unfazed and wholly at ease in the spotlight. Their thirst satisfied, they turn away, and you begin the drive back to camp. However, one more surprise is in store. Your tracker spots an owl, stationed like a nocturnal sentinel on a branch overhead, round eyes wide and unblinking.

Back at camp, you freshen up and walk over to the Lounge to have a drink with your companions. How many points was your party able to add to the animal sighting scoreboard over the bar? It is with some satisfaction that you note you've seen the legendary "Big Five" all within the course of one day, in addition to other fascinating animals and an abundance of natural wonders. Dinner conversation around the bonfire in the boma will be filled with the recounting of the day's extraordinary events and the anticipation of what wonders tomorrow will bring.

Stwise and Poliwe seen from Campbell Koppies.

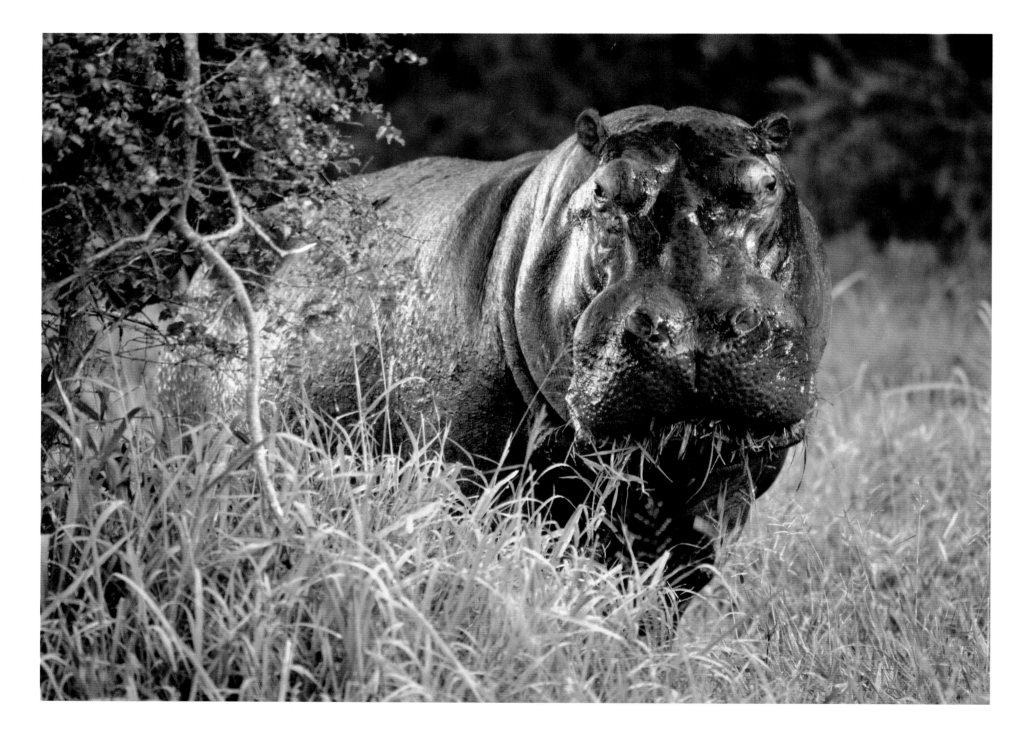

A hippo uses large square lips to rip off large quantities of grass, its only source of food.

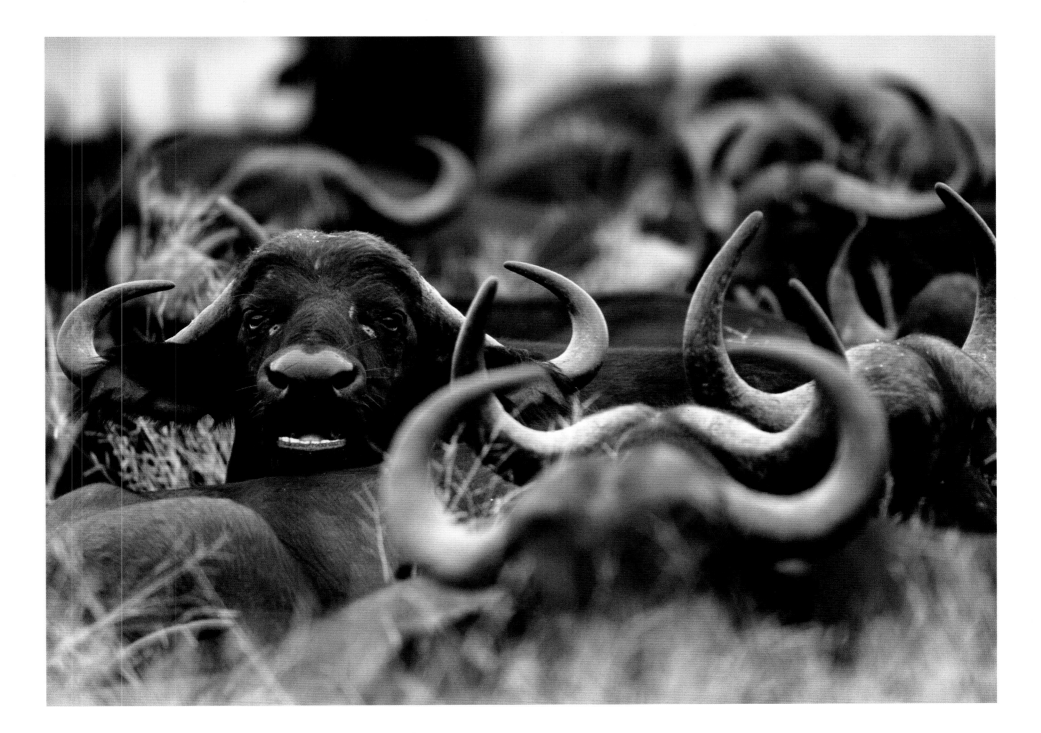

A buffalo cow ruminates amongst the large herd, numbering a few hundred.

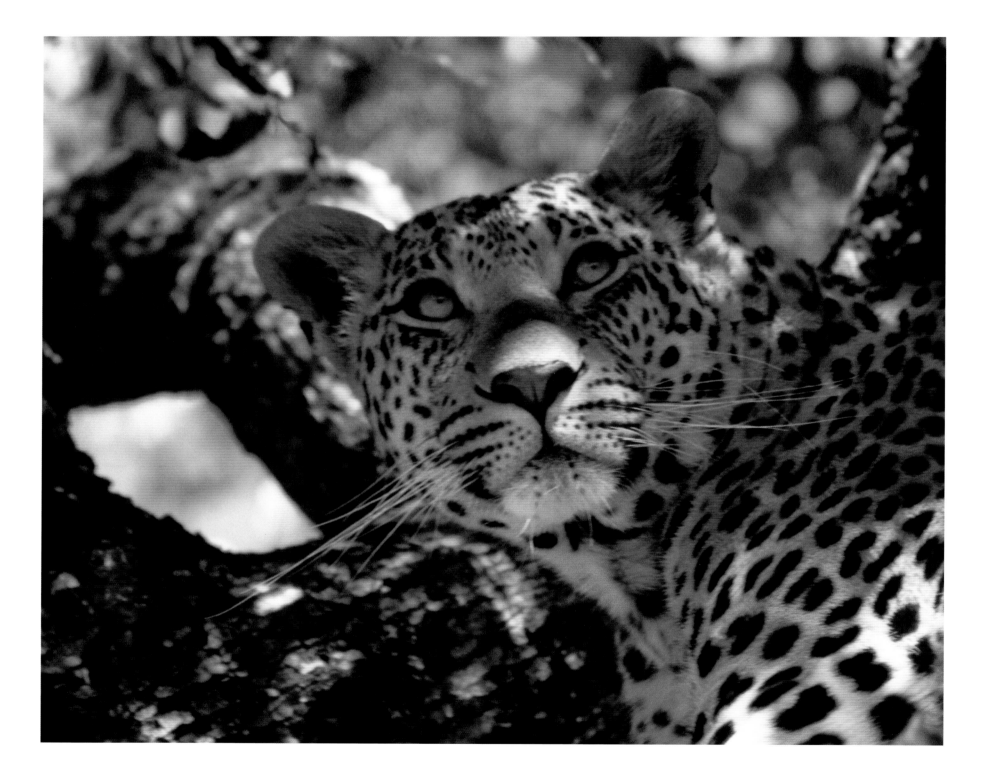

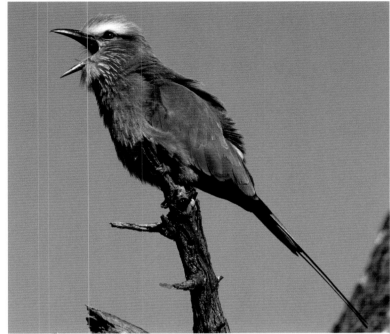

ABOVE: A lilacbreasted roller brightens the bushveld with its vivid colors.

RIGHT: A blackheaded oriole making use of an aloe in camp.

LEFT: During the heat of the day, a leopard eyes her treetop neighbors from a shady spot in the trees.

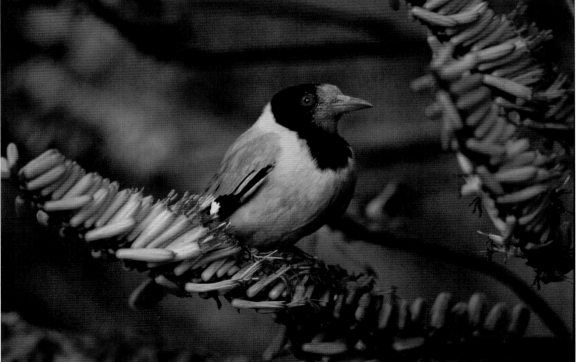

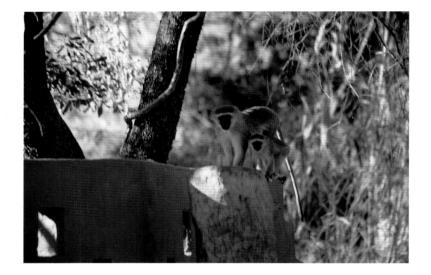

ABOVE: Vervet monkeys come into the camp in search of fruit and leftovers. Keep your doors and windows closed!
RIGHT: An elephant bull enjoys a dust bath.
BELOW: A herd of Burchell's zebras usually numbers four to six, consisting of an adult stallion, mares, and their foals.

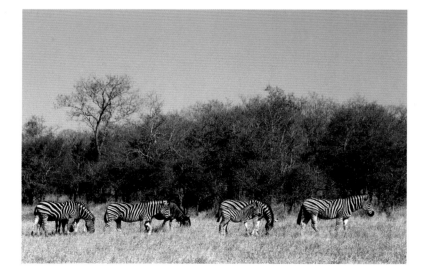

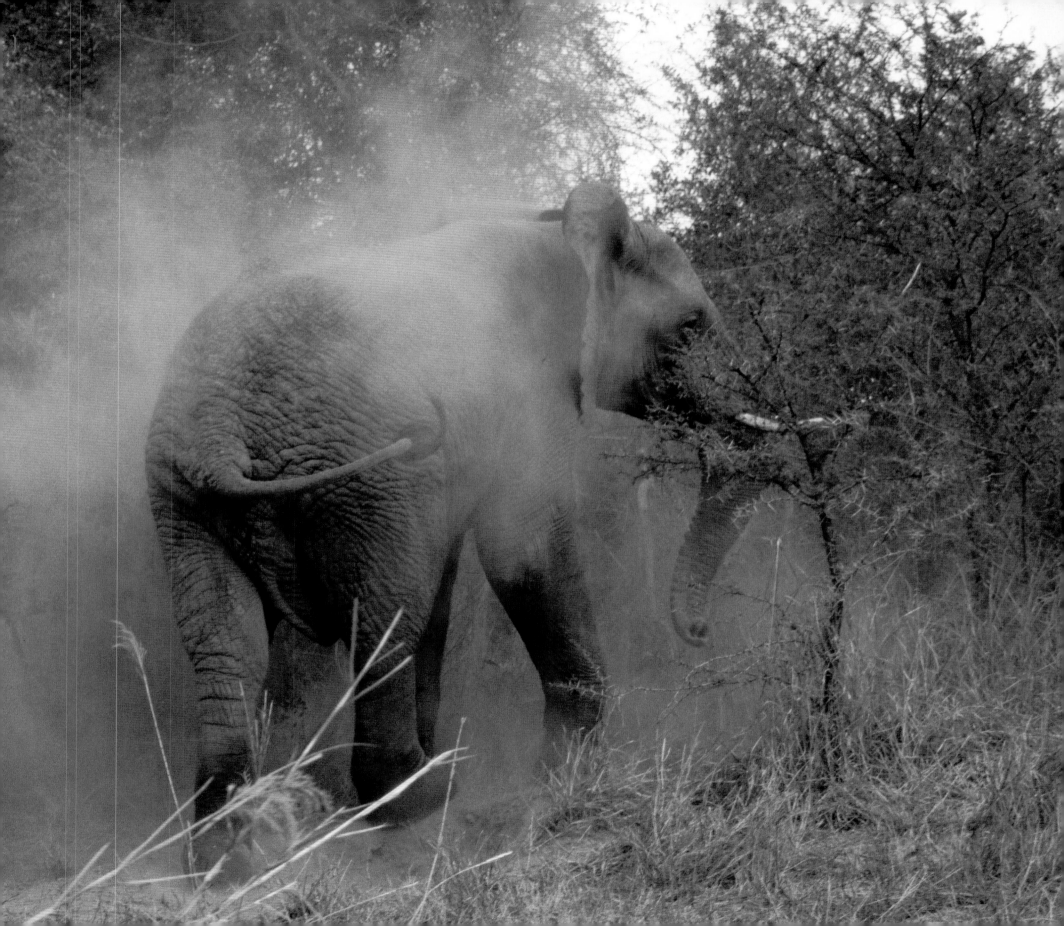

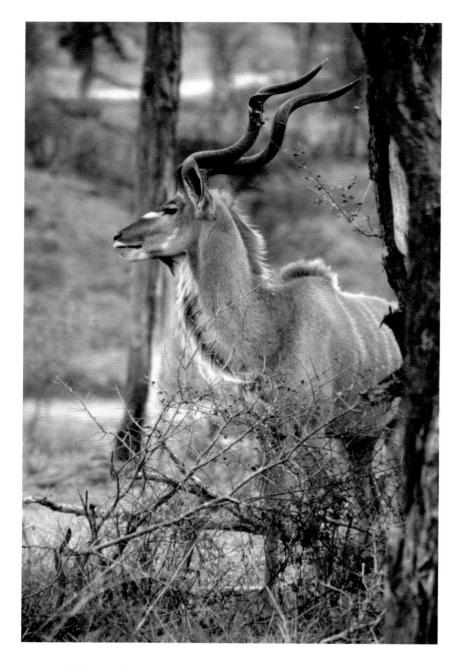

ABOVE: Male kudu near a fire break.

RIGHT: On the slopes of Campbell Koppies, impala stand attentive to the warning cry of a baboon, possibly signalling a predator nearby.

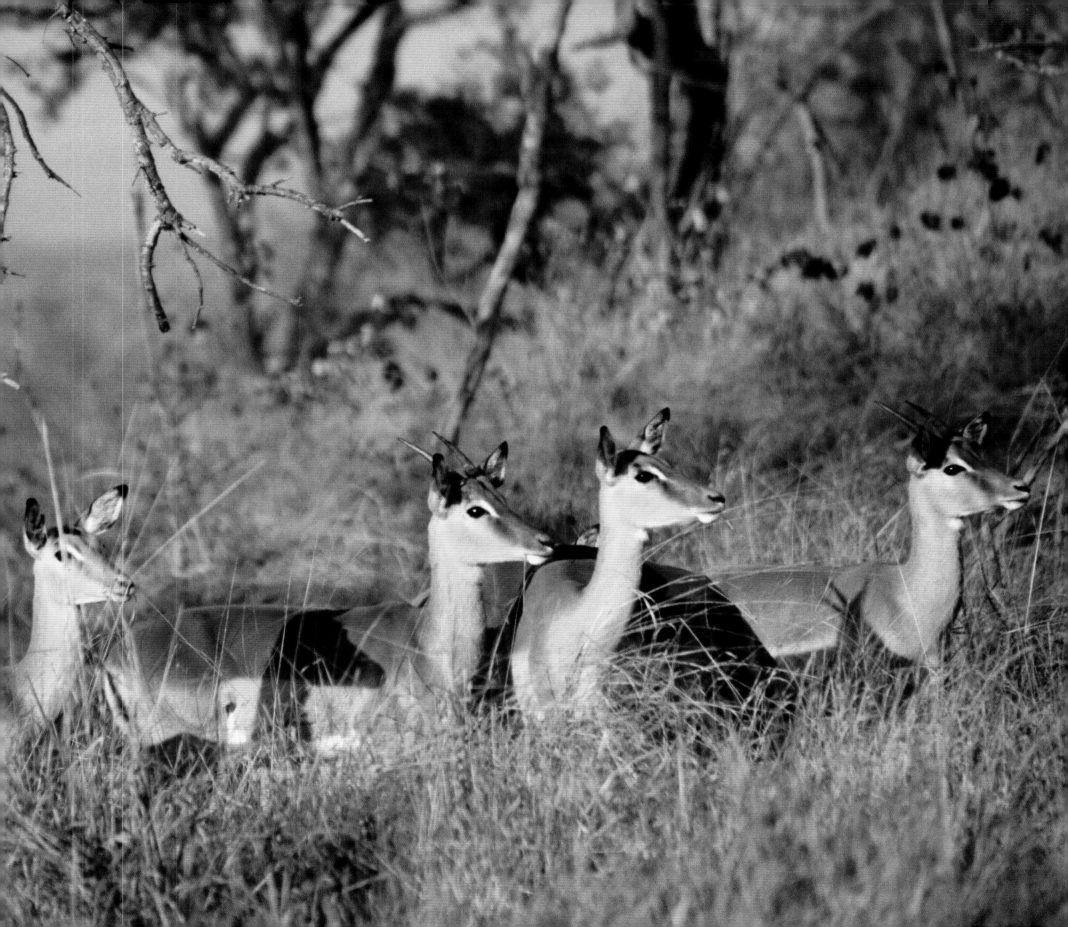

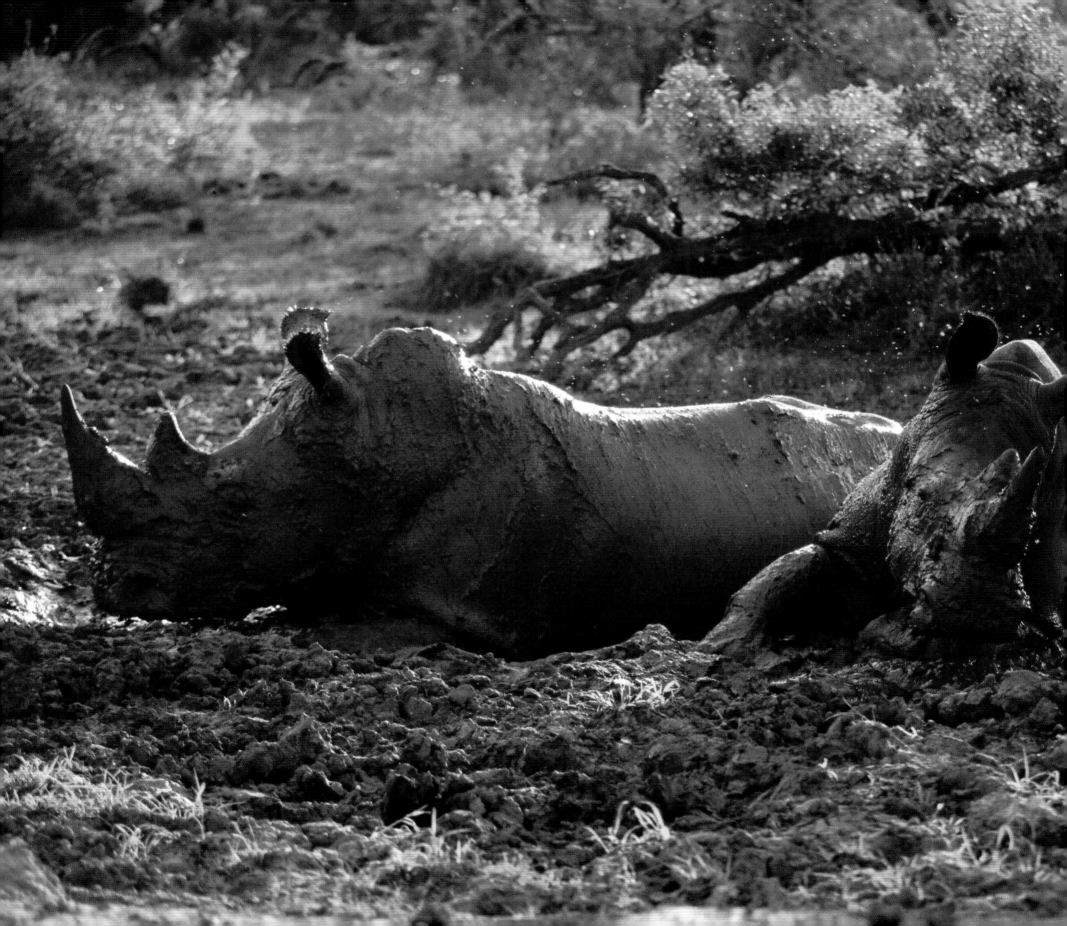

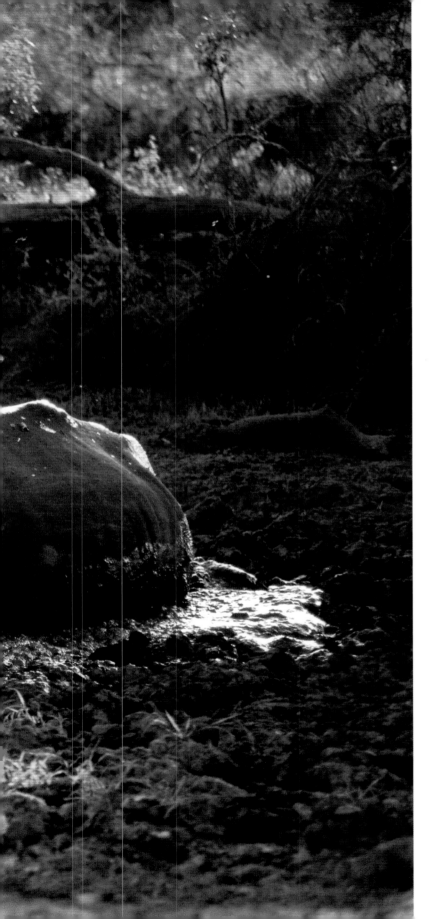

ABOVE: Dwarf mongooses use termite mounds to sleep in and as sanctuary from predators.

LEFT: Wallowing in the mud cools the rhino and gives temporary relief from parasites as well as from flies hovering overhead.

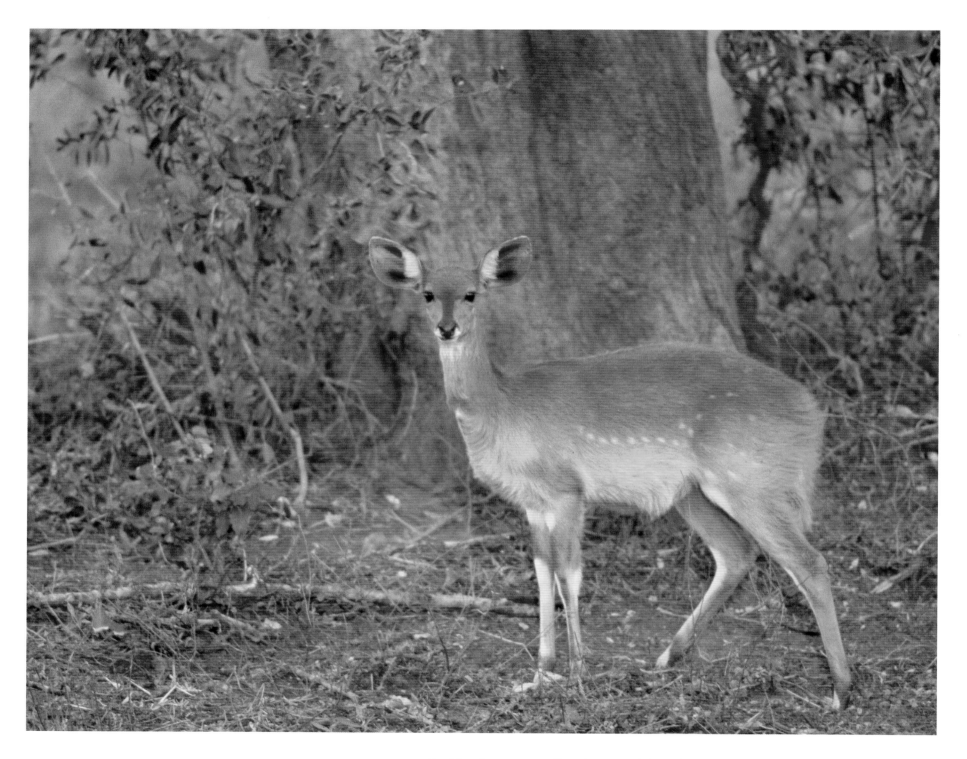

Bushbuck are generally solitary and found in the thick bush lining the watercourses.

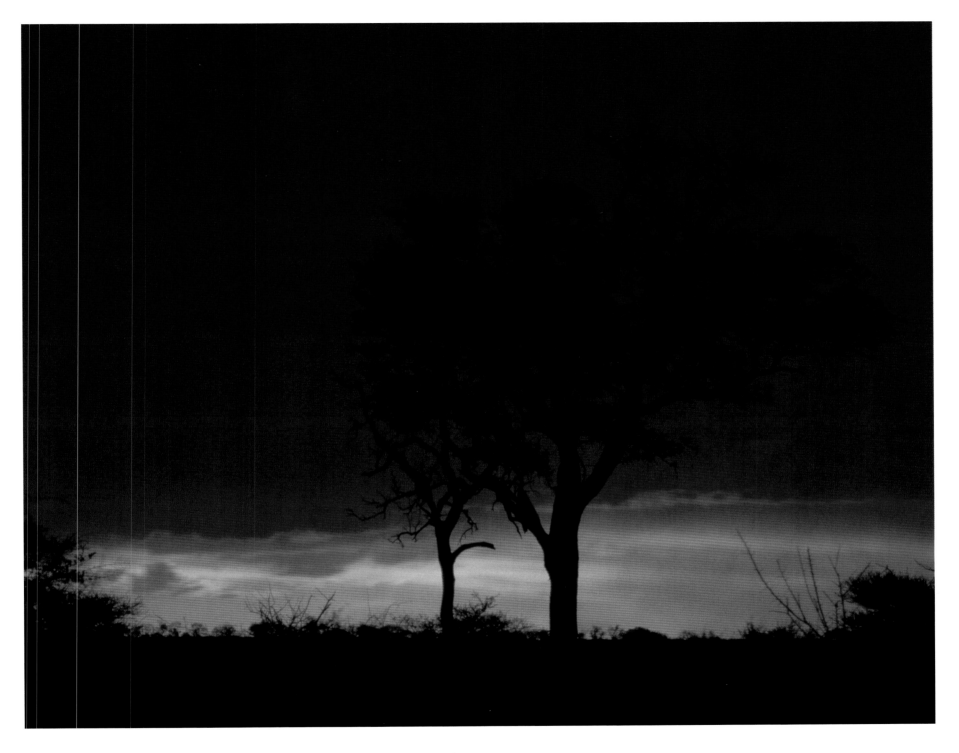

A knob thorn tree silhouetted at dusk.

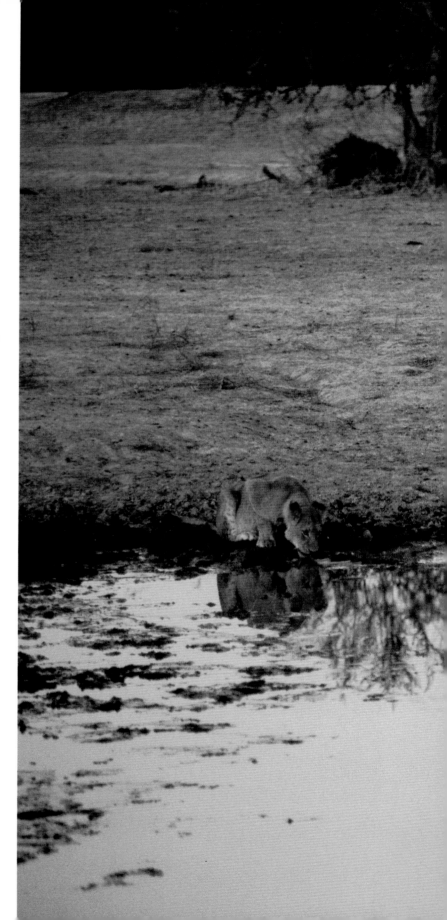

As dusk turns to night, spotlights
reveal the predators, which become
more active as it cools down.

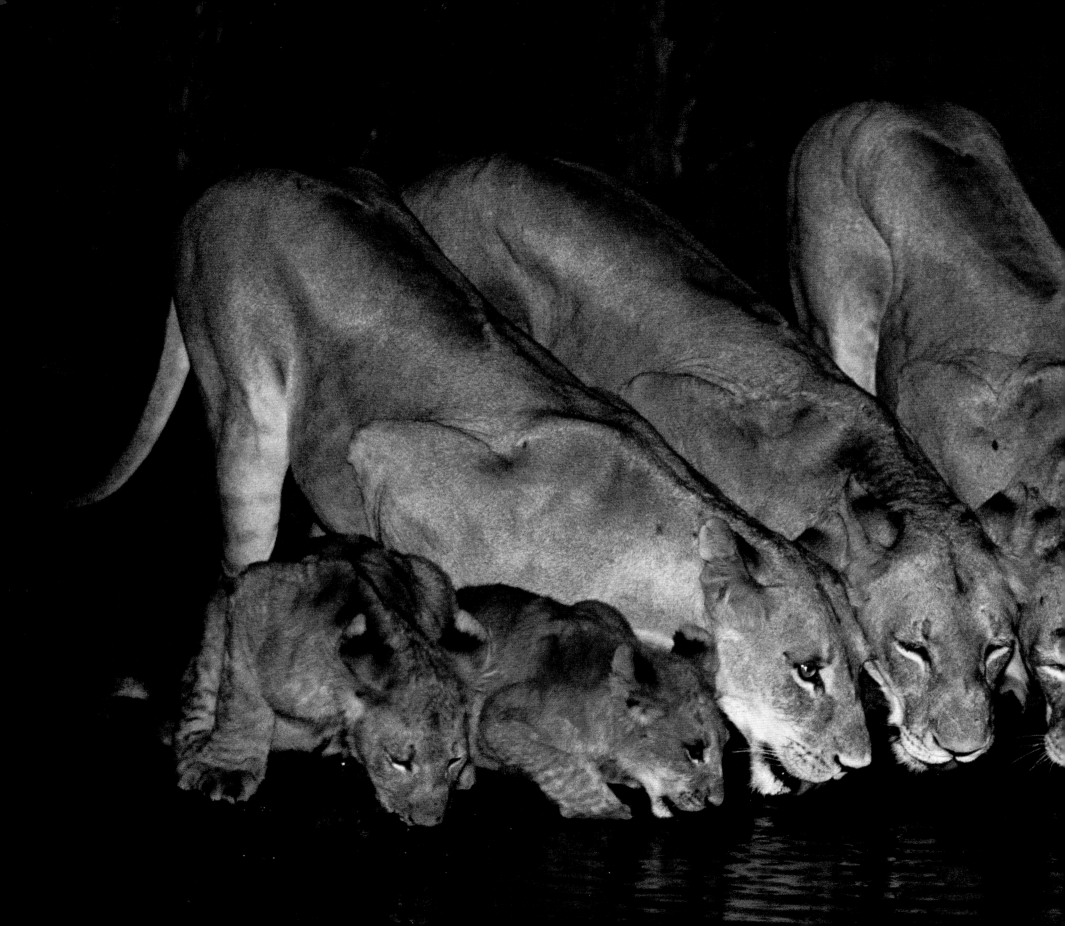

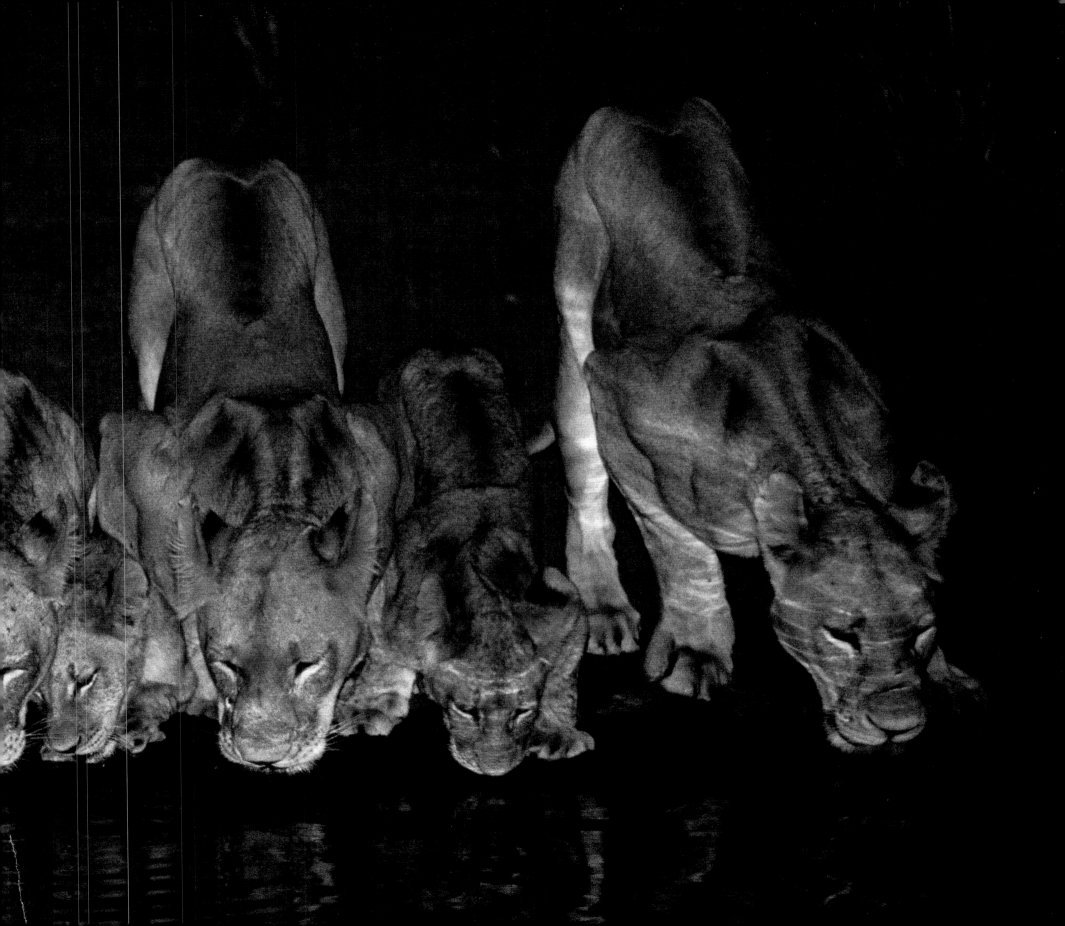

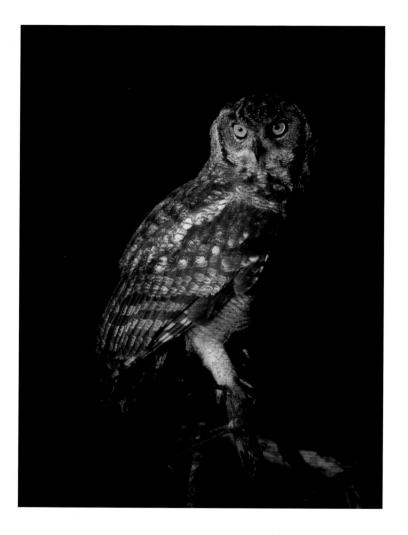

ABOVE: A spotted eagle owl searches for small rodents at night.
RIGHT: After an evening on safari, bronze warthog sculptures
mark the way back to reception at main camp.
PREVIOUS PAGE: The Eyrefield pride drinks from the pan at the
Windmill.

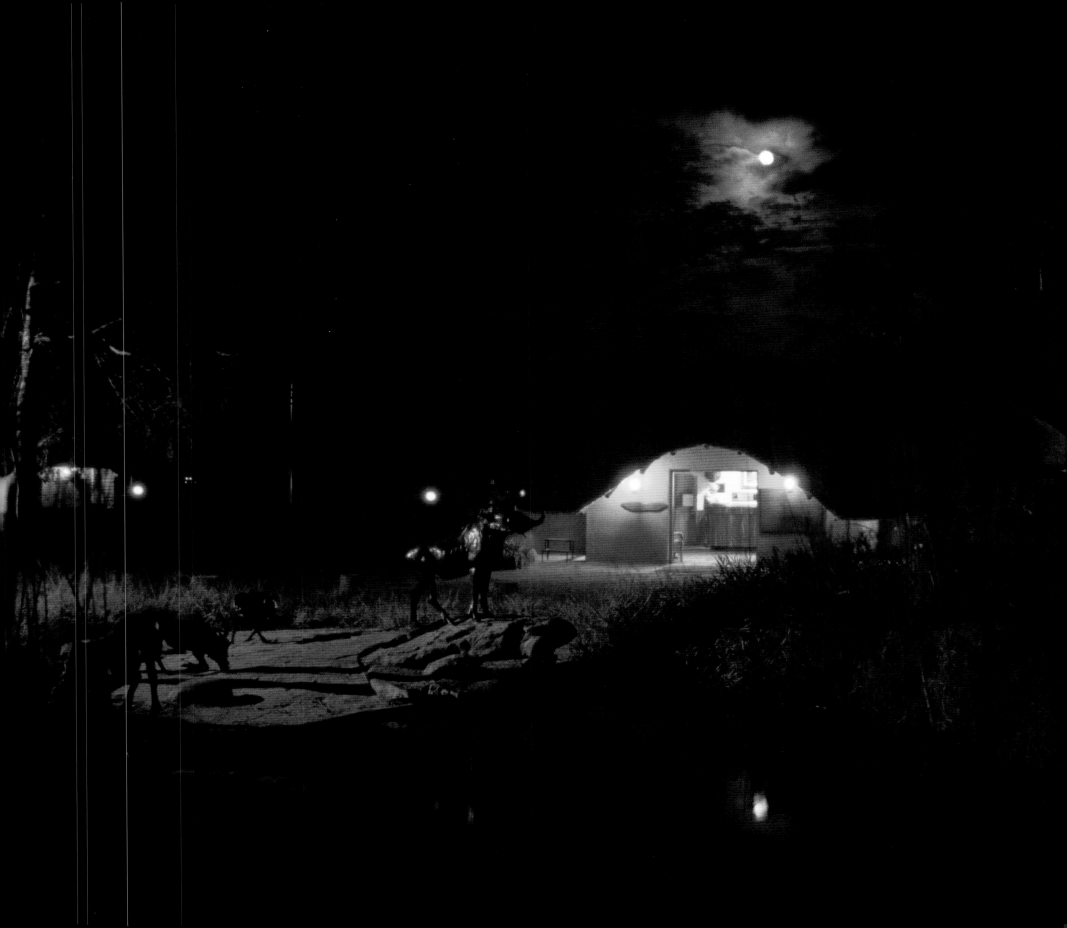

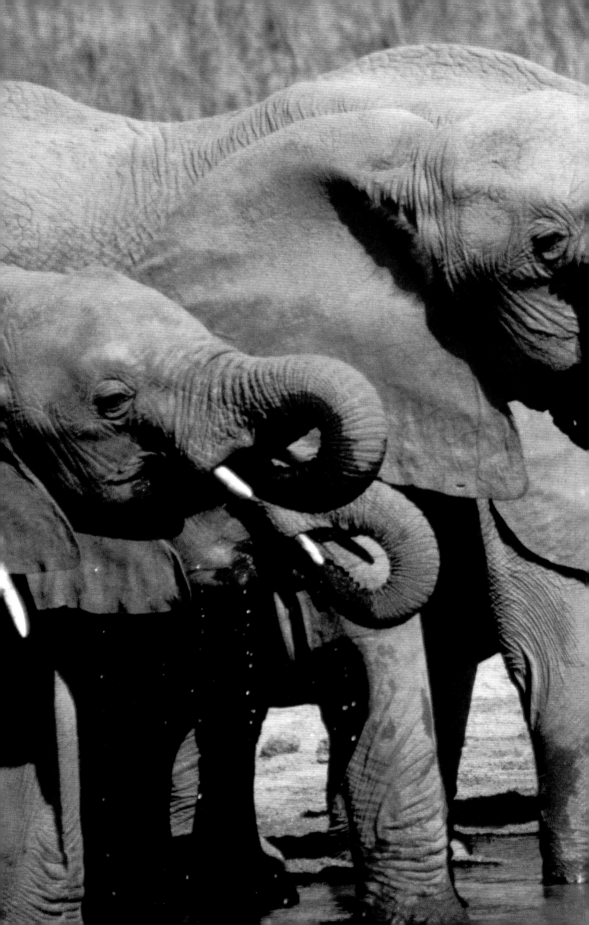

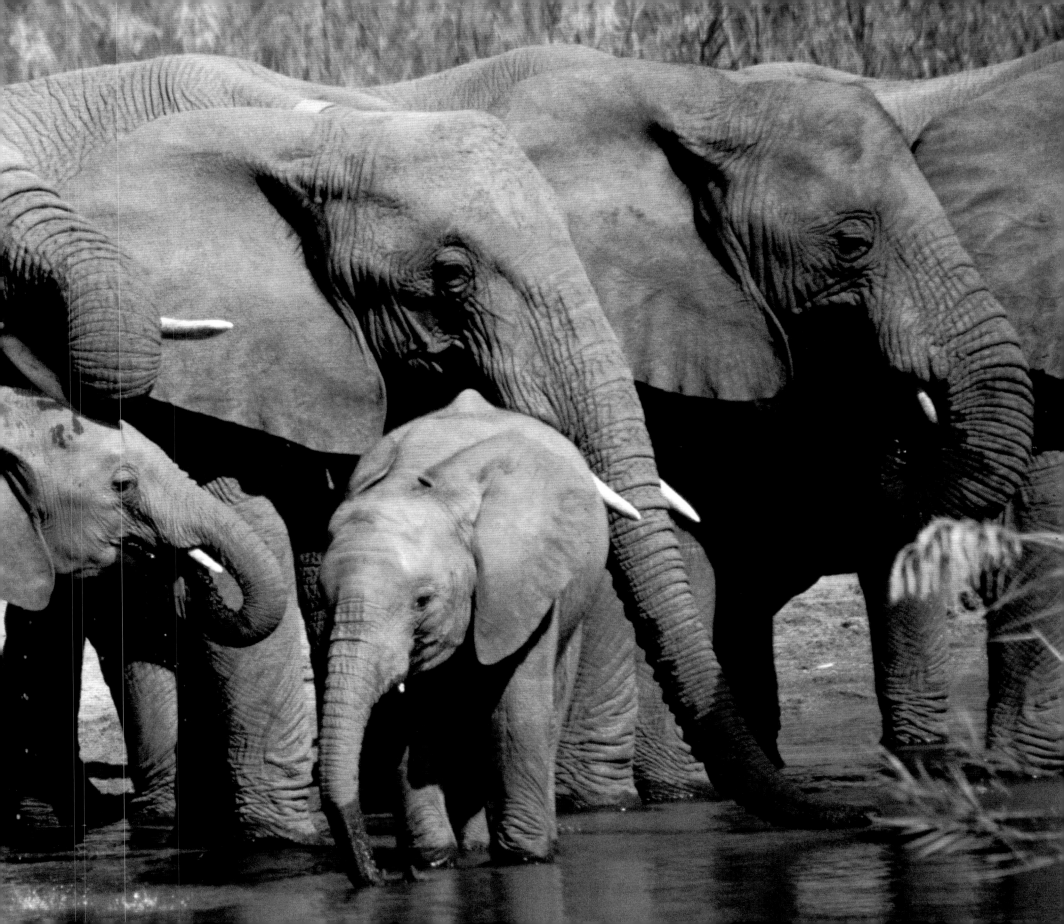

*T*HE SAND RIVER IS THE LIFEBLOOD OF MALAMALA, A LIQUID PATHWAY that nourishes, invites, and convenes an abundance of mammals, reptiles, insects, and birds. In addition to the animal life that abounds in this fertile setting, the neighboring flora also depend upon the river's life-sustaining waters.

The nature of the Sand River is ever-changing: witness the fast-moving rocky rapids, the reed-lined shallows, and the wider, deeper, murky sites known as the Hippo Pools. On any given day, by driving merely a few hundred yards upstream or downstream, one can see the changeable nature of the river and the wide range of species that are drawn to specific areas. For example, in the space of a morning's drive along the river, at one of the Hippo Pools we observed hippos wheezehonking with gusto as crocodiles glided ominously nearby and lizards basked languidly on rocks warmed by the morning sun near the river's edge. Slightly downstream, a small herd of elephants lumbered through the reeds, stopping for a drink while a young calf splashed playfully in their protective midst. A female leopard and her cub, perched like sentinels on the sturdy branch of a marula tree, calmly surveyed the scene below. A bit further down, unbeknownst to the leopards, a small herd of impala grazed on a grassy knoll.

Along much of the Sand River a thick barrier of trees, bush, and reeds render the river virtually inaccessible to both man and animal. However, a few gaps in the bush alongside the river allow animals and vehicles to ford the river. Many of these crossings are spacious and scenic, comprised of delta-style accumulations of sand. They are wonderful spots to stop your vehicle and enjoy the surrounding wildlife and vegetation. Often, vehicles find themselves waiting in line at these crossings while animals make their way across the river.

The Sand River also changes seasonally. In the South African summer months, from November to March, the river sometimes swells, overtaking the watering holes and tributaries, turning everything verdant with the advent of the summer rains. Amidst the gentle hues of the winter landscape, the river becomes an even more important focal point, since the animals are, by necessity, bound to its waters and the few remaining water holes. Consequently, the Sand River and its banks abound with animal activity during these arid months, making these areas prime wildlife viewing locations. In winter, the level of drama at the water's edge also increases markedly. The predators' connection to the river becomes more focused: they rely on it for their food as well as for their drink. In turn, their prey approach the banks cautiously, seemingly aware of their increased vulnerability.

As a visitor to MalaMala, one feels, much like the wildlife, drawn to the river. Luckily for us, we risk nothing in our exploration, except perhaps running out of film. It almost seems as if the main camp is the heart of MalaMala, and the Sand River is its major artery. Theirs is a synergistic relationship in the truest sense.

RIGHT: Hippo calves are able to nurse underwater. Their mothers are savagely protective.
PREVIOUS PAGE: Breeding herds of elephants frequent the Sand River to satisfy their thirst. Elephants can drink between one hundred and two hundred liters per day.

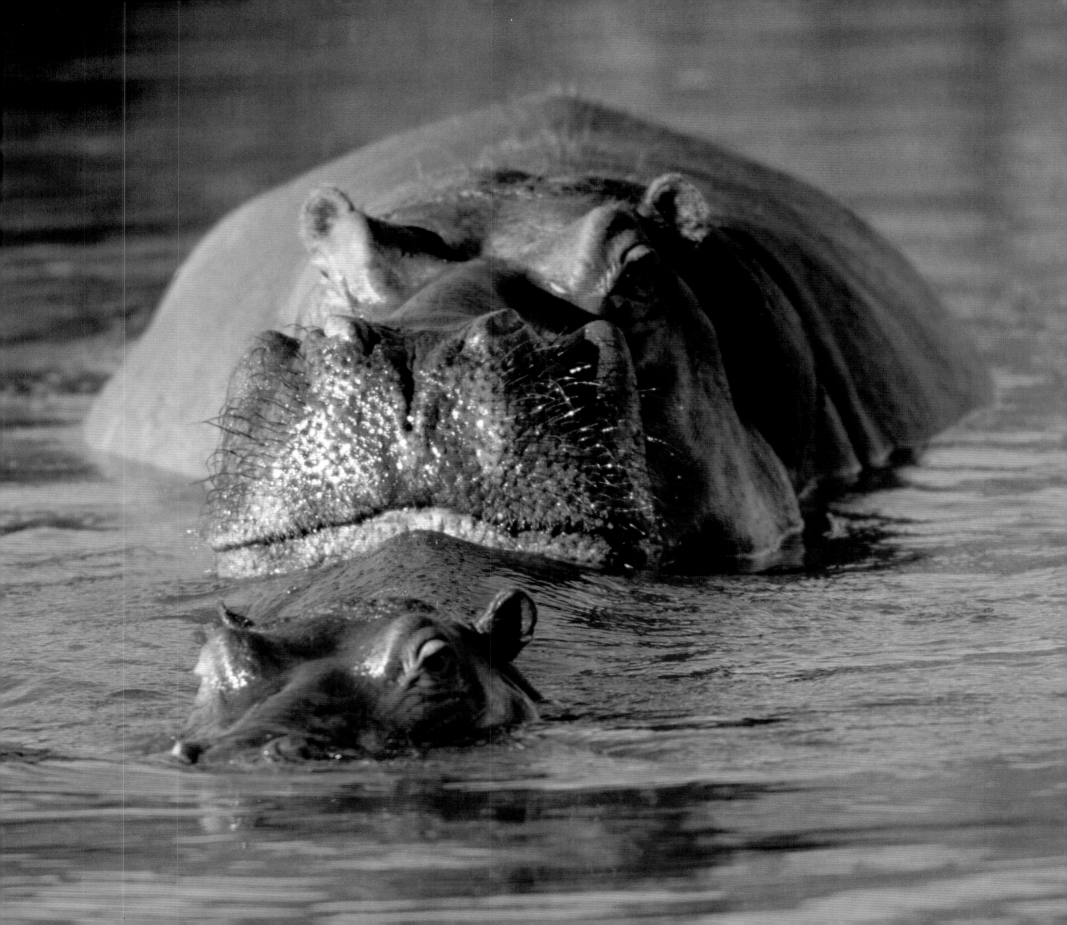

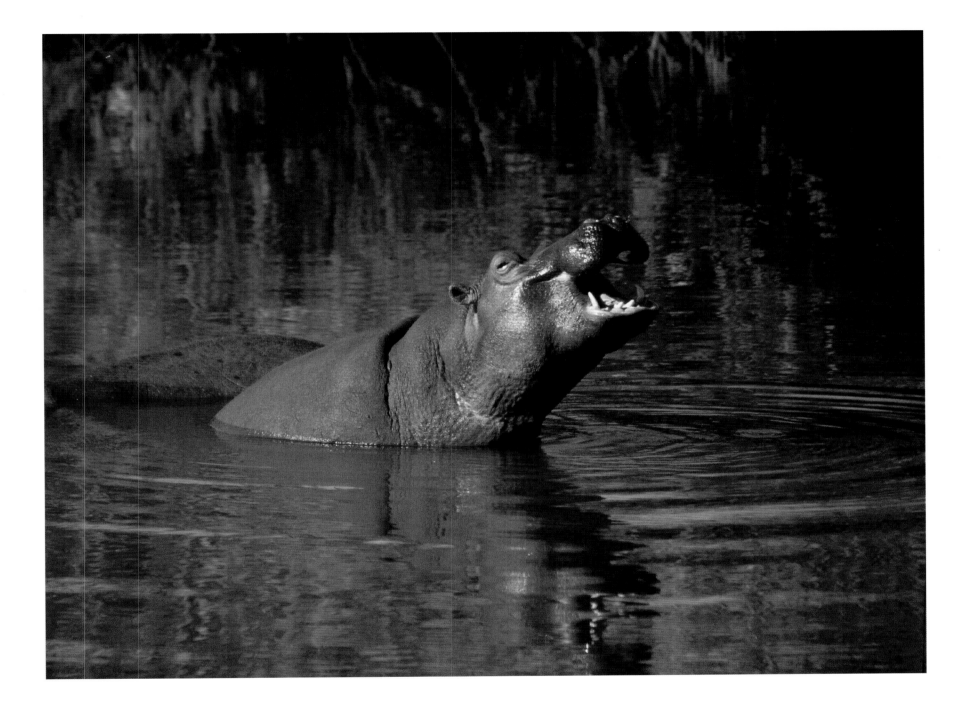

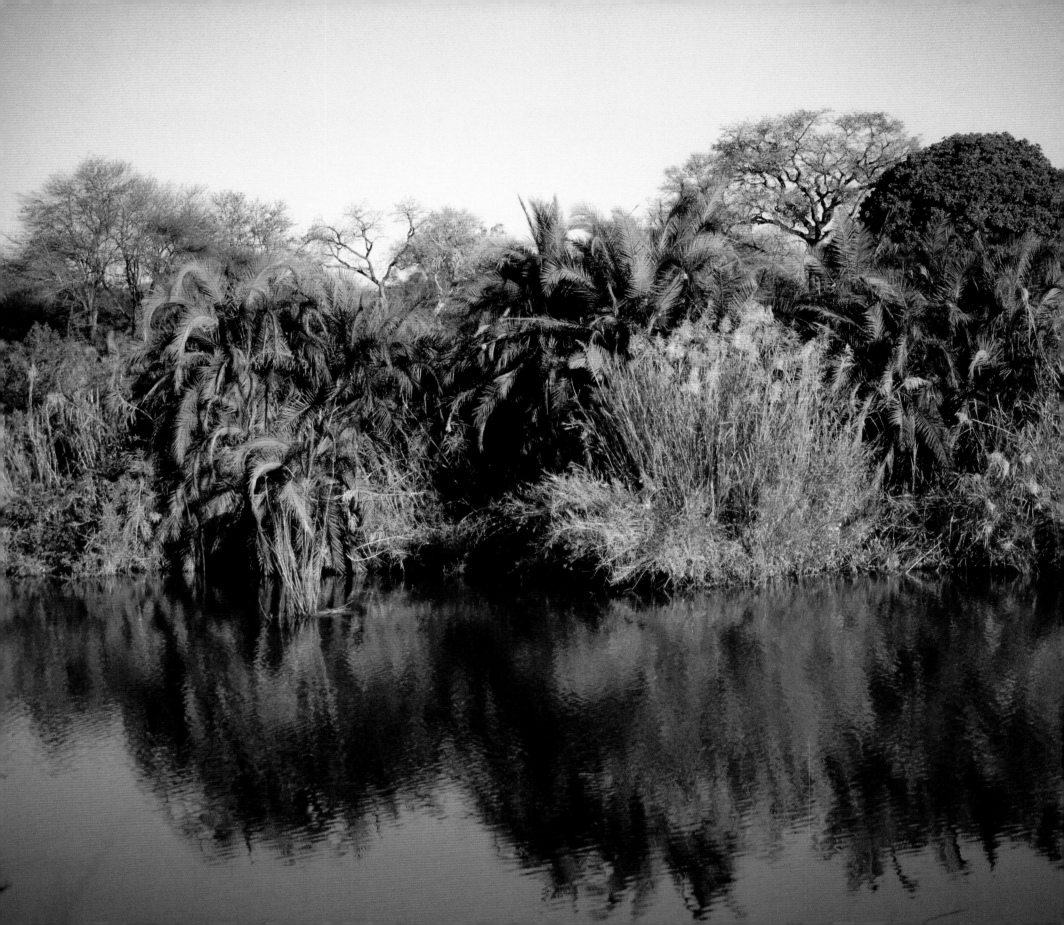

ABOVE: Bushbuck ewe at hippo pools.

LEFT: "Hippo Pools" is a stretch of the Sand River where the water usually remains deep throughout the year. As a result, hippos submerge themselves here, avoiding dehydration and overheating.

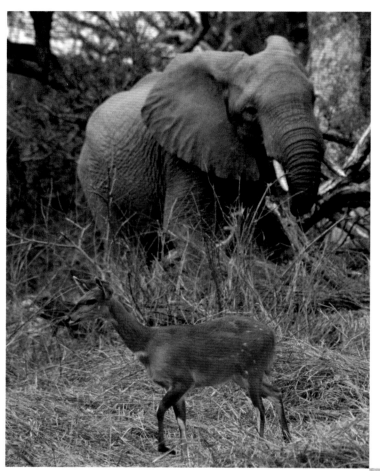

LEFT: Elephant and bushbuck cohabit the banks of the river.
BELOW: Impala at the old bridge.
RIGHT: Wildebeest crossing is well used by animals and vehicles when the water level allows.

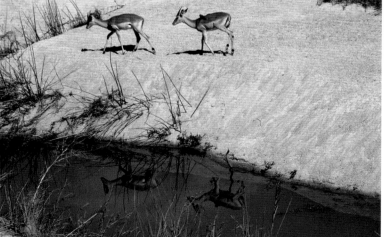

Two male elephants taking
a drink at Pedro's Pub.

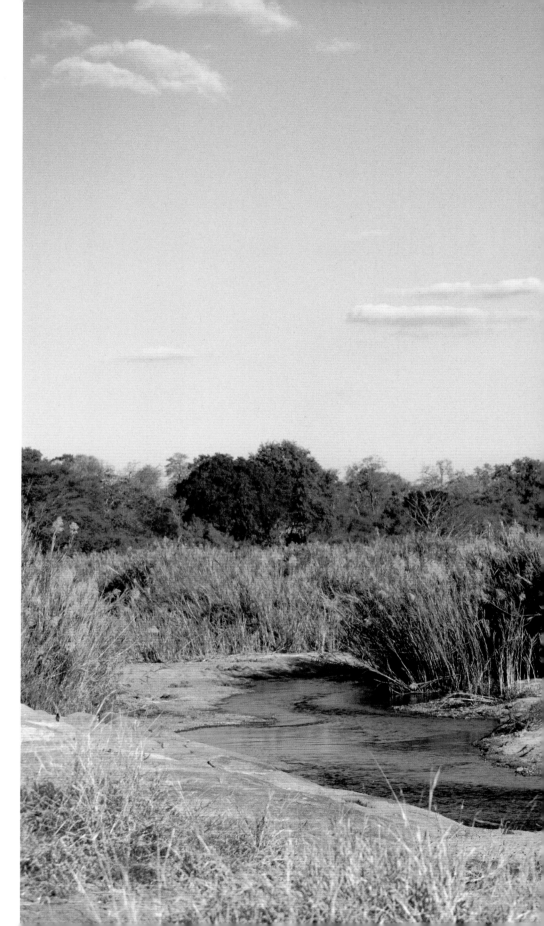

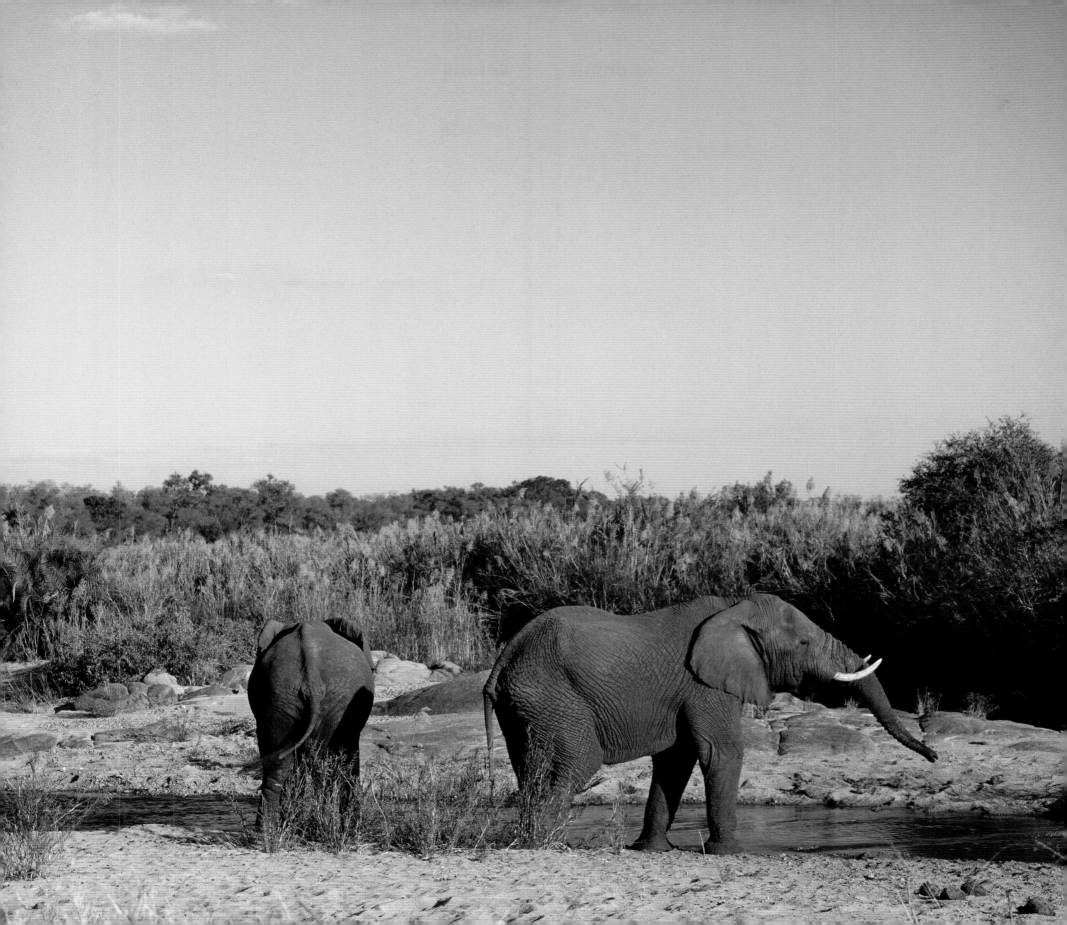

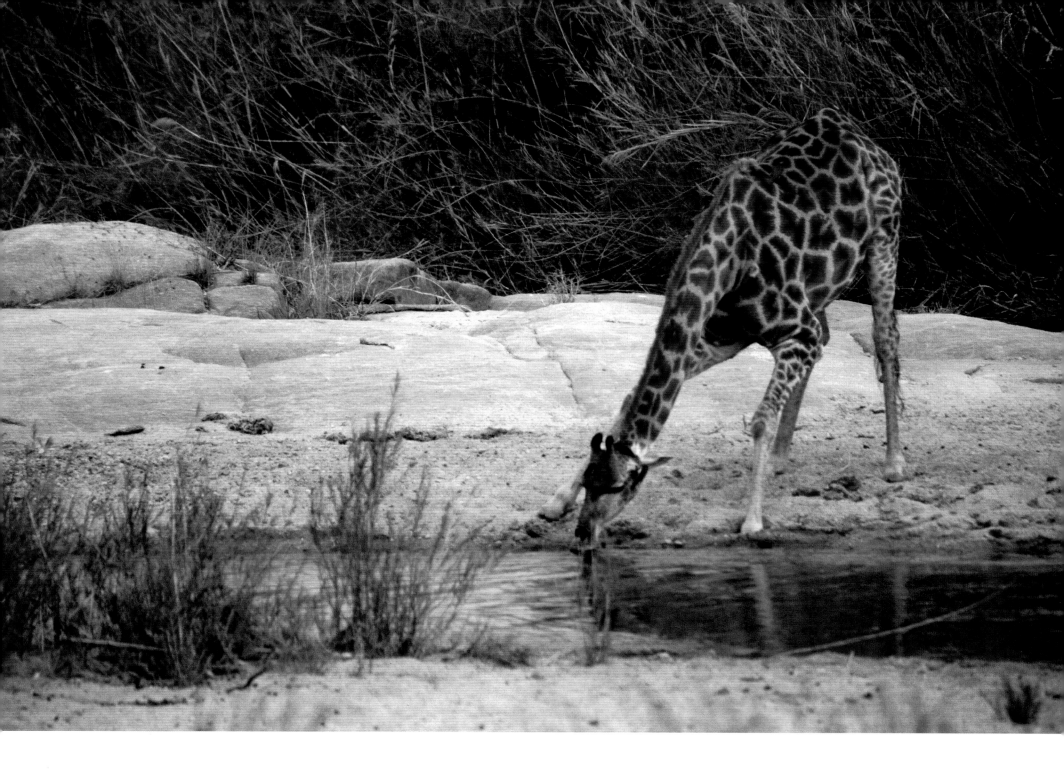

LEFT: A skittish female giraffe reluctantly lowers her head to drink at Pedro's Pub.
RIGHT: As she suddenly senses danger, birds scatter from their perch upon her neck.

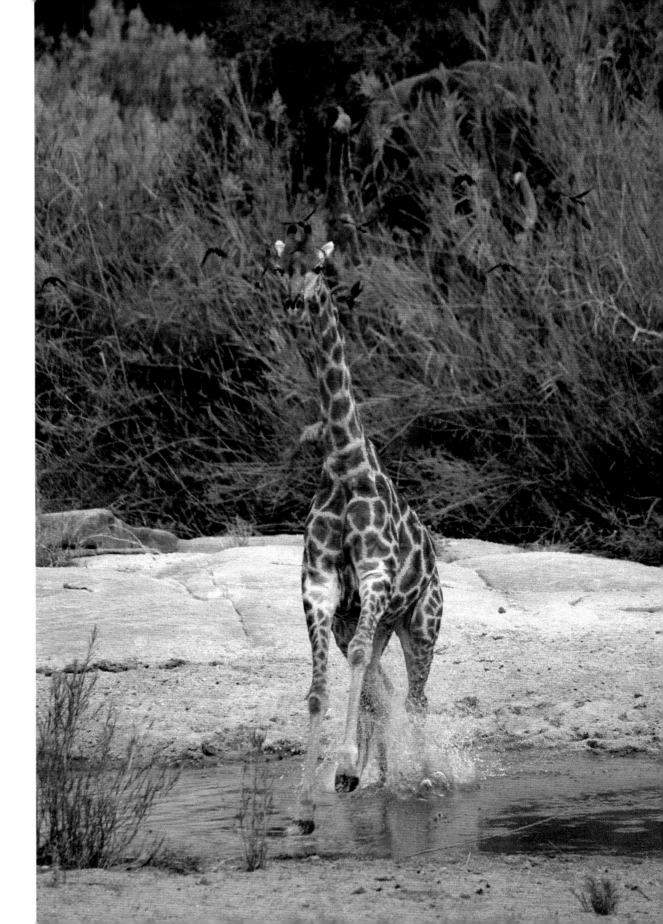

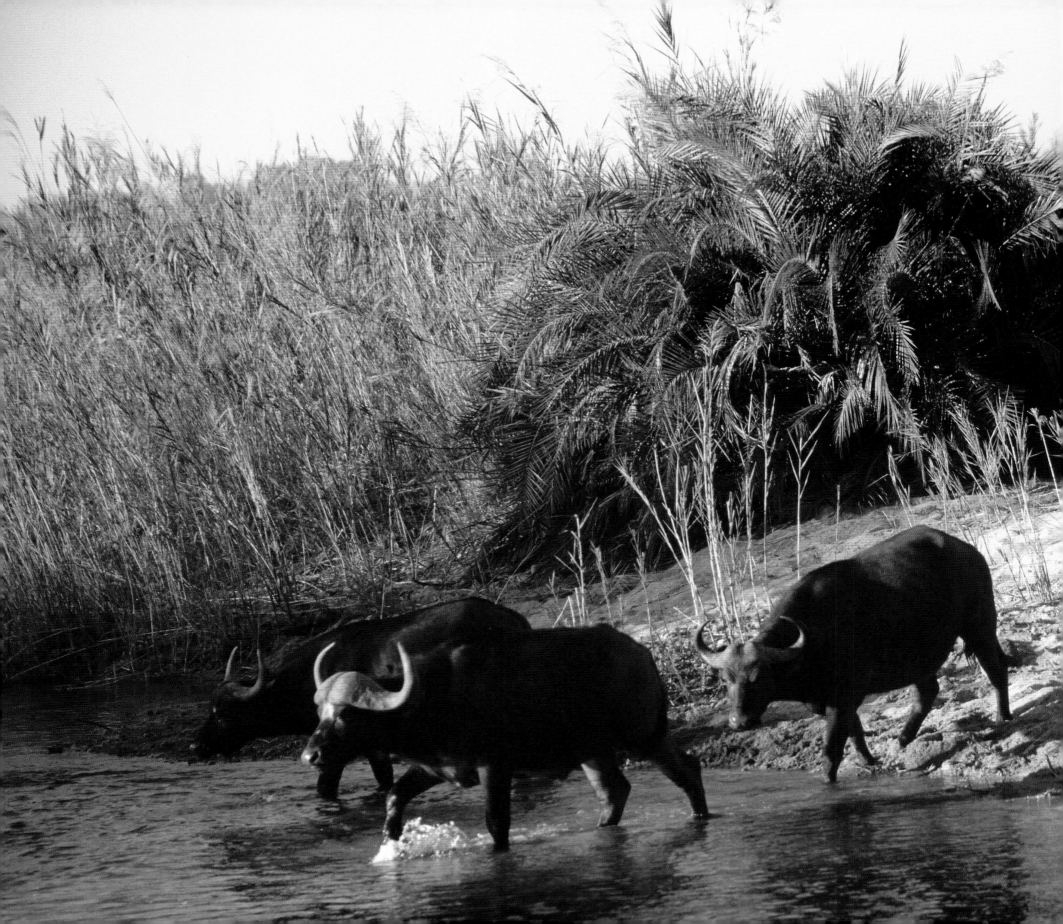

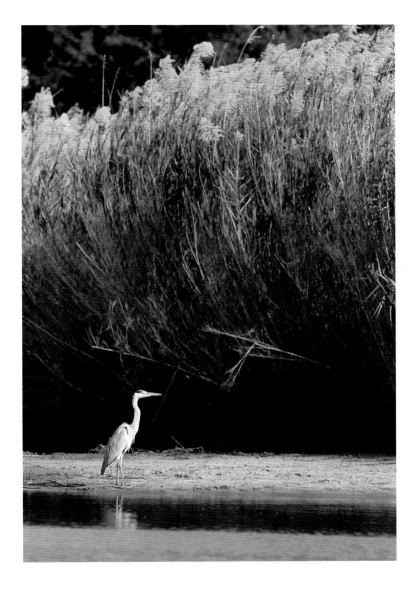

ABOVE: Grey heron to the west of Rocky Crossing.
LEFT: Cape buffaloes require water daily, spending much of
their time in and along the river during the drier months.

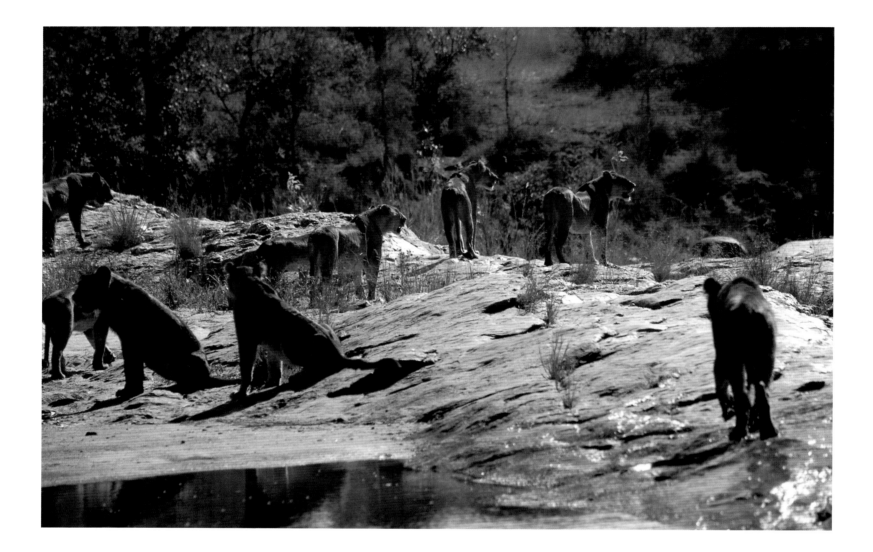

ABOVE: At Rocky Crossing the Charlston Pride takes a moment to dry off.
RIGHT: An Eyrefield pride lioness tiptoes into West Street Crossing.

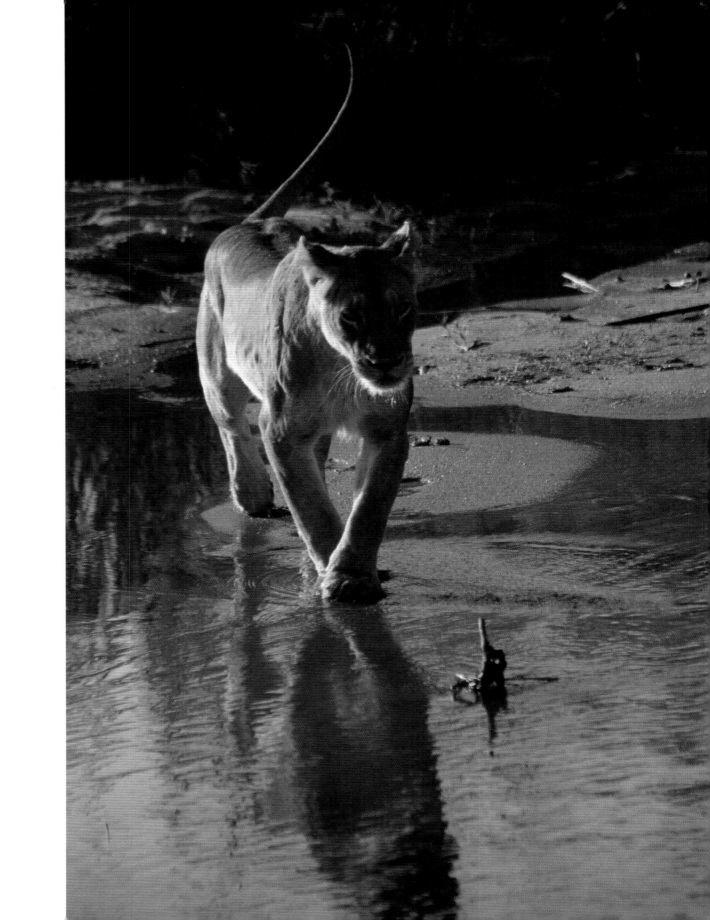

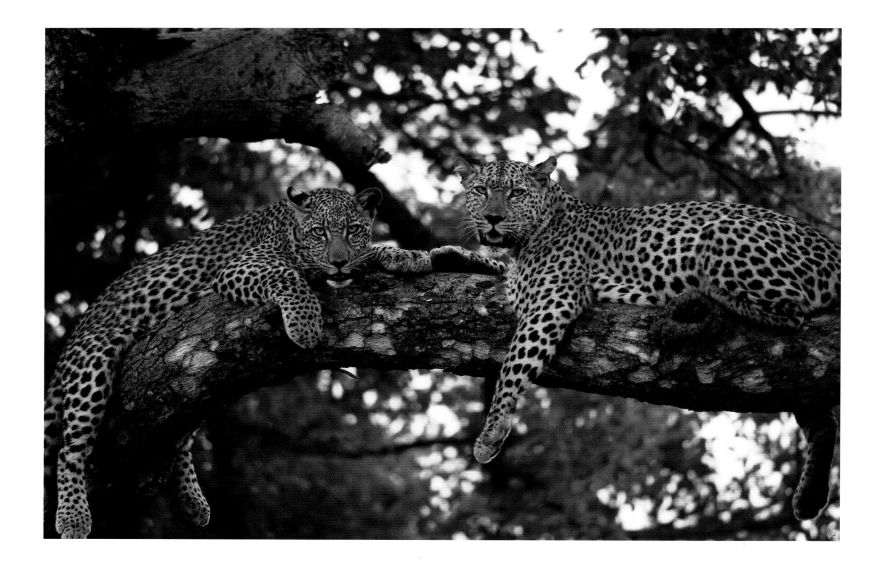

ABOVE: The Mlowathi female (right) and her cub relax amid the shade of a marula tree.

RIGHT: The Marthly pride cubs lap up water from a rock pool while the cameras buzz in a nearby Land Rover.

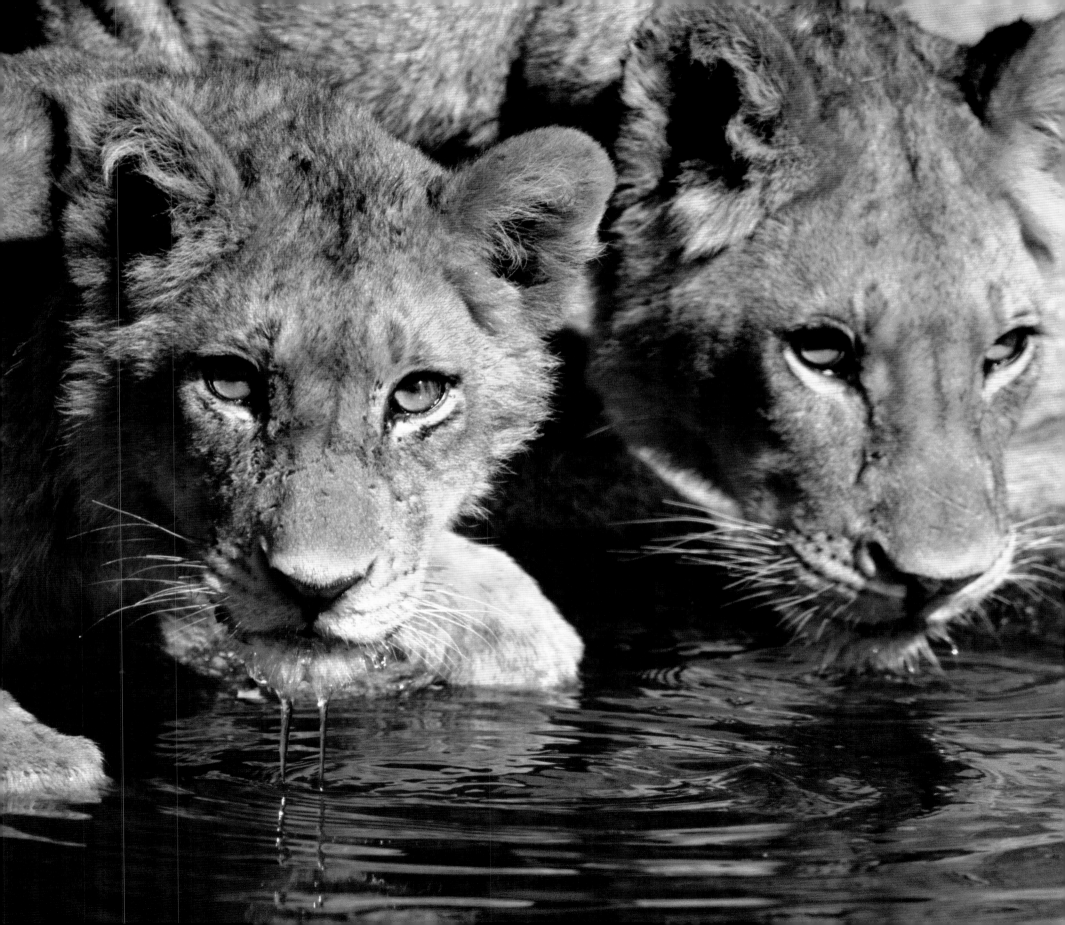

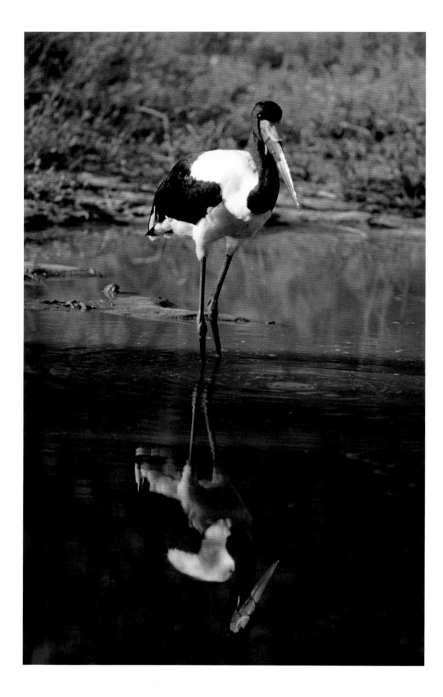

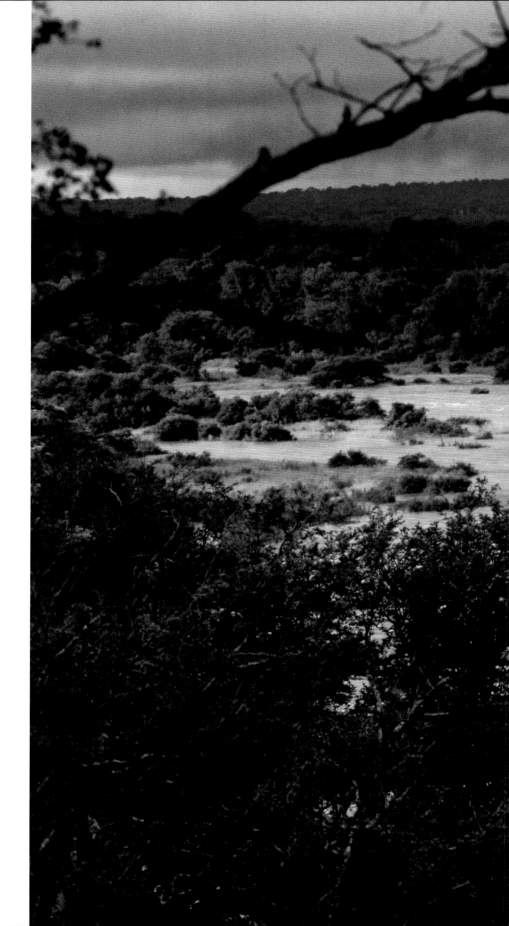

ABOVE: A saddlebilled stork searching for fish and frogs.
RIGHT: Swollen waters of the Sand River in early 1996, photographed from Maxim's Lookout.

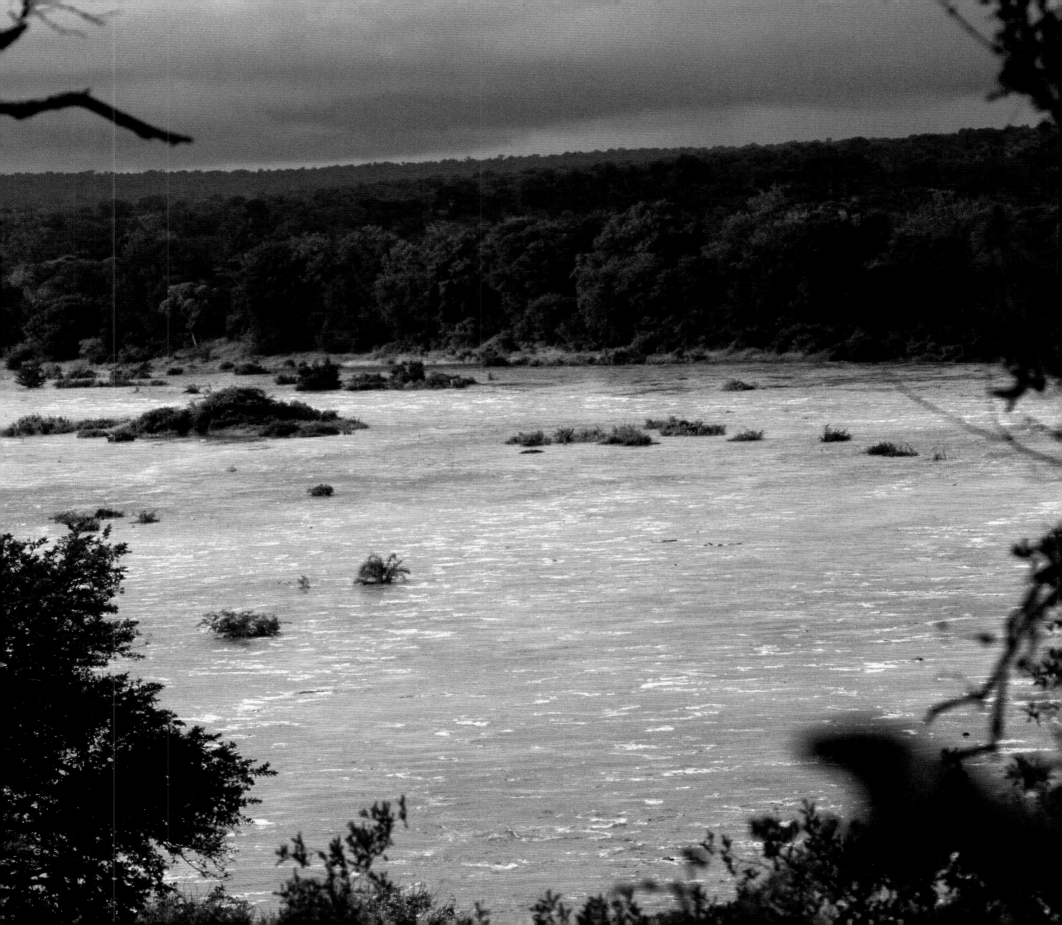

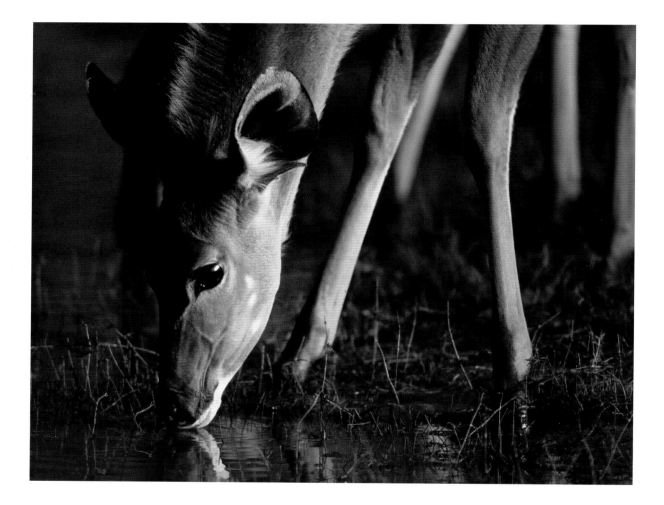

ABOVE: Kudus are plentiful in the dry season, feeding off the riverine bush, becoming a regular prey species for lions.
RIGHT: The Charlston pride gingerly crosses the cold water at Charlston North, eager to get to a freshly killed waterbuck.

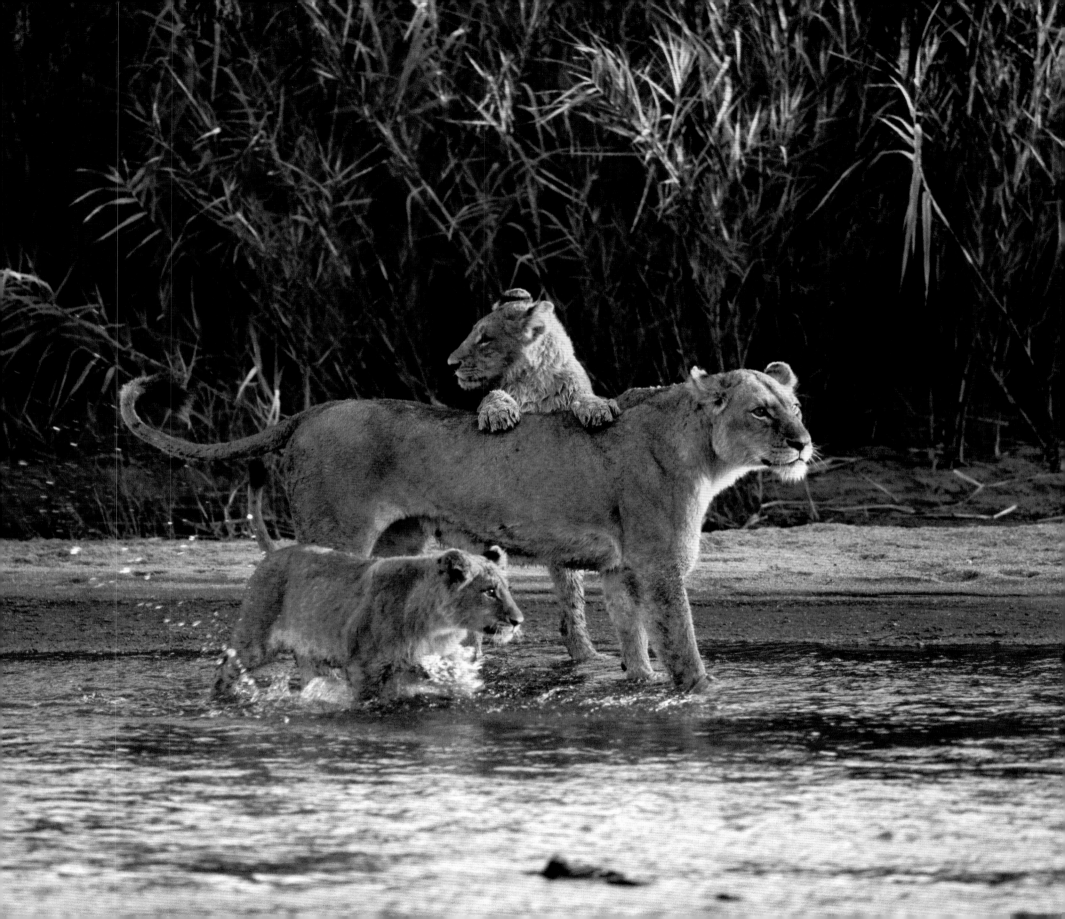

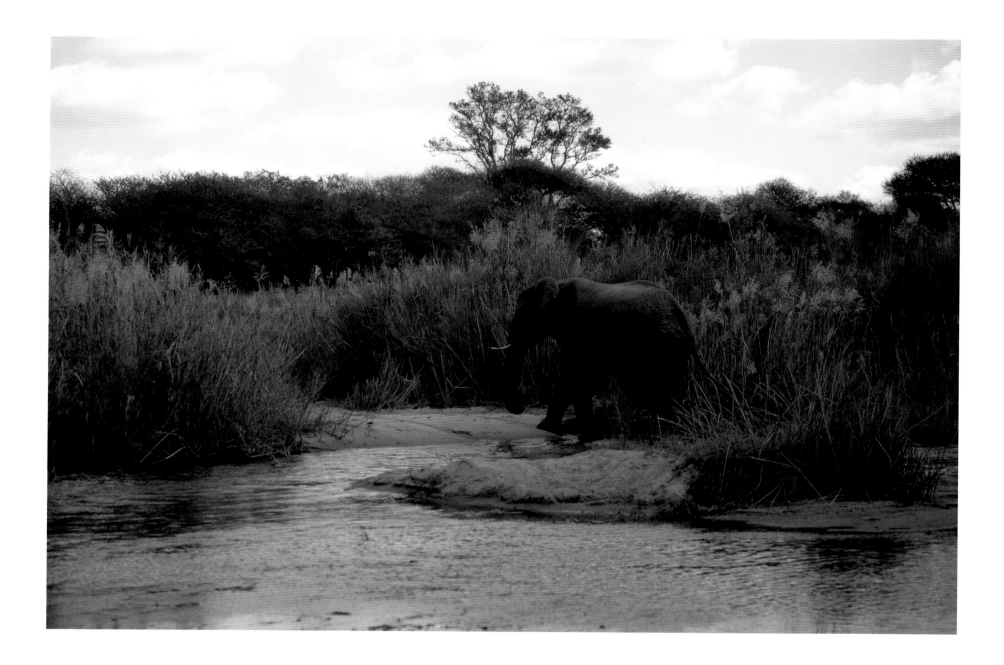

Animals have right of way, always!

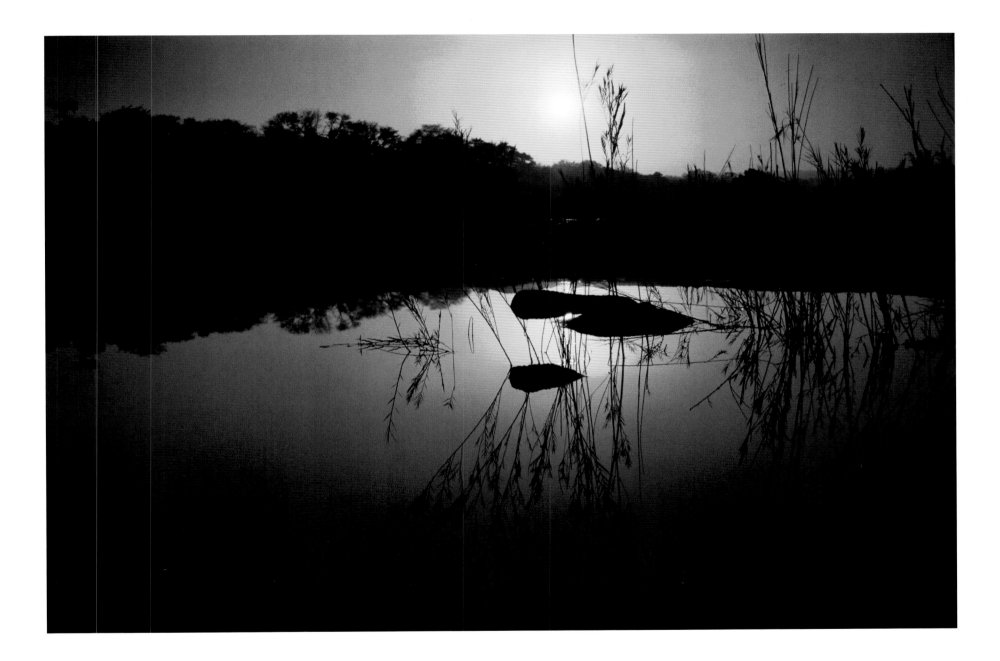

Calm waters create perfect reflections at Rocky Crossing.

*Grassy
Open
Areas*

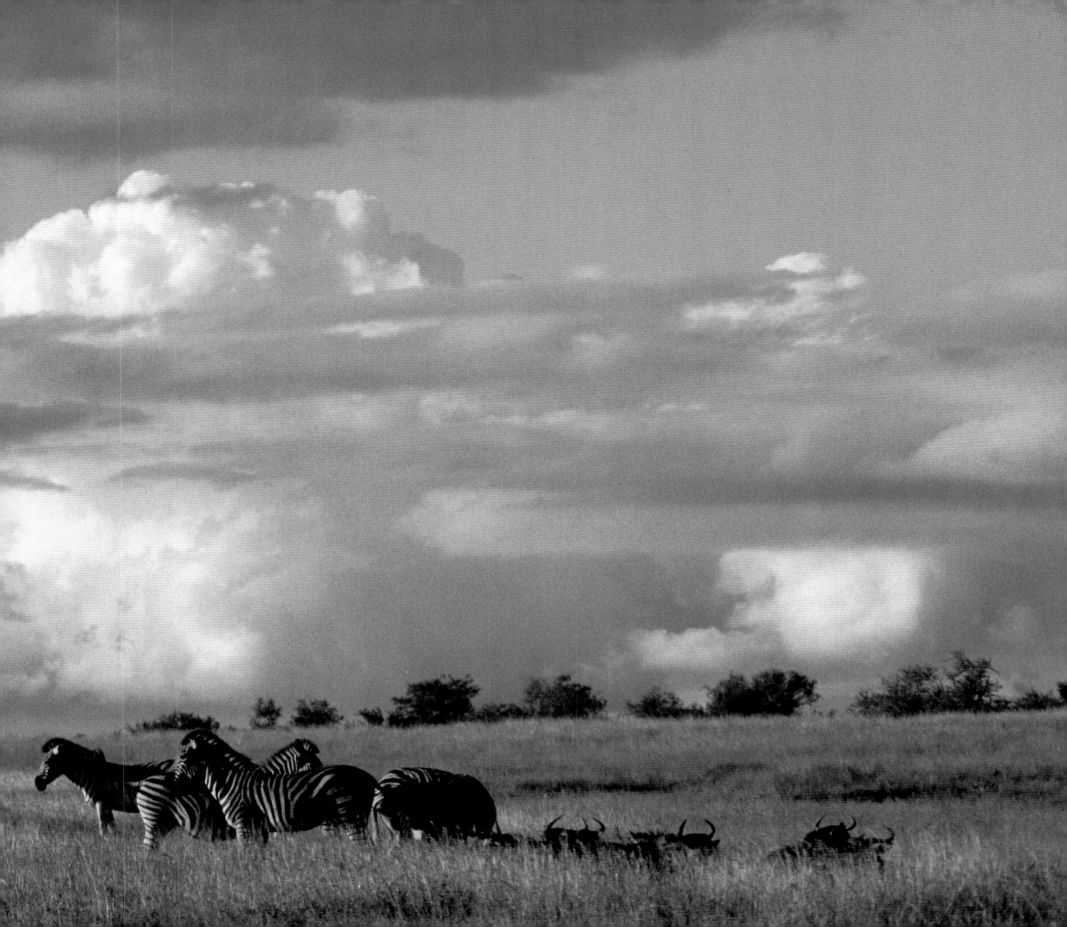

WHETHER POPULATED BY A HERD OF ZEBRA, A PRIDE OF LIONS, OR A LONE MARULA TREE, these grassy open areas reflect the freedom and beauty which most people perceive to be the essence of Africa. We are not the only creatures drawn to this type of expansive setting. Many varieties of animals are attracted to these open areas as well. Wildebeest, zebra, Cape buffalo, and warthogs are some of the animals which seek out the open areas because their main food source, nutritious and palatable grass, is available there. They also seek out the visibility these open areas afford, secure that they can detect a predator before a predator notices them. Cheetahs also like these open areas for the protection afforded and because they need to gain speed quickly in order to run down their prey.

As one might expect, these open areas change dramatically from summer to winter. In the dry winter season, the grass is buff-colored, and the earth arid and dusty. One of the most captivating sights a visitor to MalaMala can be privy to is gently swelling acres of honey-brown scrub grass stretching out beneath the limitless cornflower-blue sky. To that idyllic panorama, strategically place some zebra, or perhaps several cheetahs, and you have what could easily pass for a scene straight out of Eden. A wonderful variety of nonmigratory birds live here, but very few insects.

The summer months are dfferent. Due to the increased rainfall, the scrub grass turns verdant and grows waist-high. The bogs form after the rains, and thousands of frogs add their din to the noise of the insects. There is a lush-ness to the savanna during the summer. Ants get busy building new hills and tunnels, termites pair up and initiate new mounds, and many varieties of wildflowers spring up, including wild foxglove and wild hibiscus.

The rolling terrain of the savanna, with its unobstructed view of the surrounding veld, the warmth of the noonday sun and the gentle, pristine breeze against your face makes you realize that you, too, like the zebra, wilde-beest, and Cape buffalo, would feel quite at home on the grassy open areas. A cloudless azure sky arching overhead, the breathtaking view of the seemingly limitless horizon, and the calls of birds contribute to the undeniable impres-sion that you have stumbled upon paradise.

RIGHT: Cheetahs are the most diurnal of cats, doing most of their hunting by daylight.
PREVIOUS PAGE: The new airstrip is a common place for zebras and wildebeests.

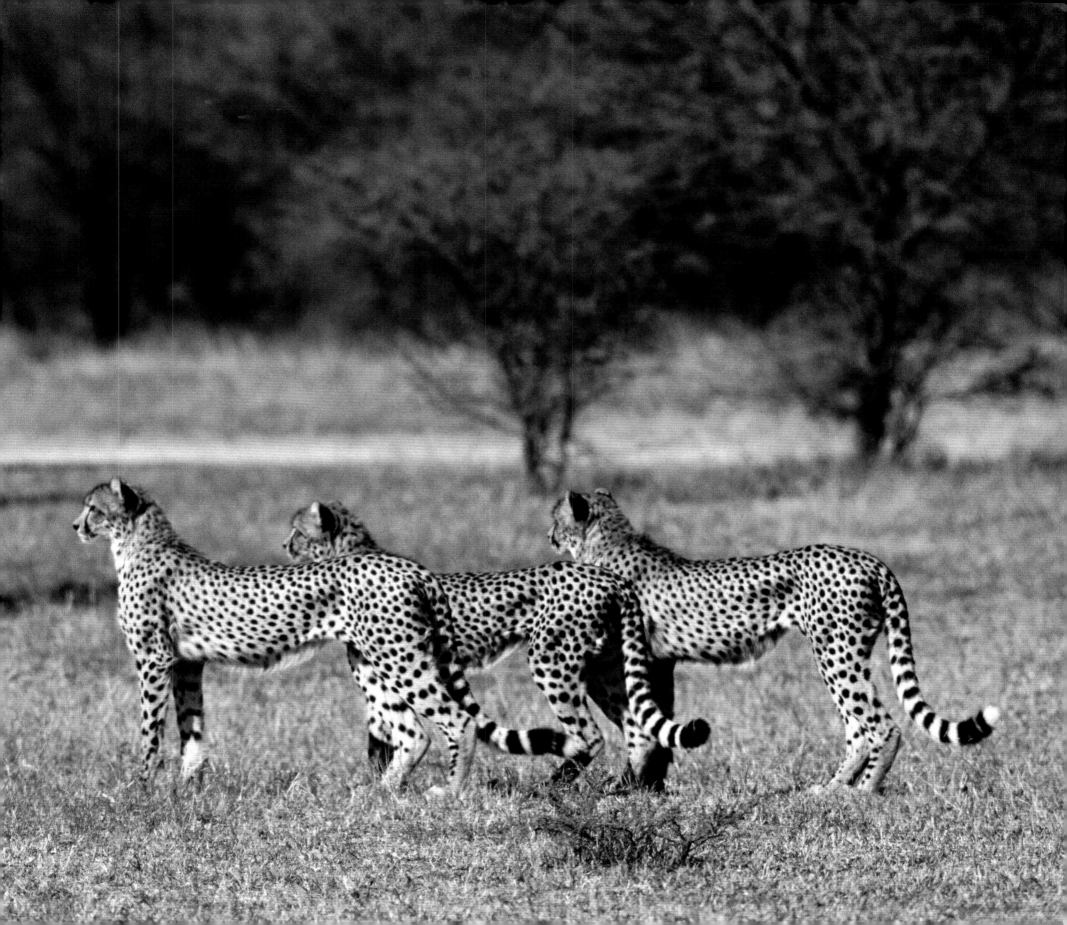

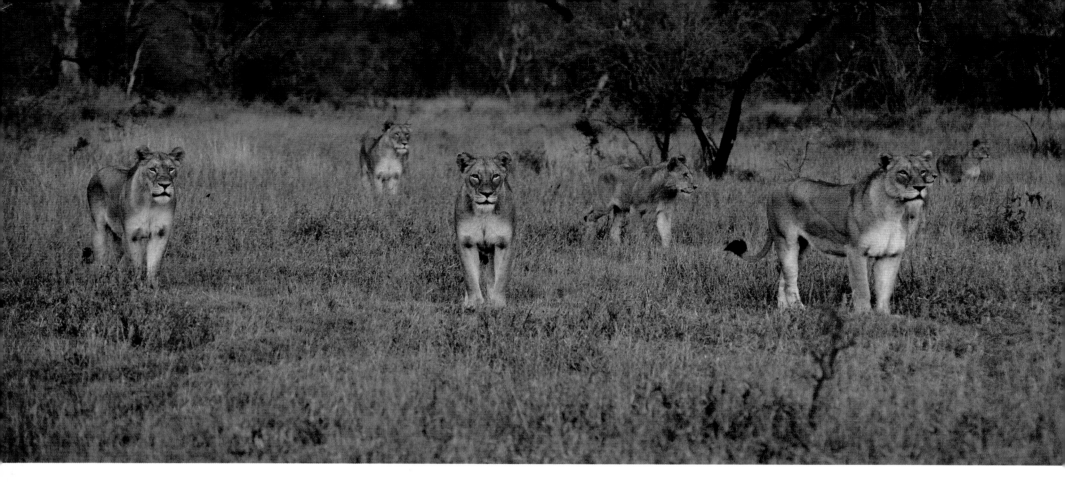

ABOVE: The Eyrefield pride searches for prey off
Redhawk Road.
RIGHT & OPPOSITE ABOVE: Lions sometimes chase
and catch buffaloes, although more often buffaloes
chase lions.
OPPOSITE BELOW: A lioness stalks a herd of impala.

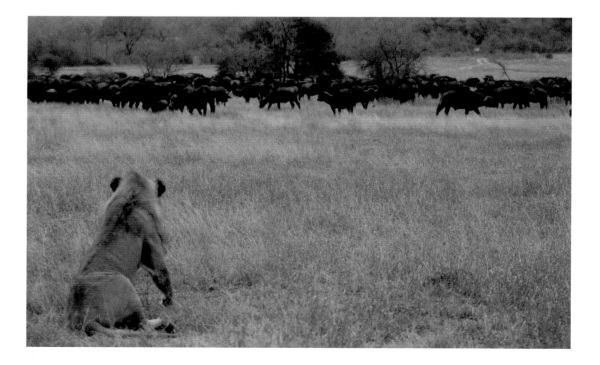

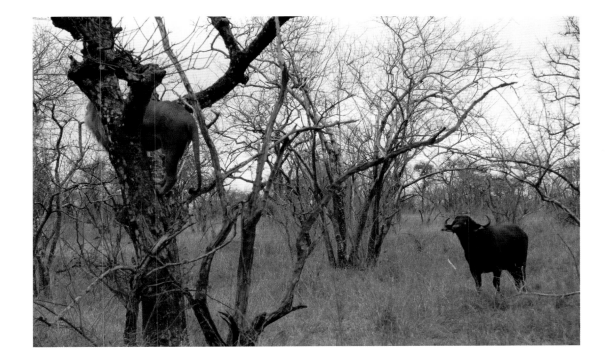

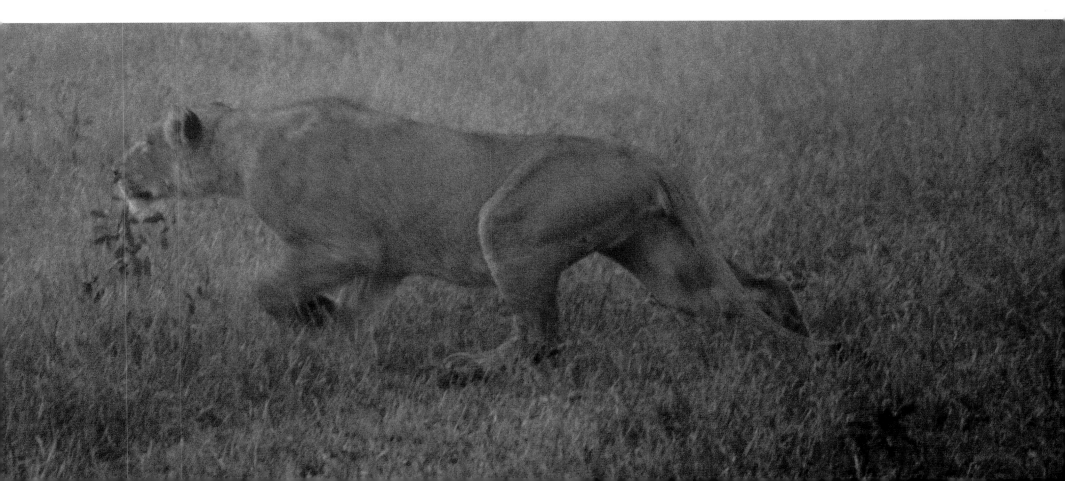

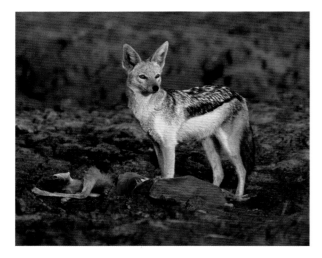

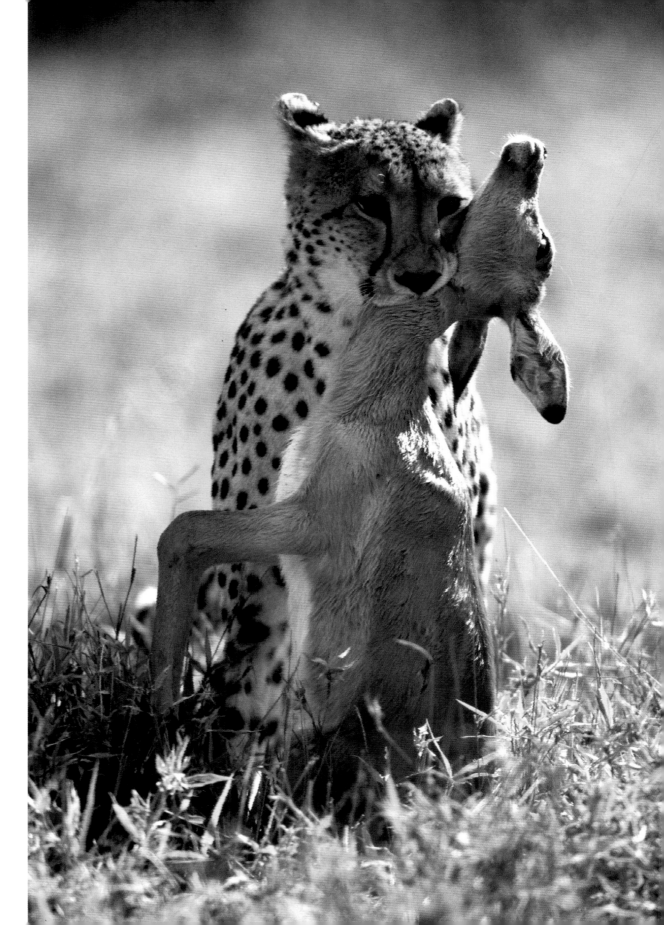

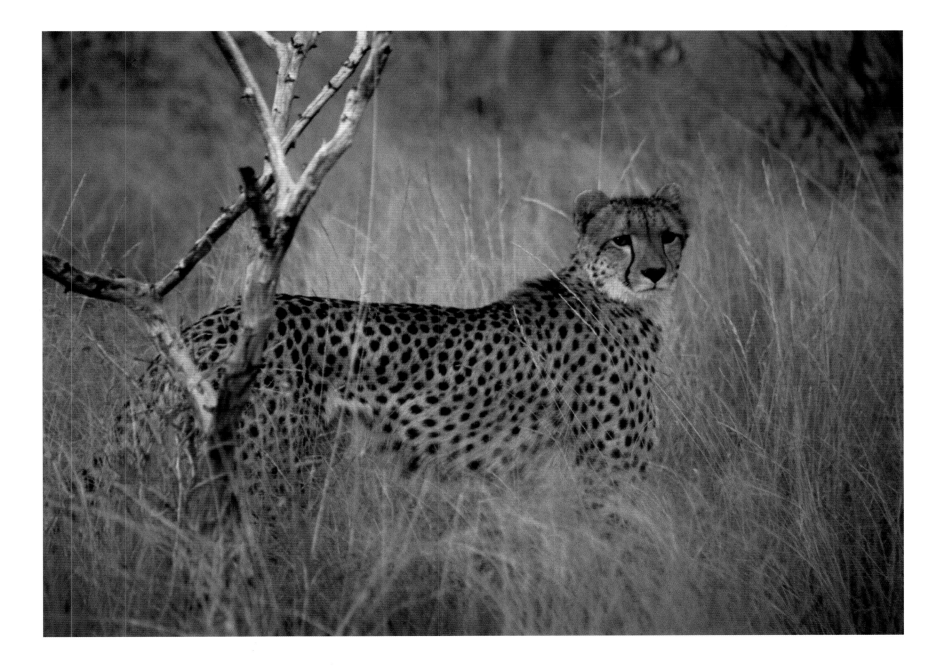

ABOVE: Cheetahs are long-legged, slenderly built, and perfectly designed for speed.

LEFT: Impala are well adapted to the habitat at MalaMala, and are by far the most numerous species. Young impala are easy prey for most predators.

UPPER FAR LEFT: Impala are the most numerous of the herbivores.

LOWER FAR LEFT: Blackbacked jackals occasionally kill small mammals such as steenbok. In addition to this they eat birds, insects, snakes, rodents, and they scavenge too.

Firebreaks are burned during the dry months to prevent spontaneous fires that could destroy the entire property.

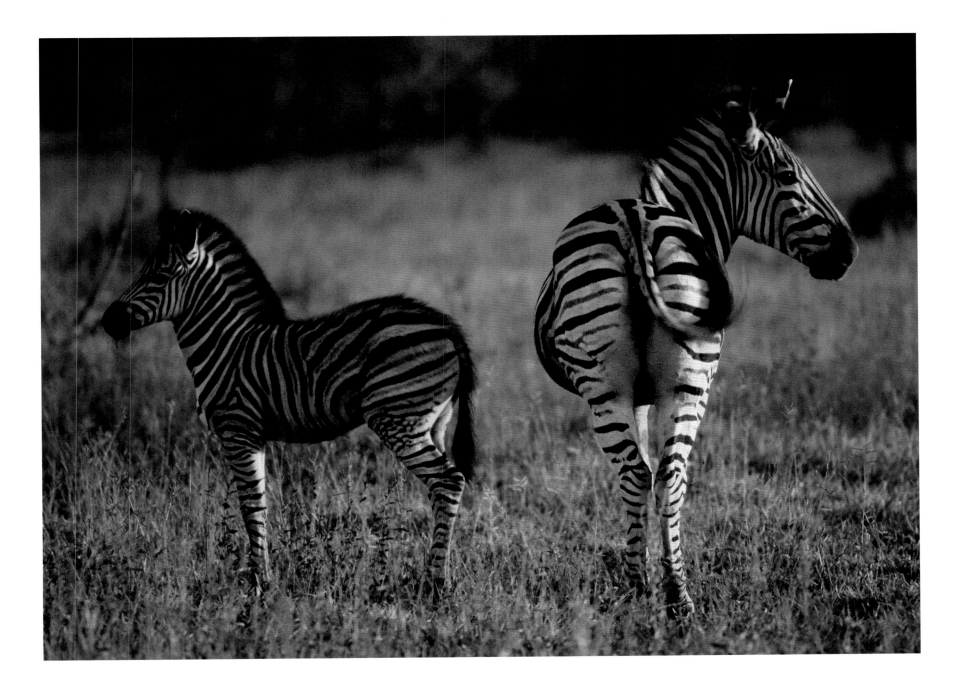

A zebra foal recognizes its mother by her unique stripe pattern and voice.

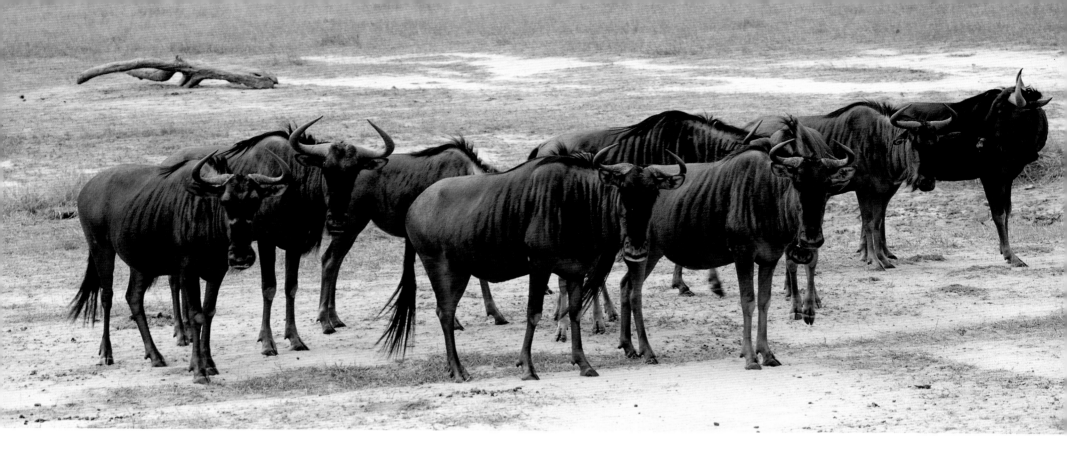

ABOVE: Small herds of wildebeest move through the open areas. Often a lone territorial bull will be seen in such an area waiting for the females.
RIGHT: Buffalo bulls challenge each other to establish rank and dominance. Usually the heavier one wins.
OPPOSITE: Like most of the species with sparse hair covering, buffaloes enjoy wallowing in mud.

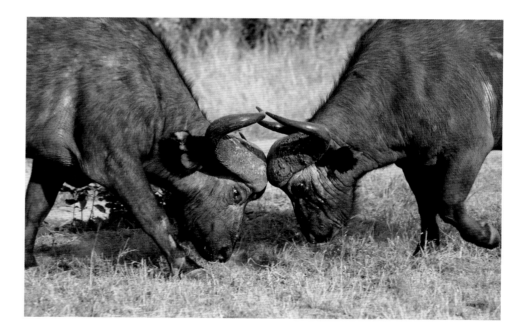

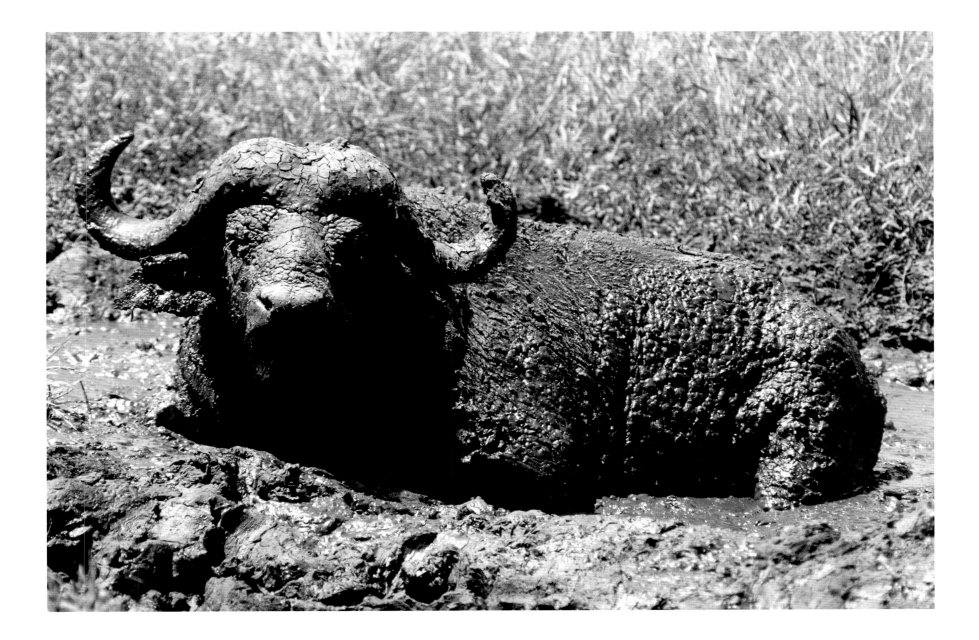

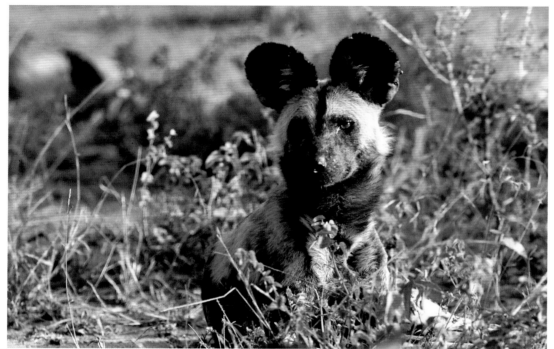

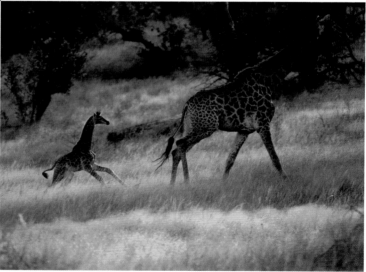

ABOVE: The Cape hunting dog, or wild dog, is one of Africa's most endangered species. Only a few hundred live in the greater Kruger National Park ecosystem.

RIGHT: Mother giraffes are ever watchful over their young, which spend most of the first week lying down amongst trees and bushes to camouflage themselves.

OPPOSITE: Waterbuck are easily recognized by the white circle on their rumps. They conceal their young for around six weeks after giving birth.

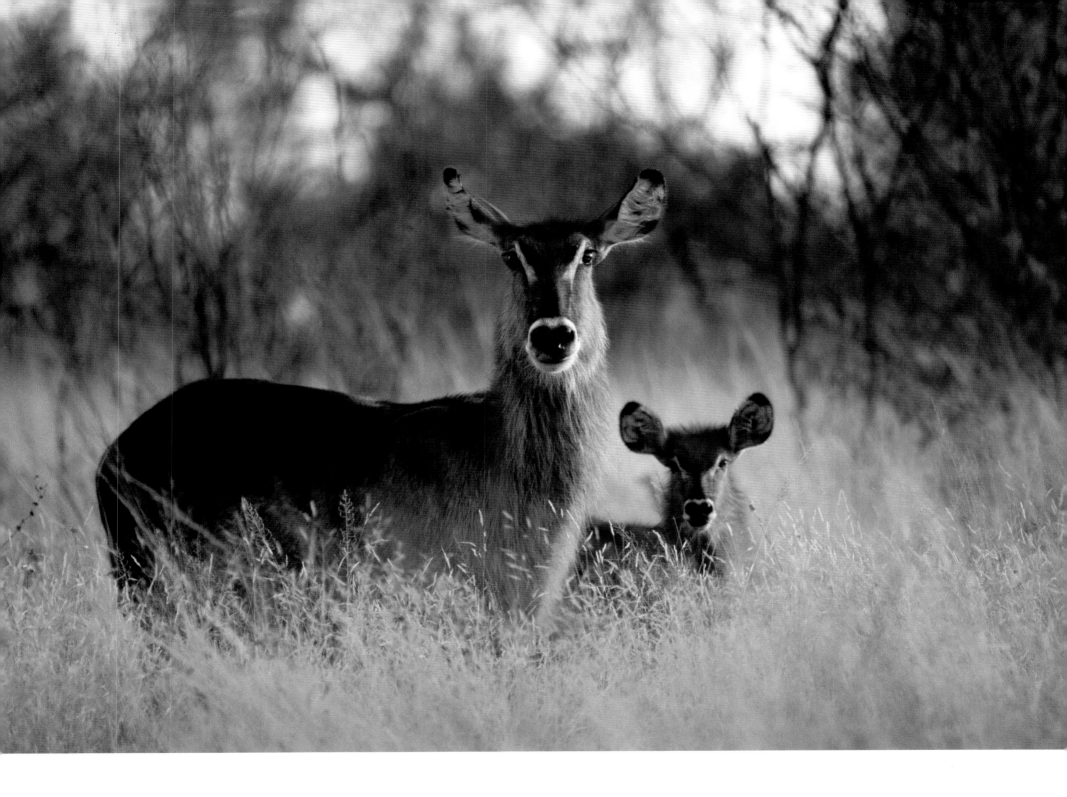

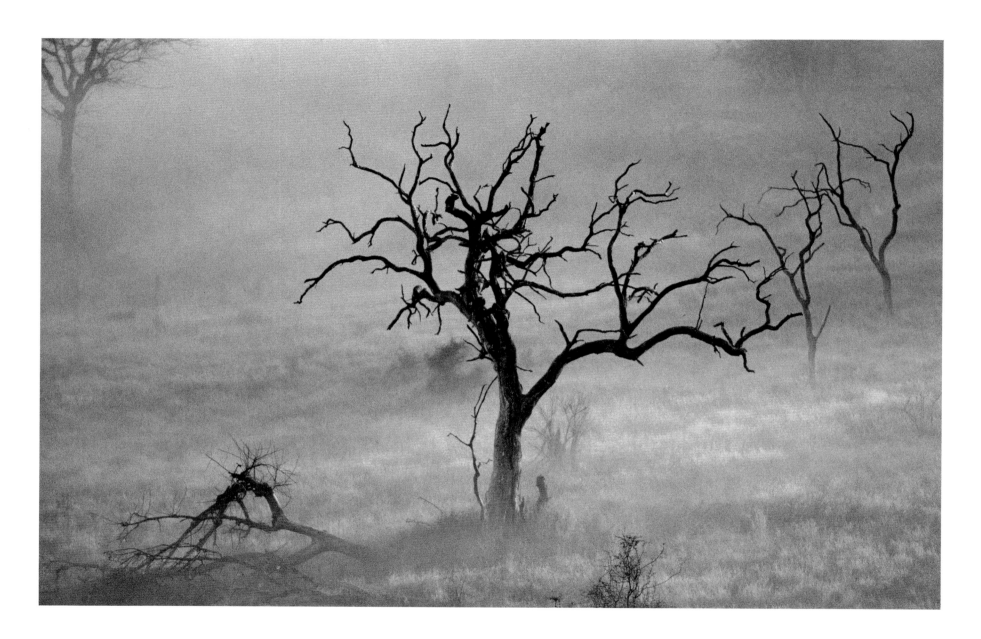

Sculpture-like dead leadwood trees dot the reserve.

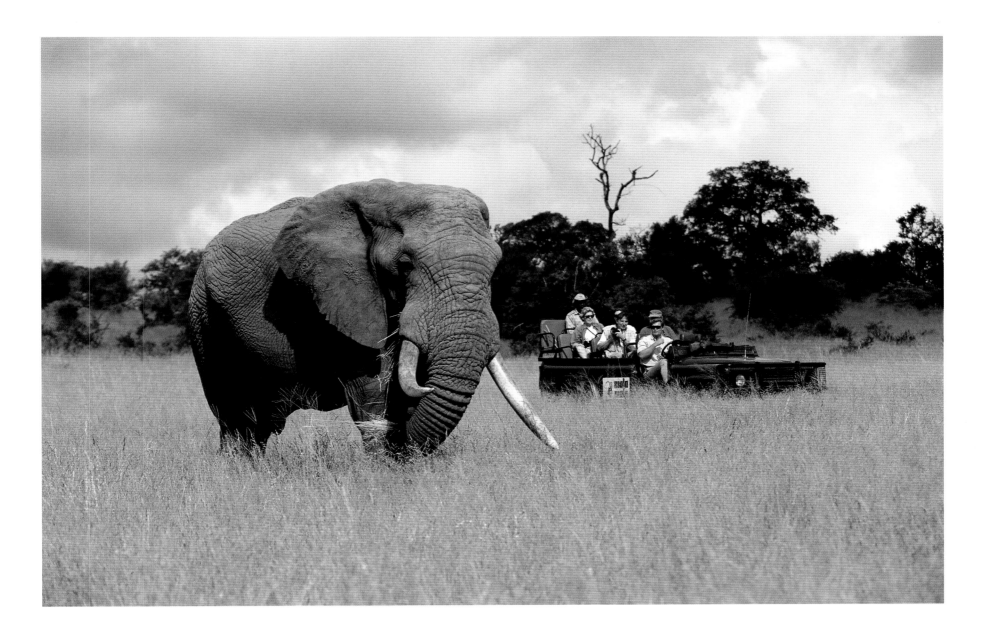

A large elephant bull moves through Mlowathi open area toward Mlowathi Dam, almost always eating.

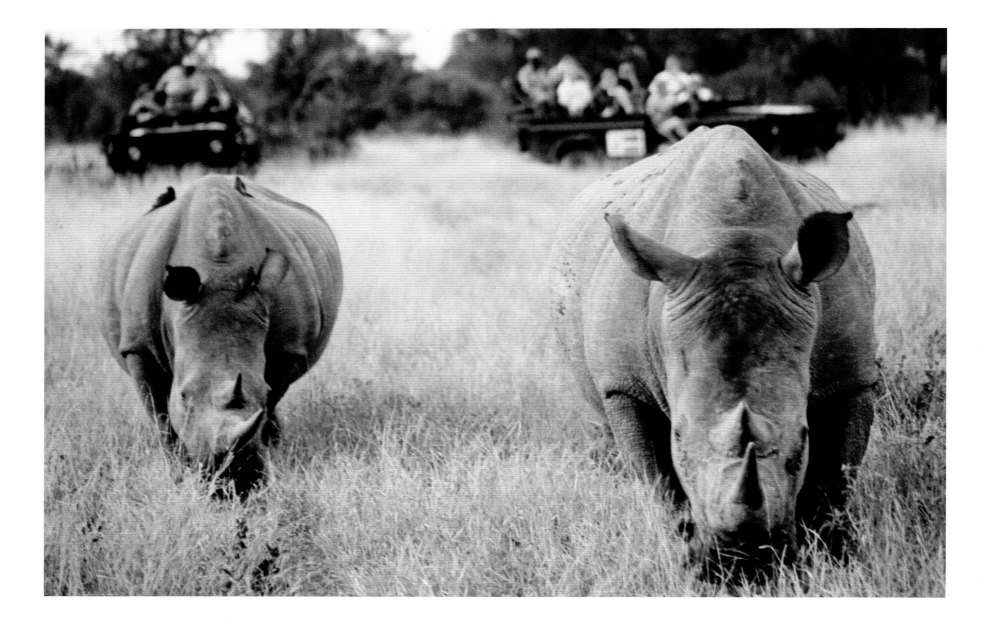

White rhinos are pure grazers and are almost always accompanied by redbilled oxpeckers, sometimes Land Rovers, too.

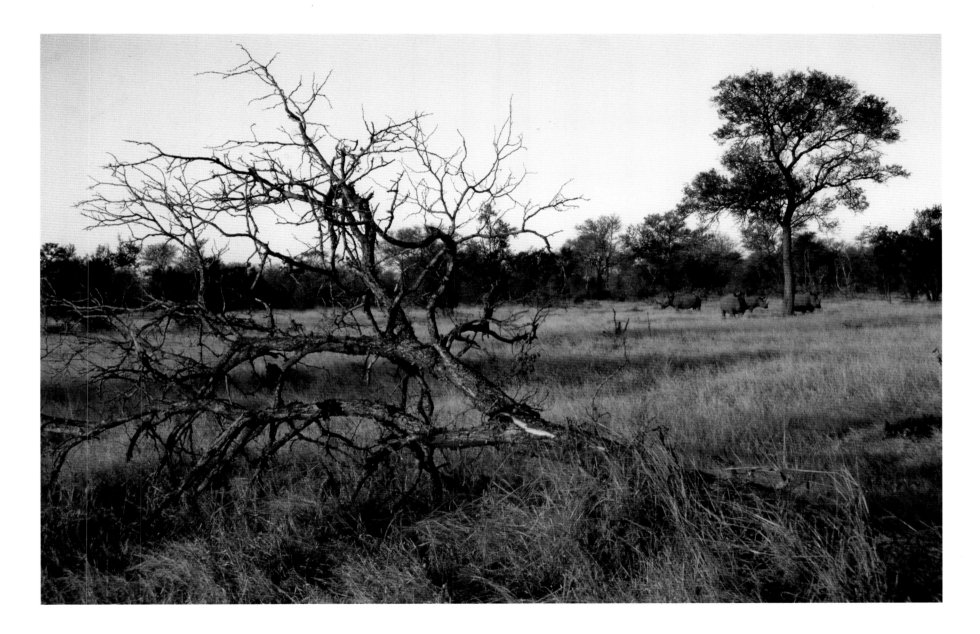

Rhinos can congregate in groups of up to ten or fifteen. Competition for short grass can be fierce.

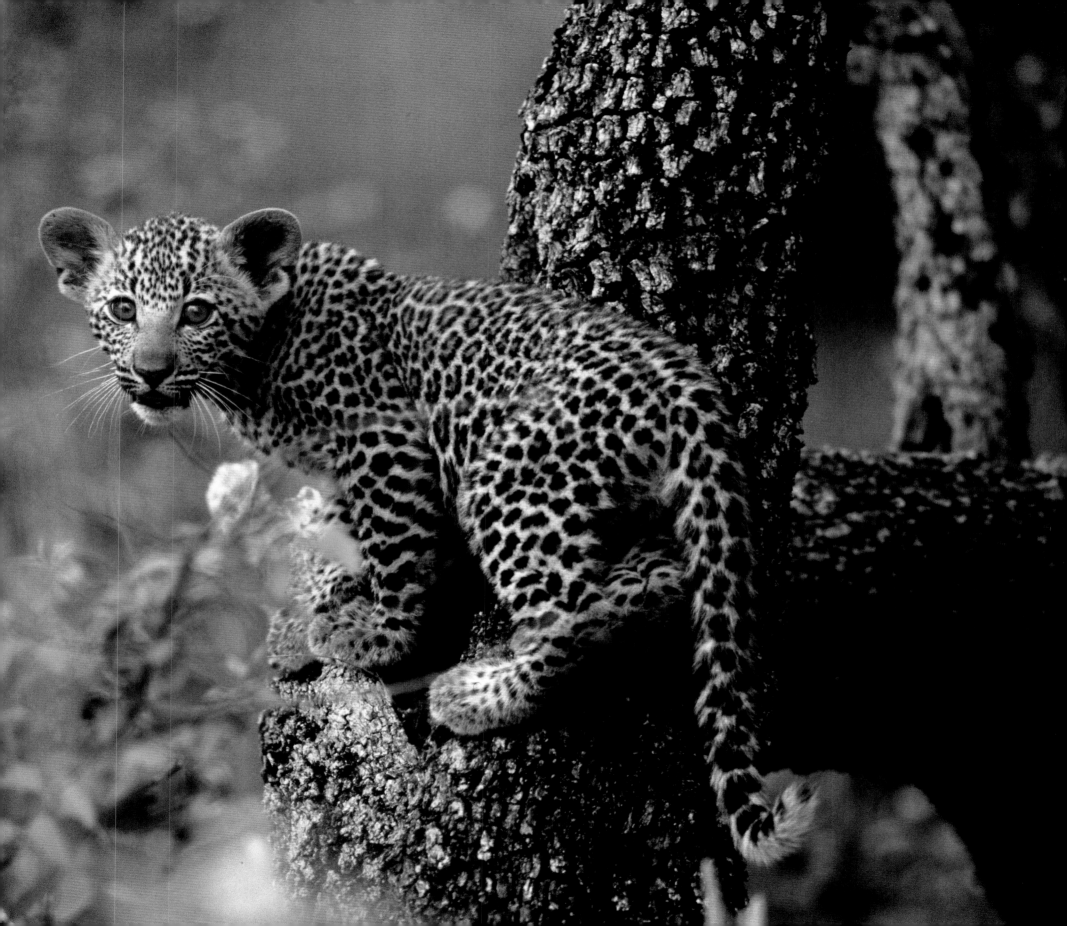

\mathcal{I}NITIALLY, MANY VISITORS FIND THE TREED BUSHVELD TO BE A CHALLENGING PLACE to view game. A mix of bush-willows, acacias, marula trees, small shrubs, and tall scrubgrass all conspire to restrict visibility and human access. In addition, movement through this terrain is made even more difficult by the presence of dongas (steep ravines which seem to appear out of nowhere), randomly scattered boulders, and numerous downed tree trunks. Even the Land Rovers have difficulty navigating this rough terrain.

However, once visitors have learned how to see through the seemingly chaotic jumble of grass, foliage, and rock, they discover the numerous and varied animals and vegetation which the treed bushveld conceals. At first glance, the bush appears empty; then, suddenly, an elephant materializes from behind a lush umbrella thorn tree. What might seem to be an innocuous thicket turns out to house a pride of napping lions.

While traveling through the treed bushveld, the diligent viewer is almost certain to be rewarded by the sight of a multitude of animals and a rich array of vegetation. Look up: see the giraffe munching away on a tasty spike thorn. A yellow-billed hornbill darts swiftly from branch to branch. A leopard cub peers back at you from the crook of a tamboti tree. Later, a playful vervet monkey pops into view. Closer to the ground, your newly aware eye ferrets out a lone Cape buffalo, soaking up some early morning sun. A bit further on, a mother elephant and her calf lumber slowly through the bush, grazing as they go. You notice the long, sharp spikes of a nearby umbrella thorn tree and wonder how a giraffe is able to eat the leaves. Not far away, three hyenas rest, tongues protruding, next to their den. Driving on, you glimpse a mother baboon, baby clutched to her chest, loping through the scrub grass.

In this environment, it becomes evident that one needs to put forth some effort, and even hope for that element of good fortune, to see everything. That effort is often rewarded with exceptional sightings. Many animals tend to be more at ease in the security of the treed bushveld and allow you to view them from very close range. The ablility to view these animals at such intimate proximity is a direct result of MalaMala's thirty-five year effort to gradually and sensitively introduce game-viewing vehicles into the animals' environment. This careful habituation process involves keeping a respectful distance from animals until they choose to approach the vehicles, monitoring and responding appropriately to animals' reactions, and using radio contact between rangers to coordinate the number and movement of vehicles around a particular sighting. Without the animals' apparent nonchalance around vehicles, the bush would undoubtedly conceal, rather than reveal, the richness of the animal life it contains.

In short, the treed bushveld isn't about order or convenience. The beauty of the bushveld is the beauty of unrestrained nature. Just as the animals of MalaMala are protected but not restricted, so is the vegetation of the bushveld. Man has had no part in its creation or maintenance, and at MalaMala, we recognize our place: to simply watch as nature and her creatures live their lives in this environment which only God has had a hand in shaping.

RIGHT: Chacma baboons are often seen across the river from the main camp, where they sleep among the trees at night.
PREVIOUS PAGE: The cub of the White Cloth female leopard clambers about a tamboti tree.

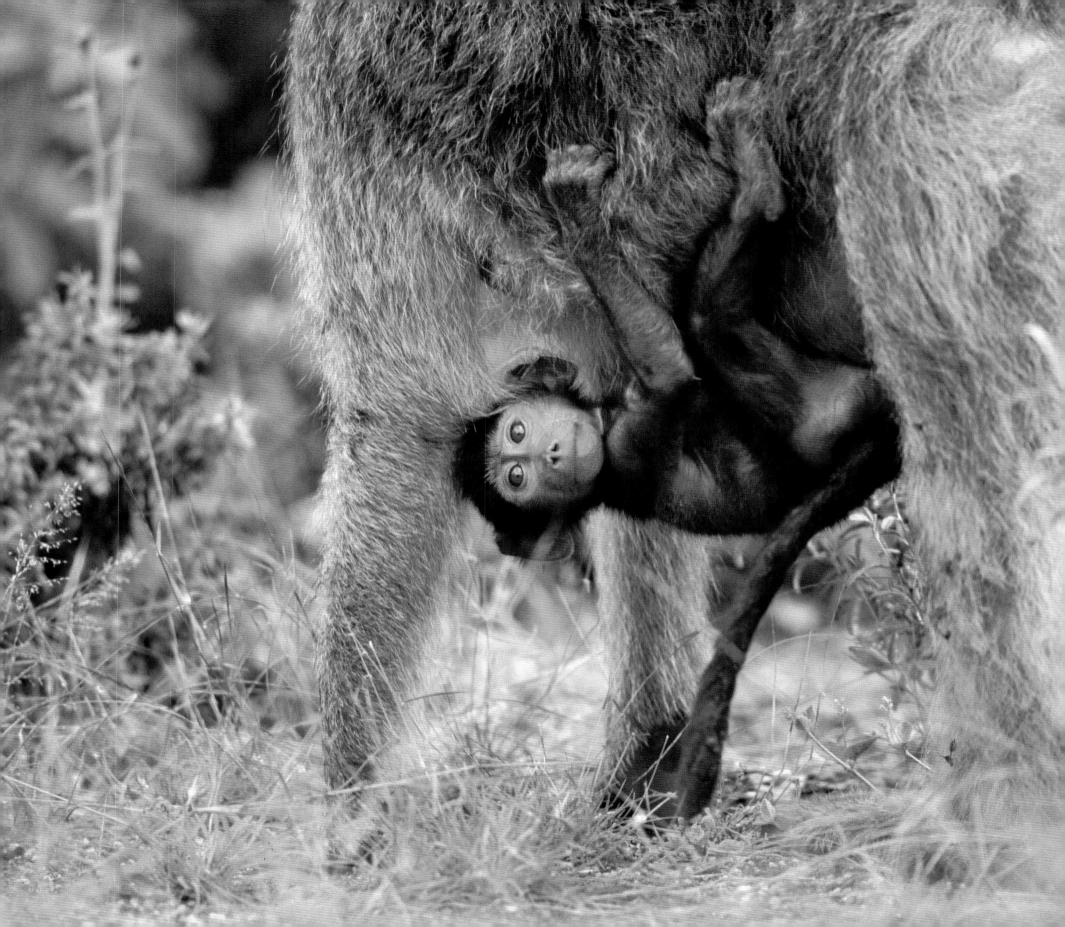

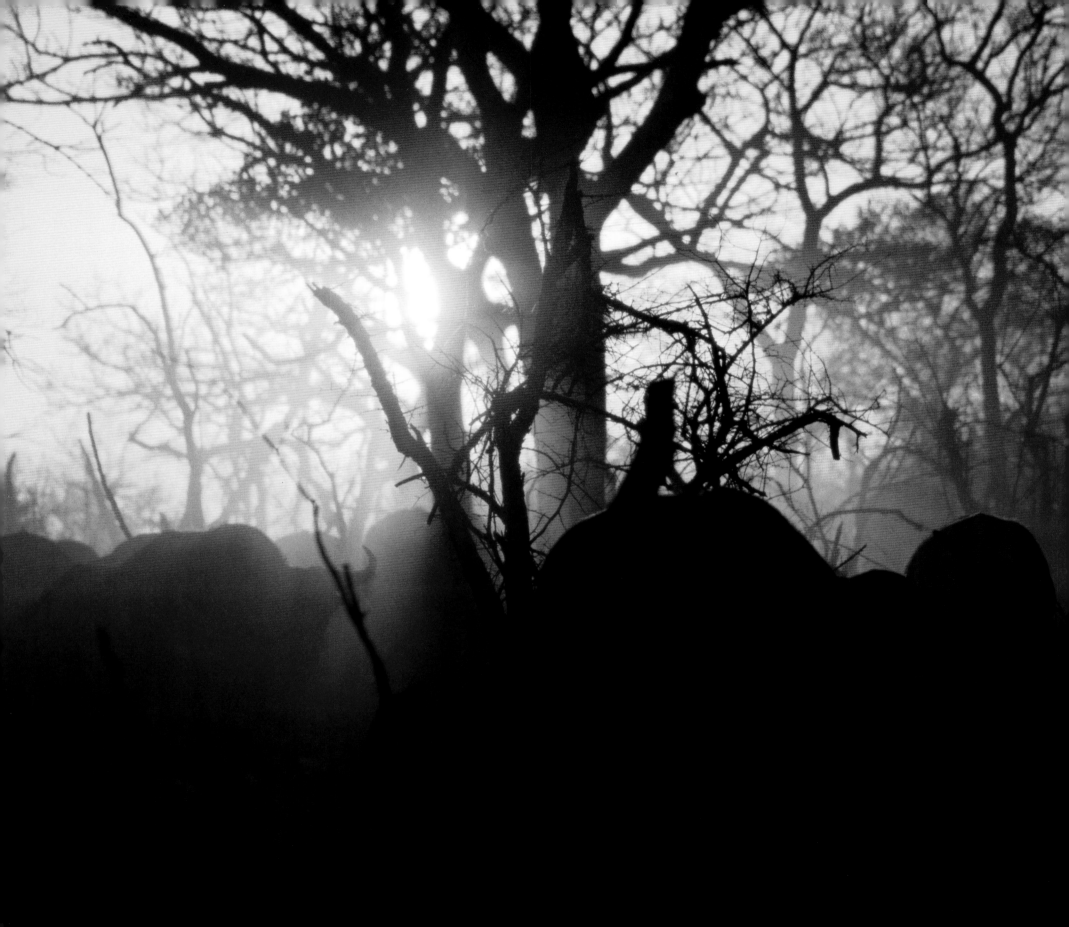

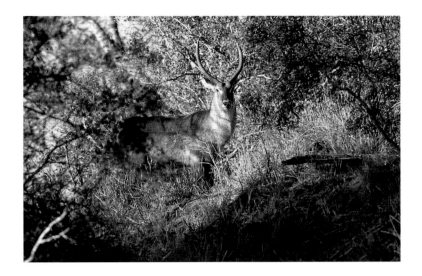

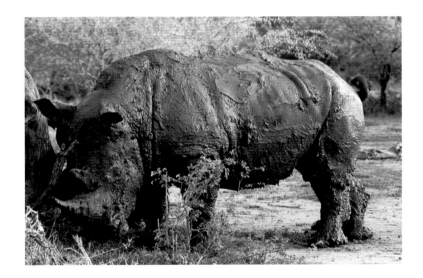

ABOVE: A bull rhino rubs himself against a stump at the pans off 1st Turning Piccadilly.

TOP: Waterbuck are one of the larger antelope at MalaMala, and possibly the most water-dependent.

LEFT: The large herd of buffalo moves steadily through the northern reaches of MalaMala.

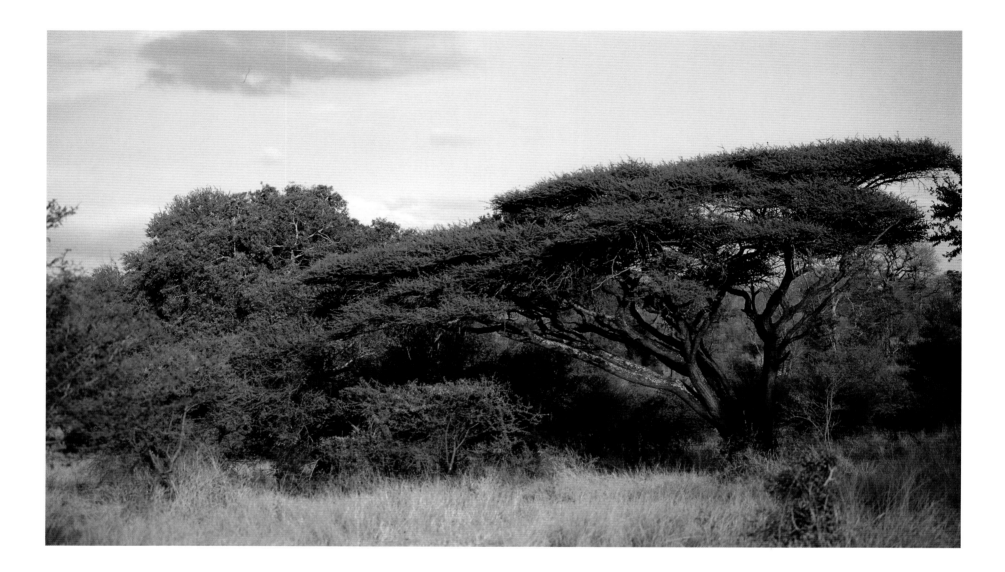

ABOVE: The umbrella thorn at Entrance Flockfield Lookout is unmistakable.

OPP. UPPER LEFT: Rangers have a healthy respect for elephants which are huge and powerful!

OPP. UPPER RIGHT: Toothpick type thorns characterize some of the acacia tree species.

OPP. BELOW: Trackers spot many animals hidden in deep brush, such as this giraffe dwarfed by the trees amongst which it feeds. In the past, bushmen lured ever-curious giraffes within range of their arrows by climbing a tree and reflecting a shiny stone towards them.

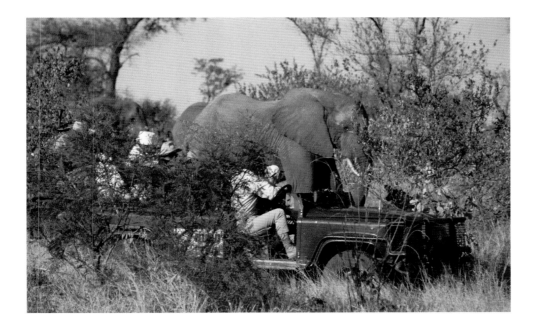

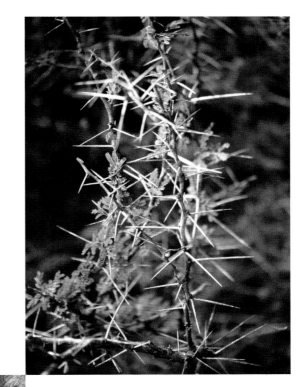

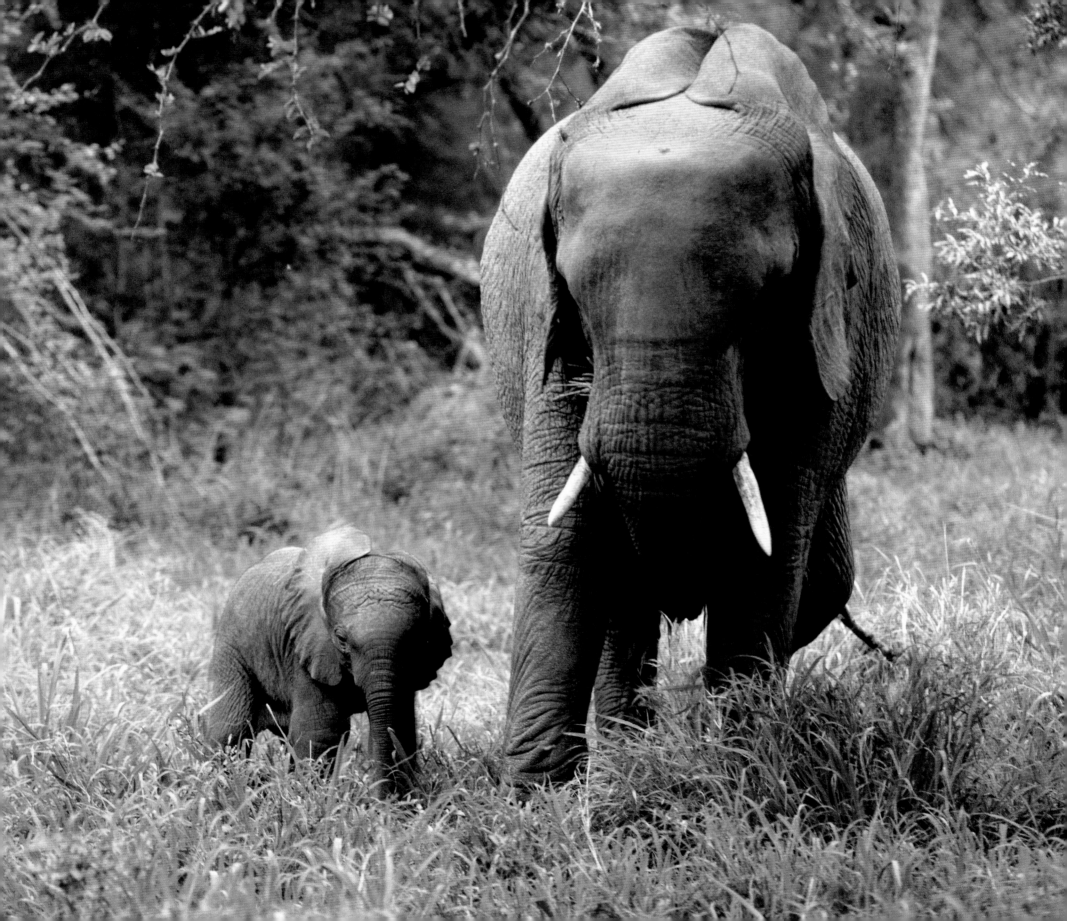

RIGHT: Preceding the hunt, lions, like this female from the Styx pride, often stretch and display claw sharpening.
LEFT: An elephant calf seldom ventures far from its mother and enjoys the protection of the herd.

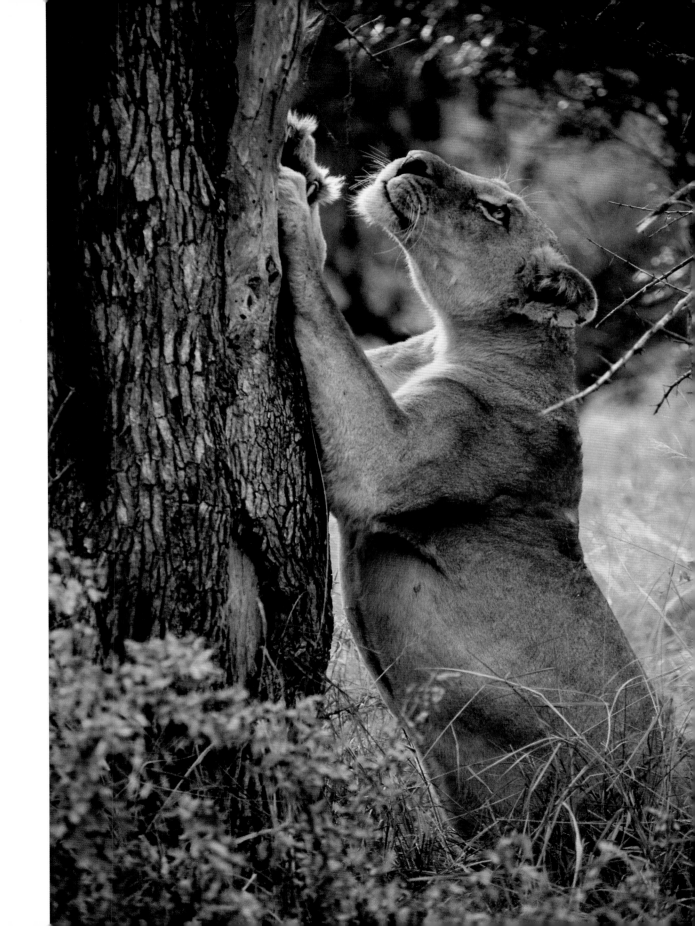

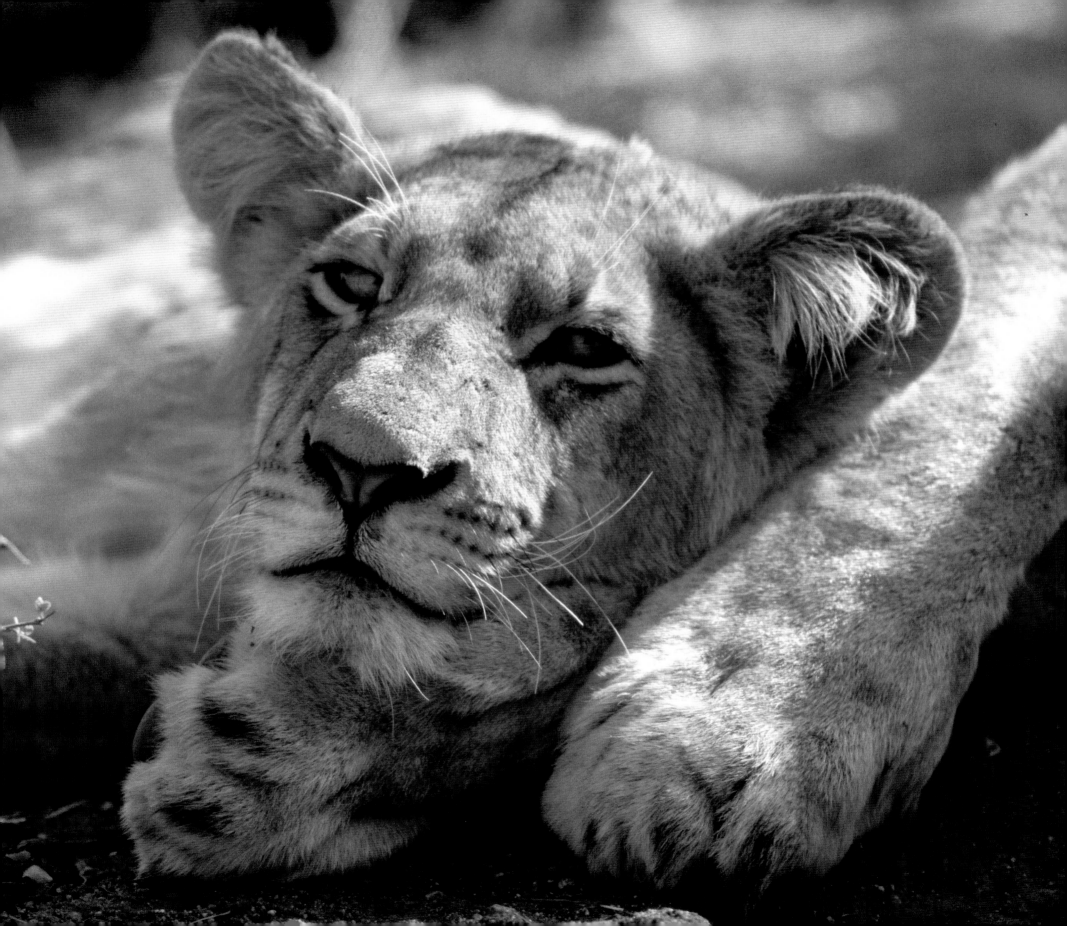

ABOVE: Warthogs have characteristic bumps and bulges like no other.
RIGHT: An elephant bull enjoys a wallow in Piccadilly Pans.
LEFT: Lions are highly sociable and lie together in close company.

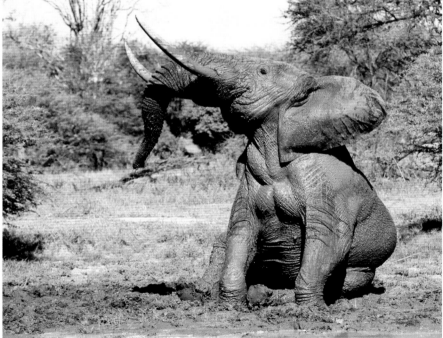

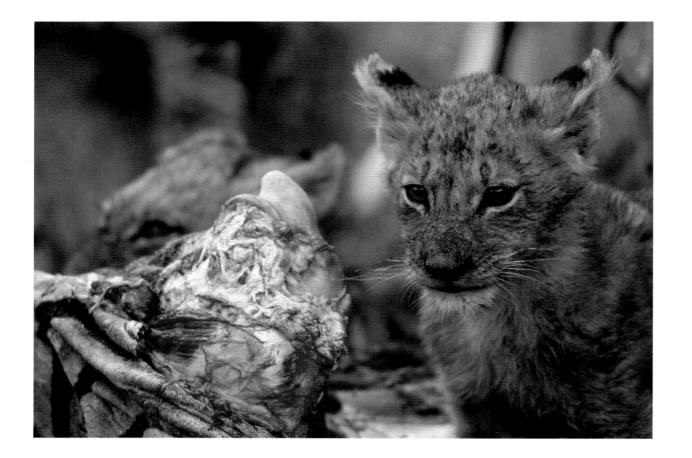

ABOVE: Zebra is definitely on the lion's menu.

RIGHT: A lone buffalo bull or "dagga boy" near Eagle's Nest Lookout. 'Dagga' is the local word for cement. Lone bulls are called this because they are often covered in cement-like mud.

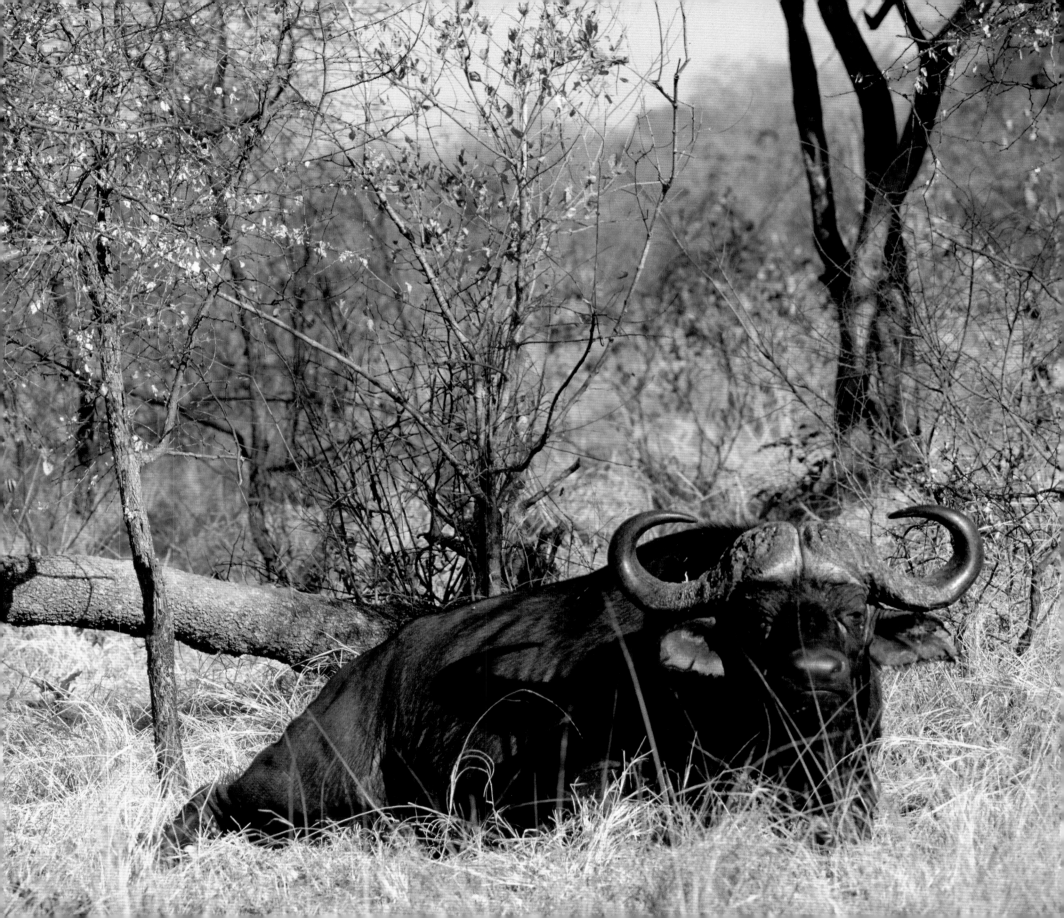

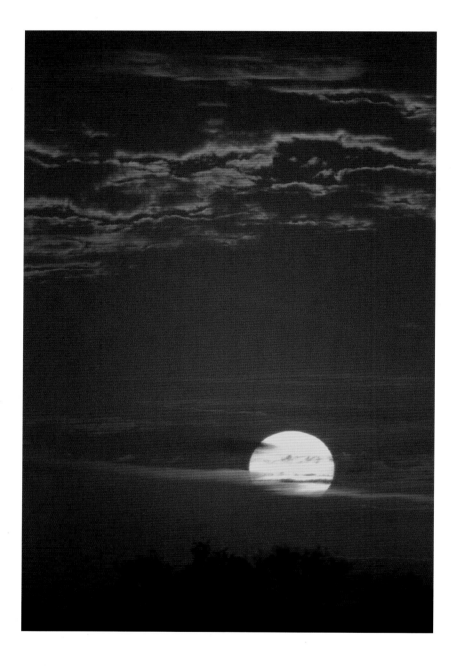

ABOVE: The last few minutes of sun illuminate the evening clouds.
RIGHT: Whitefronted bee eaters are seen in the bush and at camp.

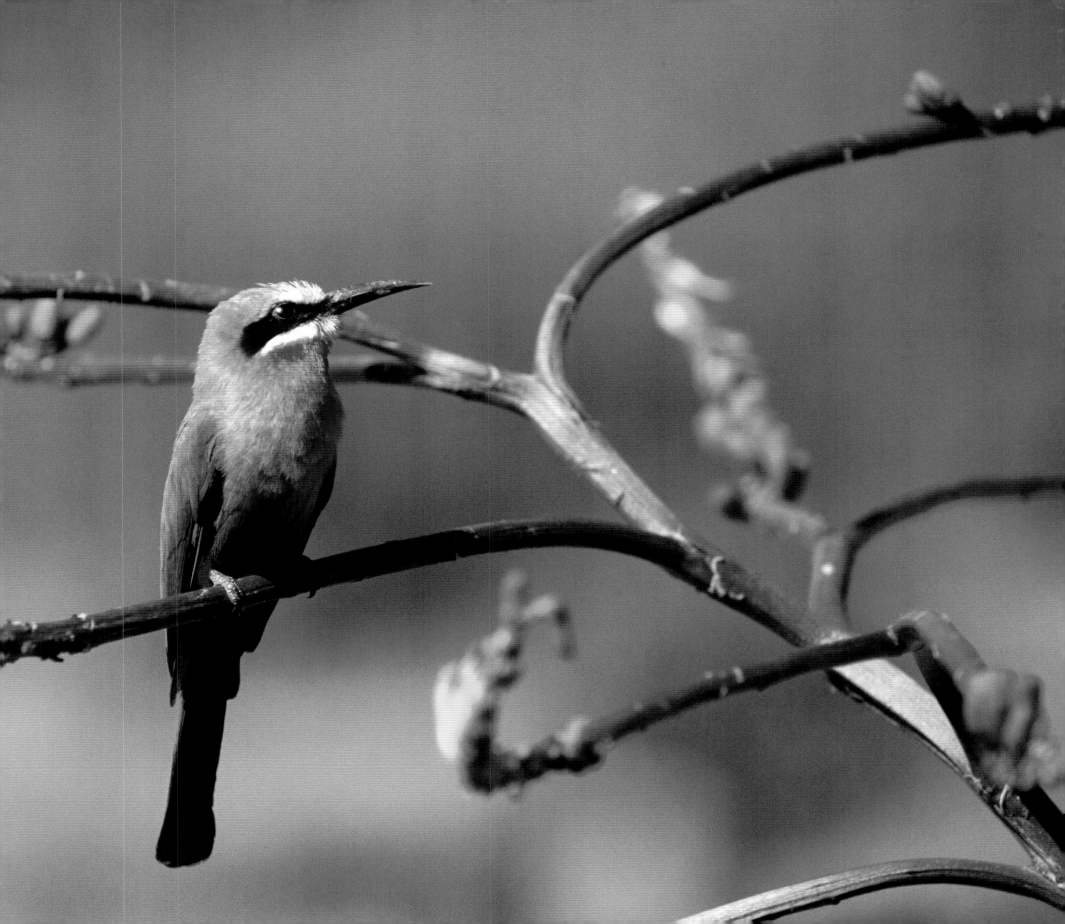

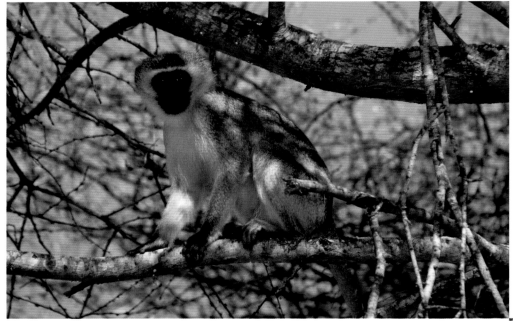

LEFT: Vervet monkeys help to find leopards as they get hysterical and sound off alarm calls.
BELOW LEFT: In conjunction with their height, giraffes use their excellent eyesight to spot approaching danger.
BELOW: Yellowbilled hornbills are common.
RIGHT: The martial eagle uses its powerful talons to catch small mammals, birds, and lizards.

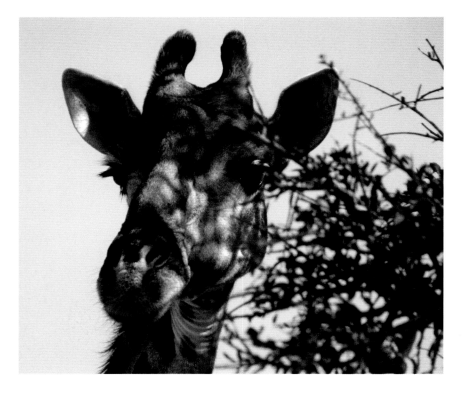

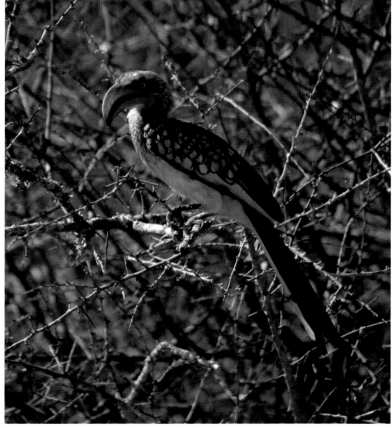

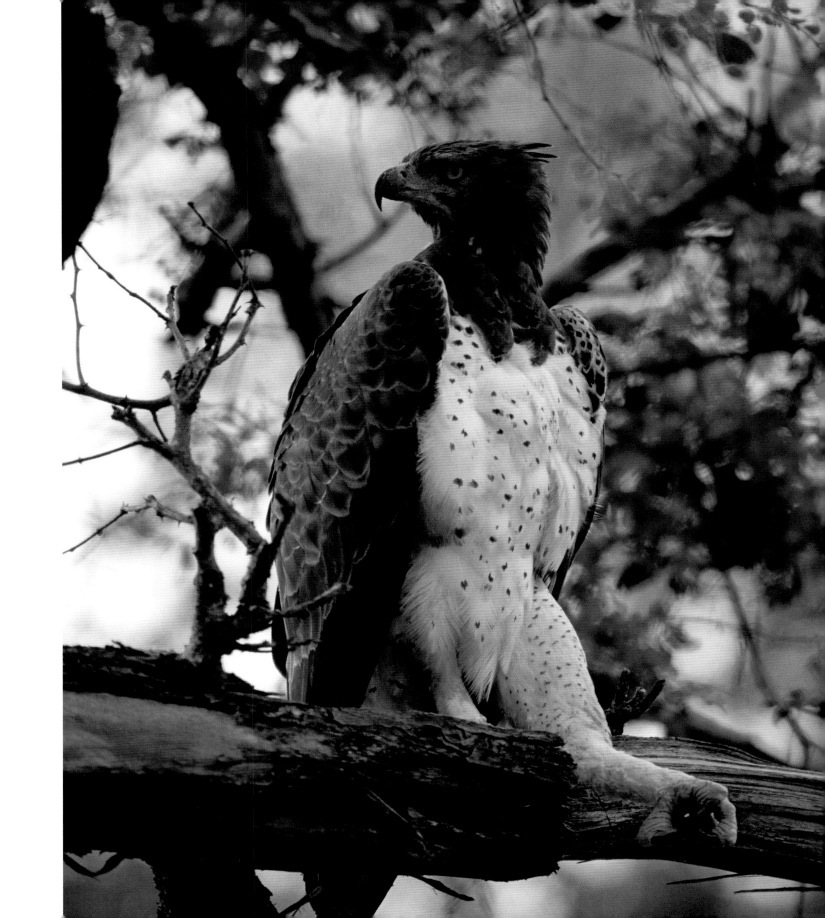

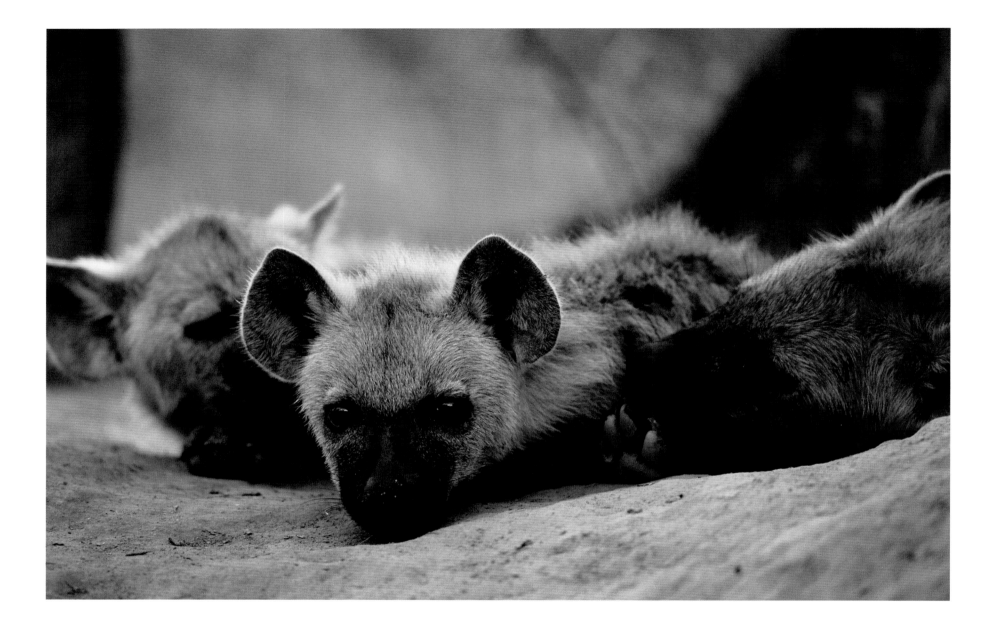

ABOVE: Hyenas are highly gregarious, territorial, and have female domi-
nated clans.
RIGHT: Leopards are fantastic tree climbers, often taking their kills up
trees to escape lions and hyenas.

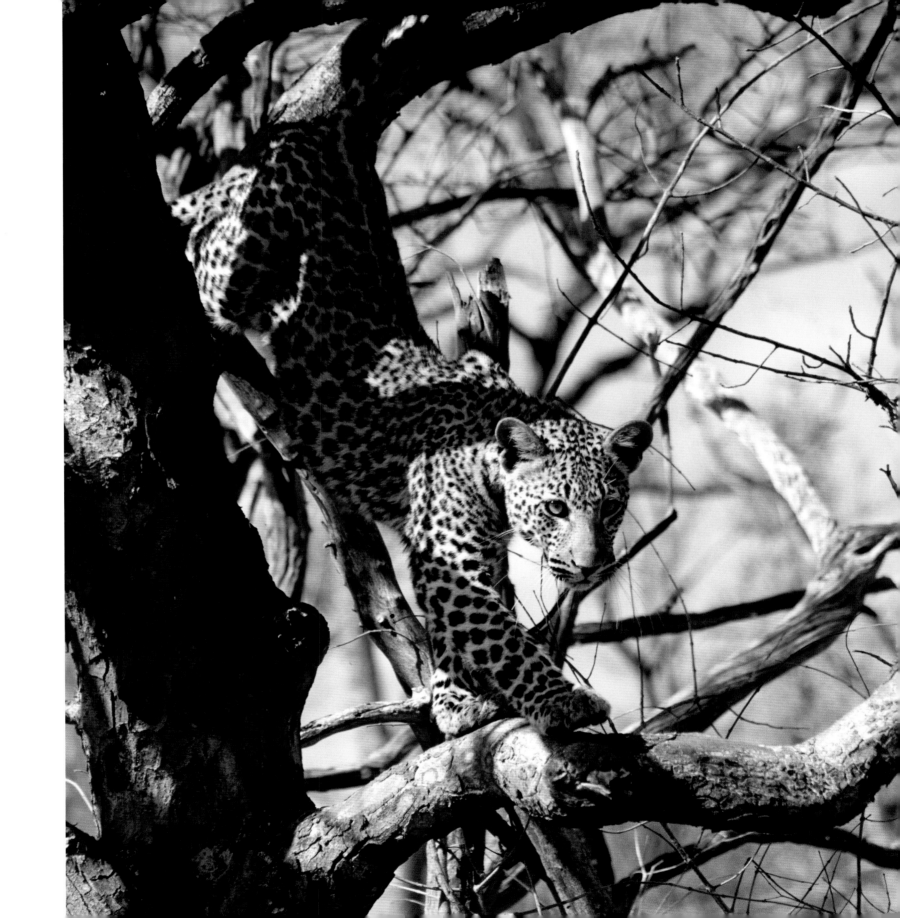

LEFT: The cub of the Mhlabatini female leopard with a duiker carcass.

BELOW: The Kapen female leopard with a bushbuck kill. Shortly after this photo was taken, a hyena stole her kill.

BELOW LEFT: A serval pounces on a small rodent. Consider yourself very lucky if you see one of these rare cats.

OPPOSITE: Leopard viewing at MalaMala is unbeatable by day or night. Over many years, most have become fully tolerant of vehicles and spotlights.

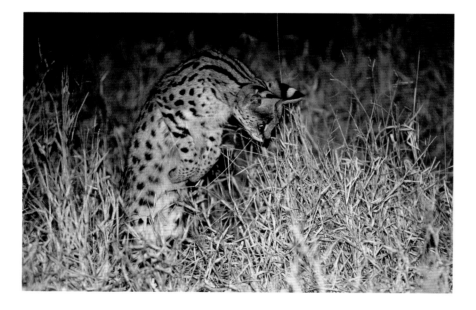

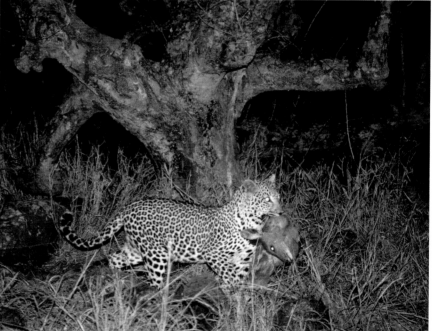

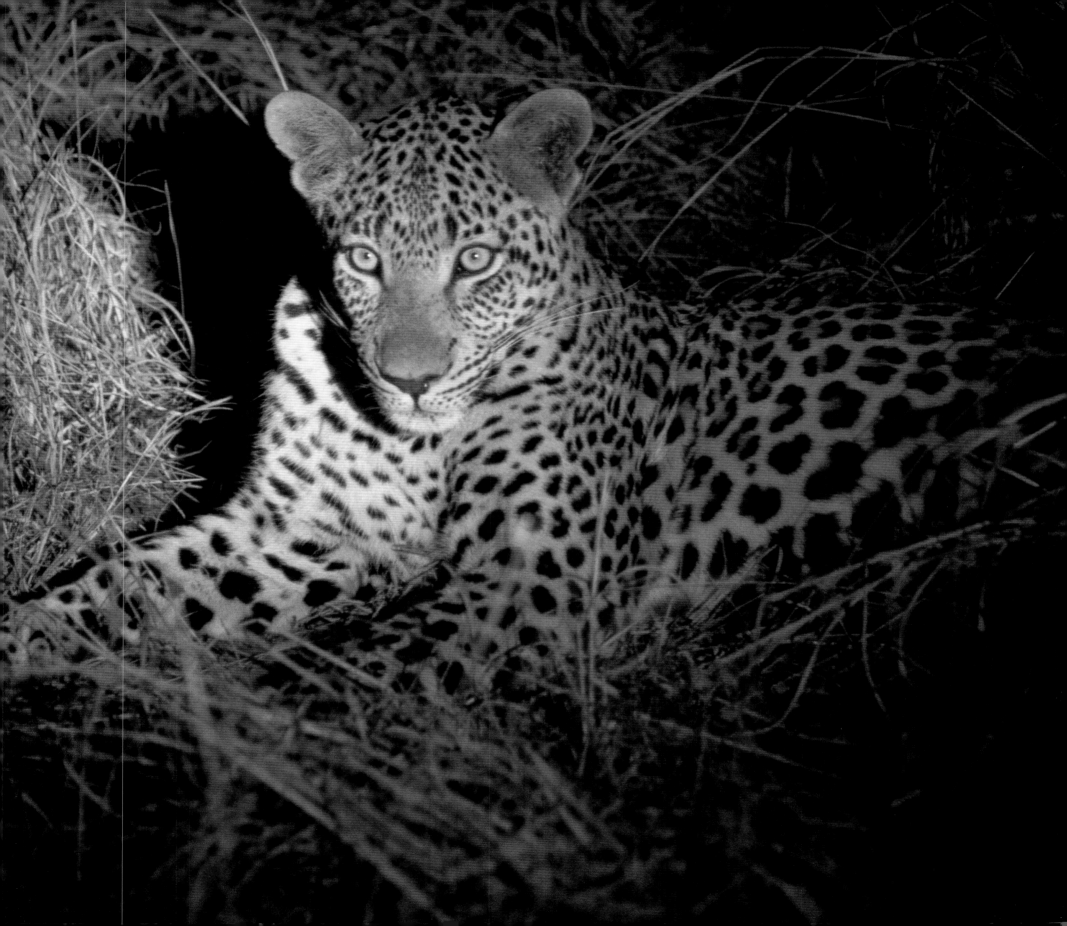

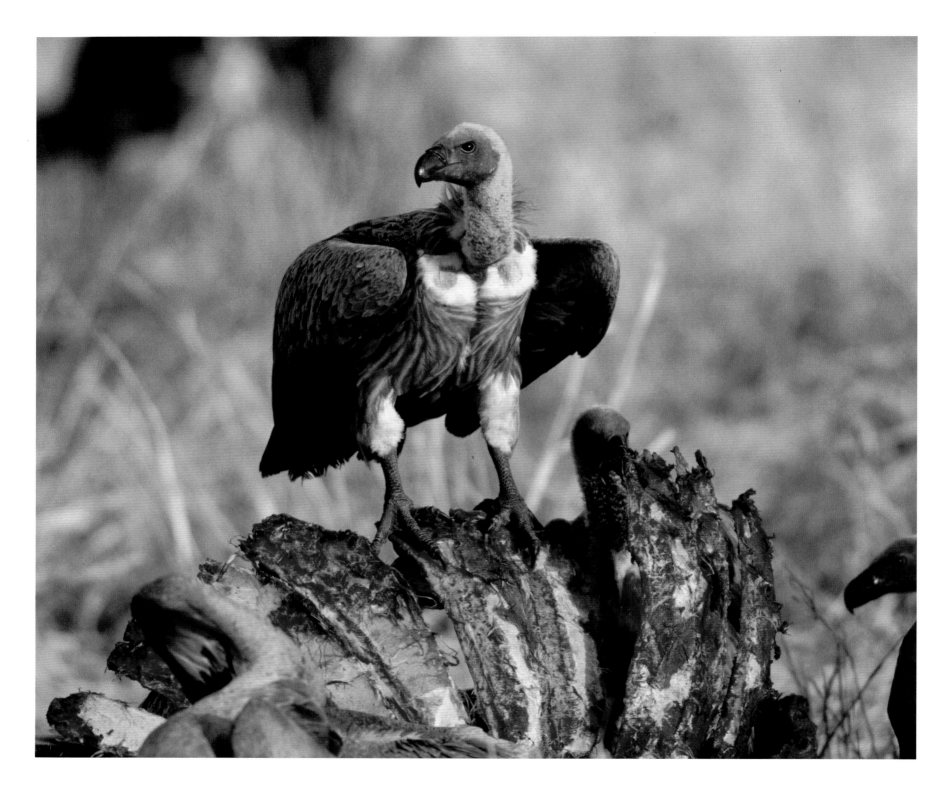

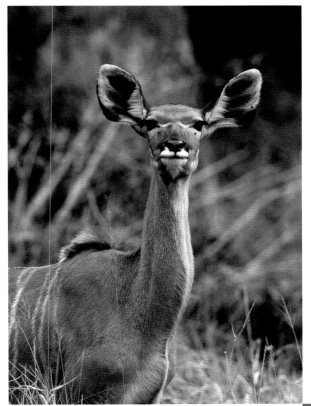

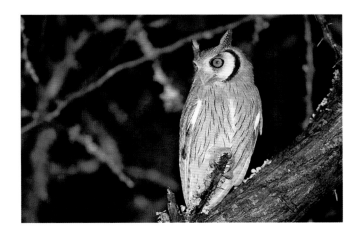

ABOVE: A kudu cow senses the presence of a leopard.

RIGHT: A yawning cheetah and her cub off the golf course.

TOP RIGHT: Whitefaced owls are easily distinguished.

LEFT: Whitebacked vultures finish off the scraps of a buffalo carcass at Exit Lion Loop.

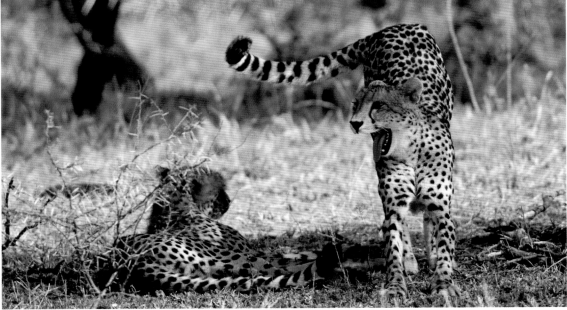

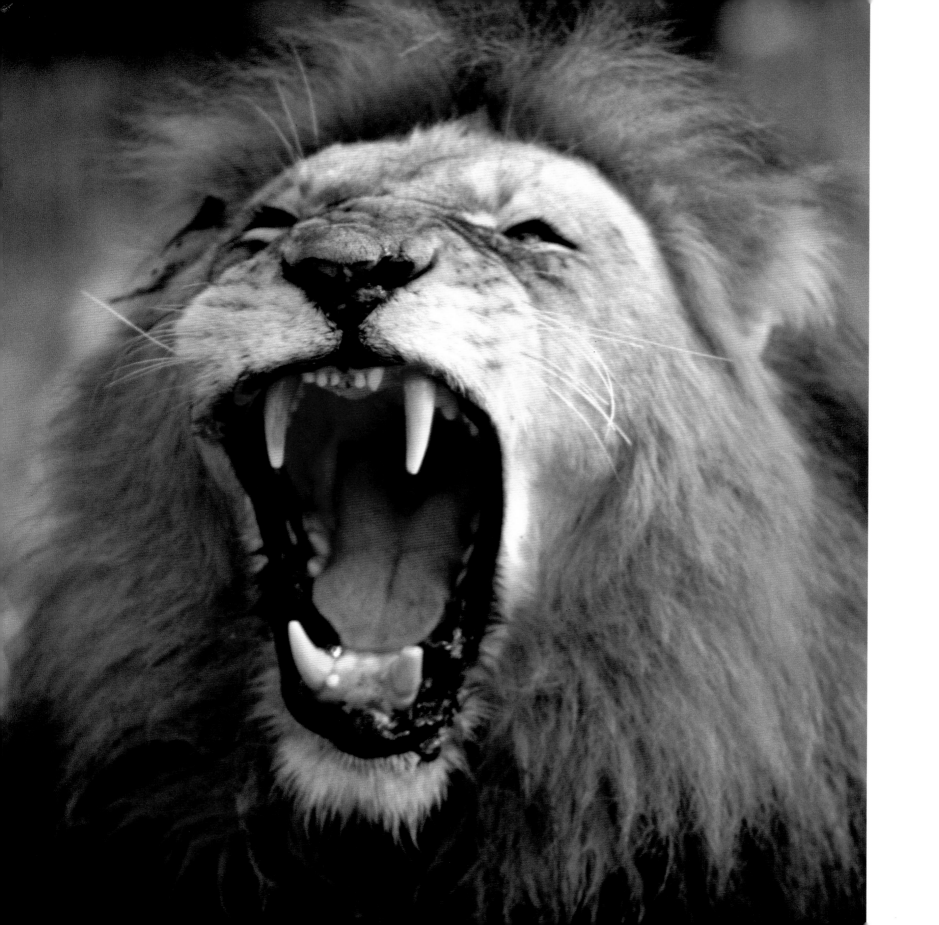

RIGHT: Don't be misled by
the placid demeanor.
These animals are not
tame.
LEFT: A West Street male
displays his formidable
array of teeth.

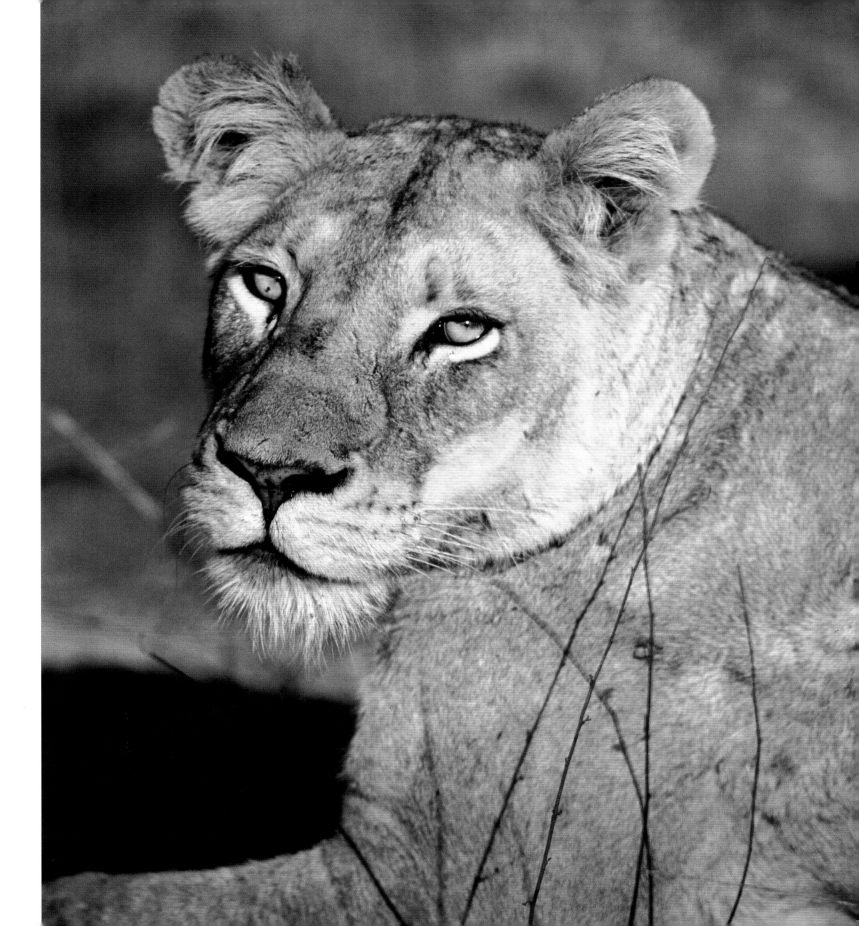

MalaMala
Pathways

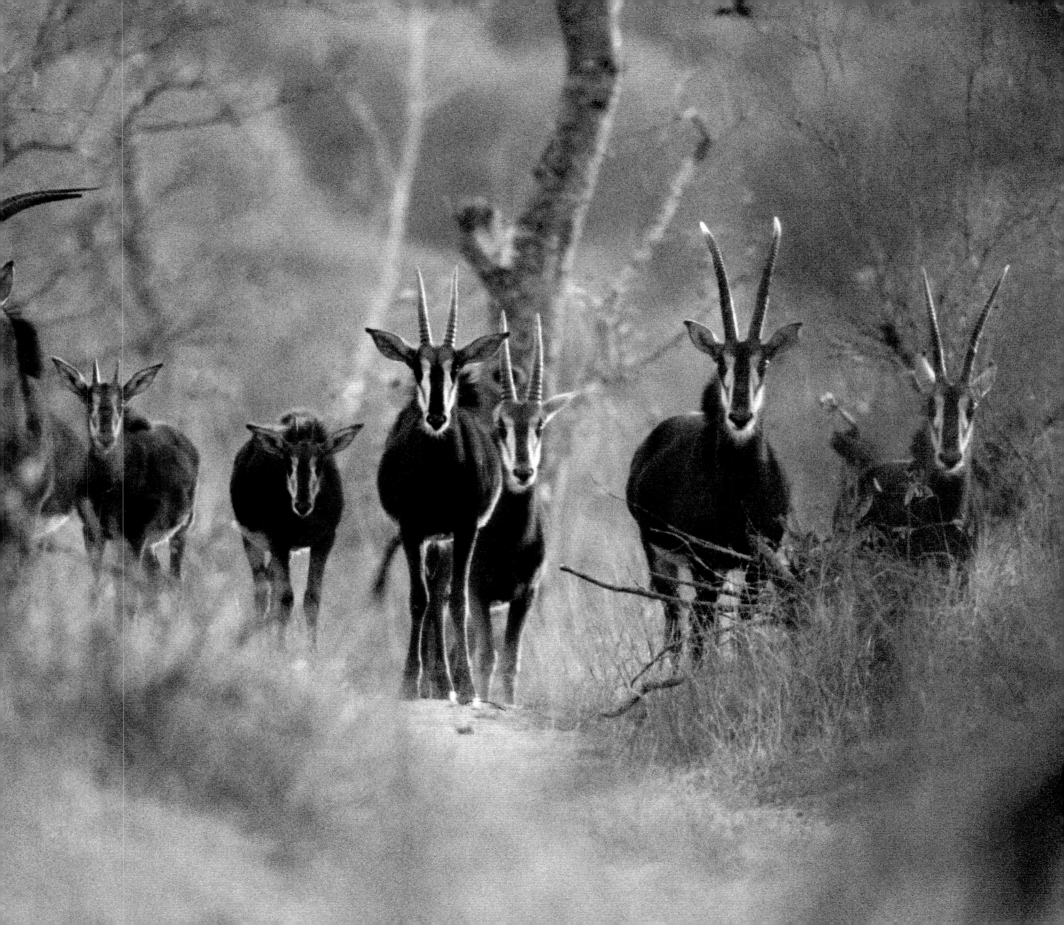

\mathcal{P}ATHWAYS AT MALAMALA DO NOT CONFORM TO A NARROW DEFINITION. They are not paved roads, nor are they even necessarily roads at all. The majority of them are game paths which will never be seen by man. They often lead to water holes or the river, or grassy areas that are sources of food. These rudimentary pathways are little more than a small trampled trail through the bush.

Then, there are the pathways wide enough to accommodate vehicles. Some of these are incredibly beautiful, shaded by trees, or offering views across the open areas and rivers. Others are more rugged, and some are simply utilitarian. There is one attribute, however, the MalaMala pathways all share: they offer a means of traveling from one place to another. The main difference is that for every animal, and for every human, this journey is a different one.

For the most part, the pathways a visitor to MalaMala sees are those the vehicles traverse. They are gentle, rustic, rutted paths, non-invasive and conducive to animal traffic as well as human. In fact, while it isn't uncommon to see animals walking on the paths, or to follow animals down these paths, it's just as common to see animals leaping over them, walking alongside them, or even sleeping in the middle of them. The rangers always stop for these animals, delicately circumvent them, or turn around and find an alternate route rather than disturb them. More often than not, however, you find the animals using the pathways much as vehicles do—for convenience, to get from one place to another. This fact adds an element of drama to your drive, as you never know what will appear around the bend, or over the crest of a hill. For example, you might come upon a herd of sable antelope, returning from a sojourn down by the river, or a pair of lions, walking toward you out of the mist. Perhaps you'll be confronted by an enormous bull elephant, whose noisy charge in your direction indicates in a not-too-subtle way that he doesn't plan on your using his road.

The pathways also add a bit of sleuth-like excitement to your drive, as you watch your ranger and tracker study markings left in the dust, enabling them to track animals. Could that be the outline of a lion's paw? It would appear so, because around a curve in the road, just ahead of your vehicle, you spot a pride, walking purposefully toward a waterhole. You are, quite literally, traveling in their footsteps (or, more accurately, their paw prints). It is an amazing feeling, to share the road with lions, and leopards, and all of the other animals for whom MalaMala is home.

RIGHT: Lions, like most of the animals, use the roads as pathways.
PREVIOUS PAGE: Herds of sable are more frequent visitors to MalaMala in the winter months, due to the removal of the fence between Kruger National Park and MalaMala.

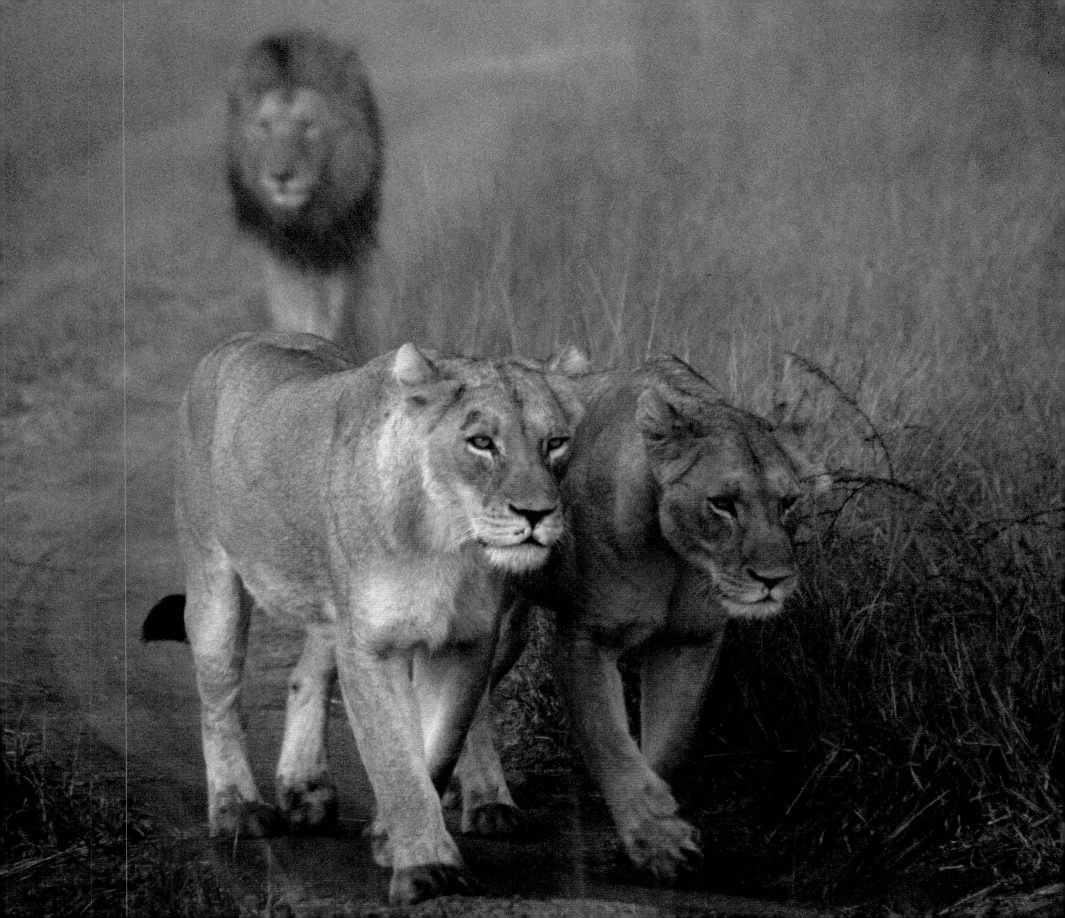

Land Rovers traverse the roads with amazing ease and smoothness.

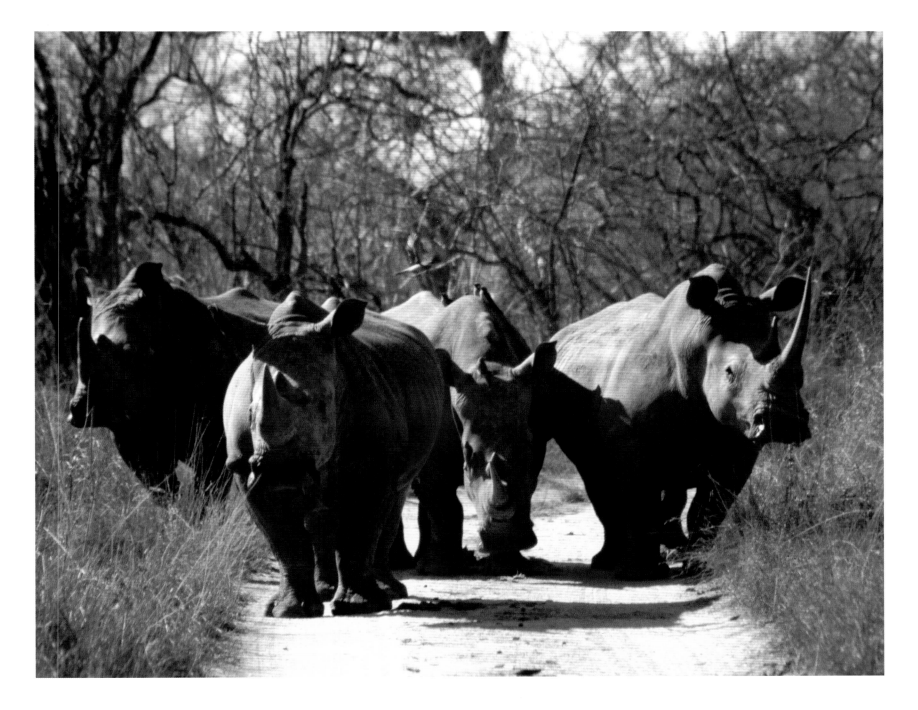

Rhinos create distinct paths by regularly using the same routes.

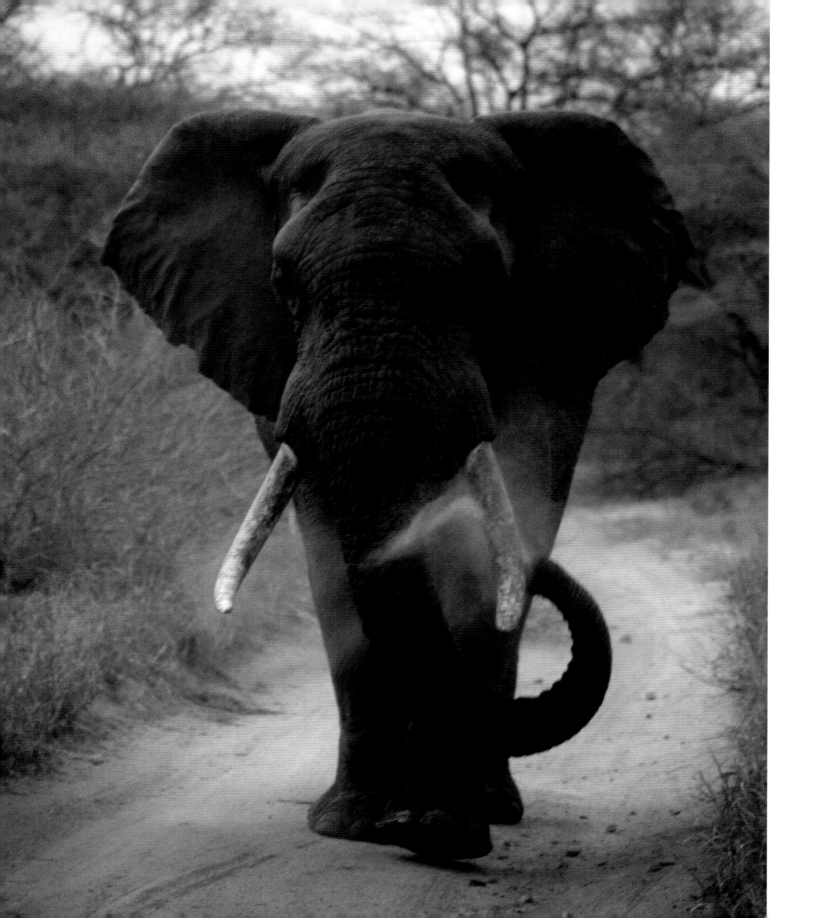

LEFT: An elephant bull sucks up dust and sprays himself while meandering down Scots Road.

RIGHT: One of the Styx pride cubs toys with a branch on Northern Side Campbell Koppies.

FAR RIGHT: A young elephant bull in midfeast turns toward a vehicle on East Side Matshapiri.

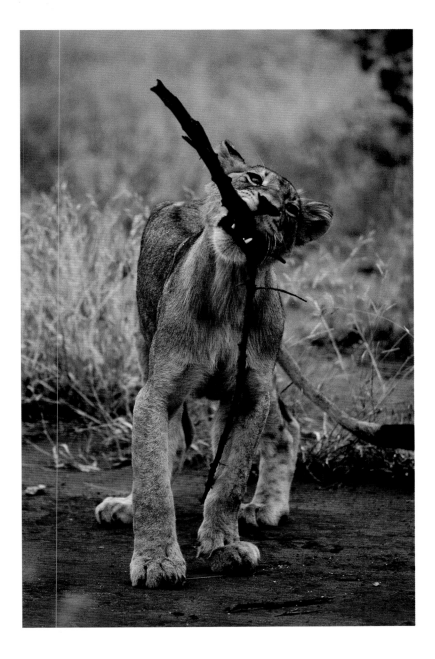

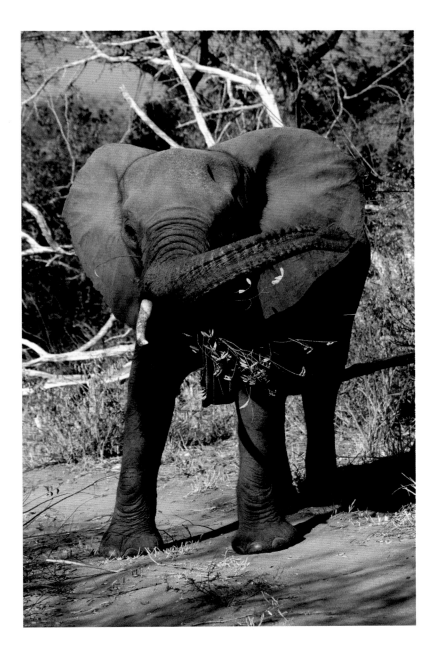

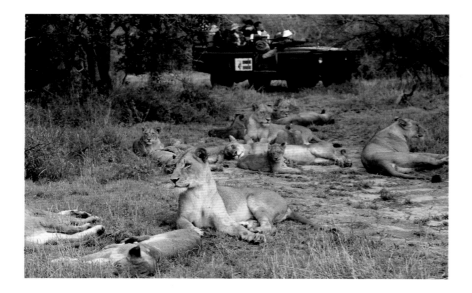

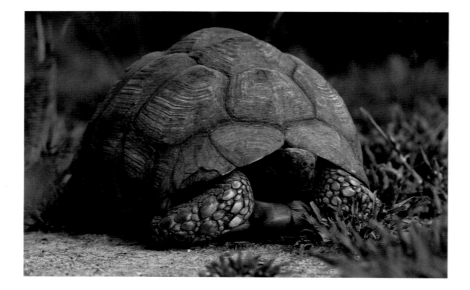

ABOVE: This leopard tortoise, at about thirty years, has lost much of its coloring.

TOP: The Eyrefield pride spread out in Buffalo Pans. Lions spend most daylight hours inactively.

RIGHT: Impalas can leap spectacularly, triggered easily when in dense vegetation.

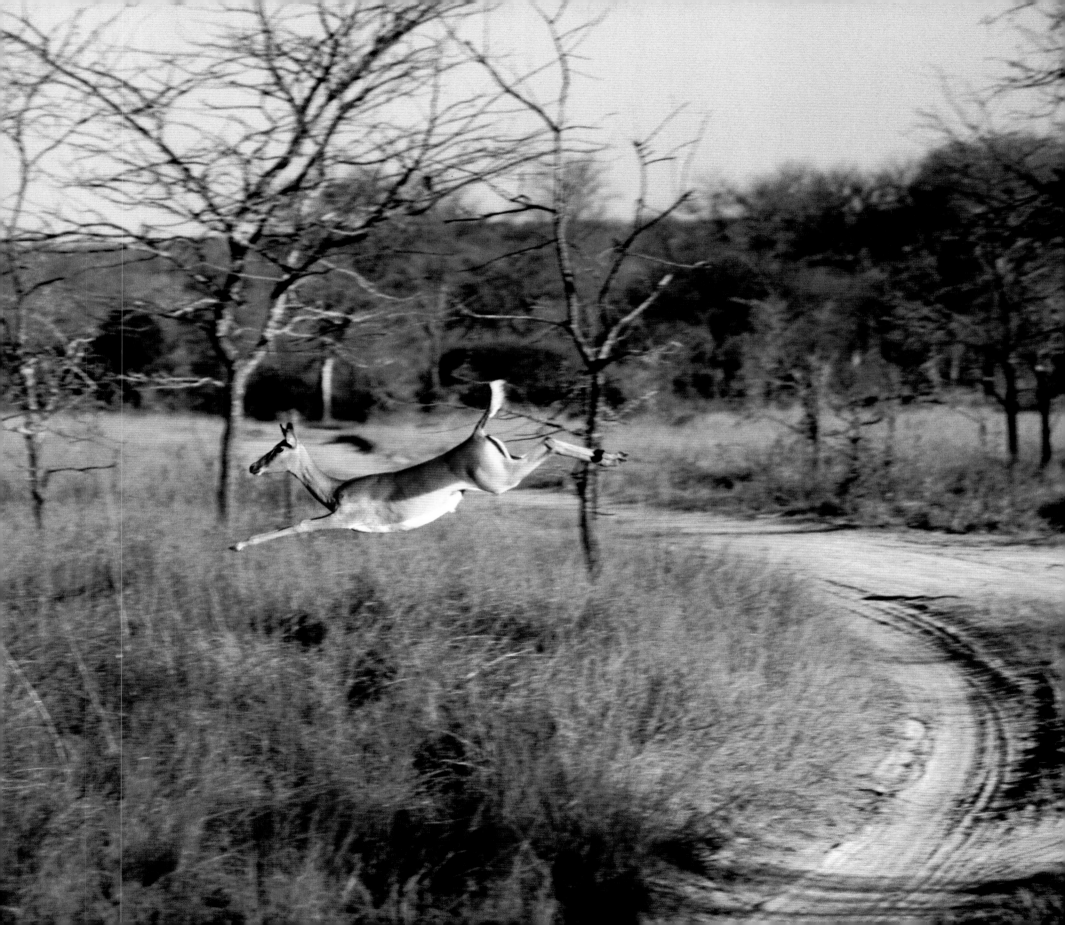

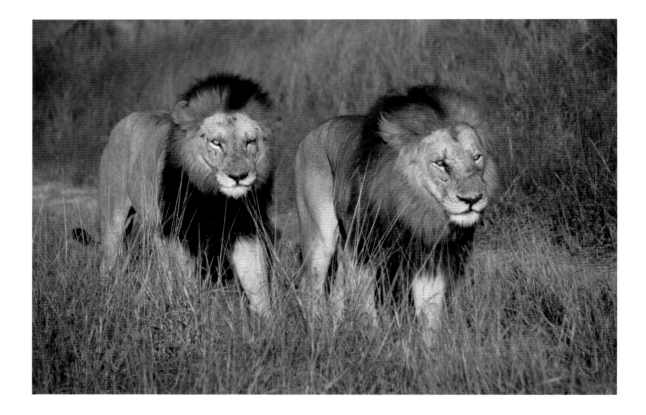

ABOVE: Male lions walk their territorial boundaries to check for any sign of intruders.
RIGHT: This elephant bull pauses in the shade of an acacia before continuing riverwards.

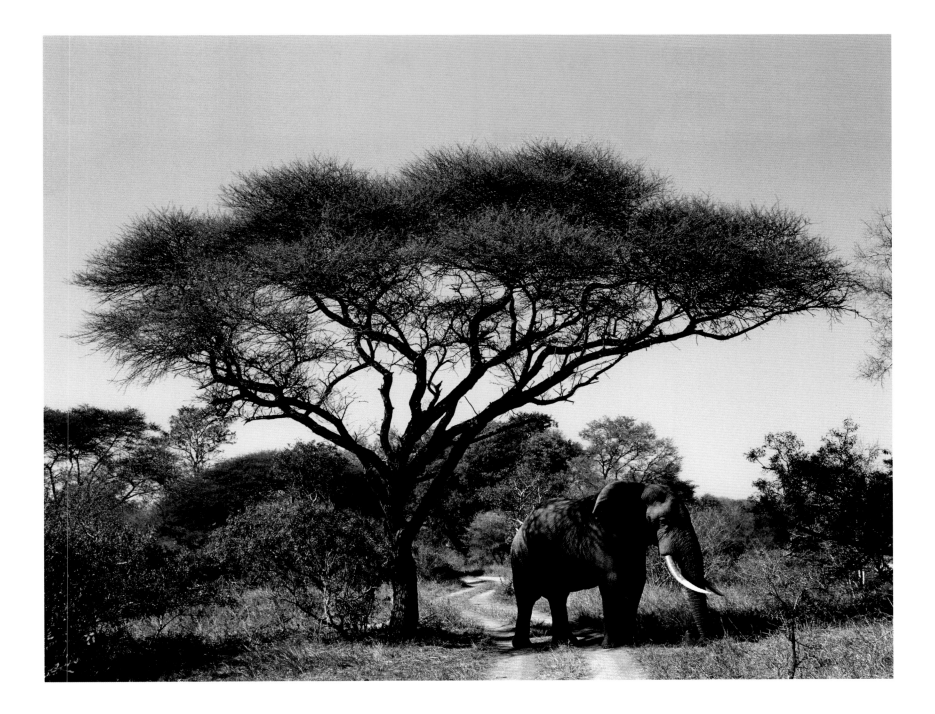

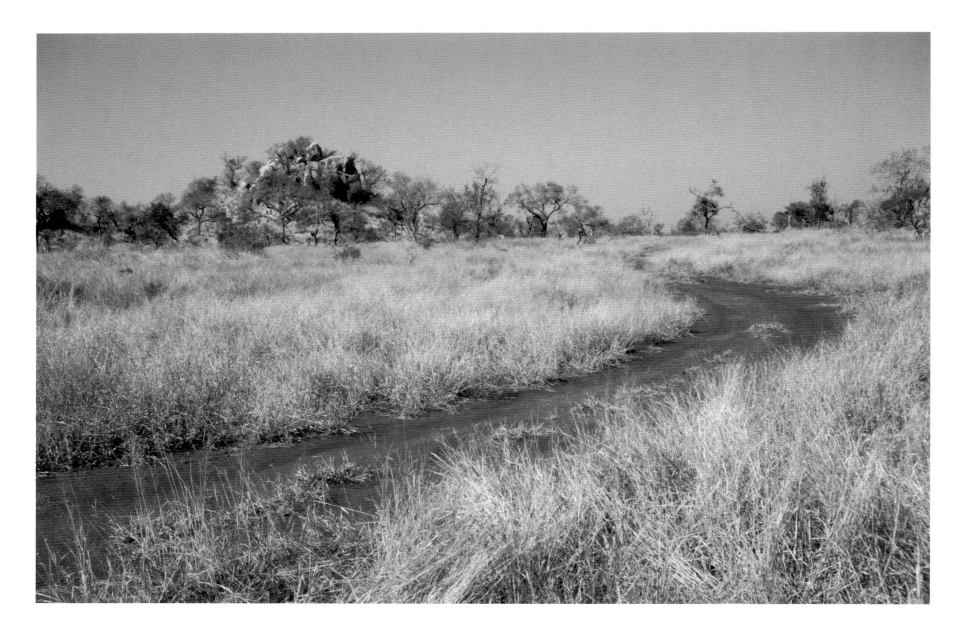

From Northern Side Campbell Koppies to the Sausage Spot.

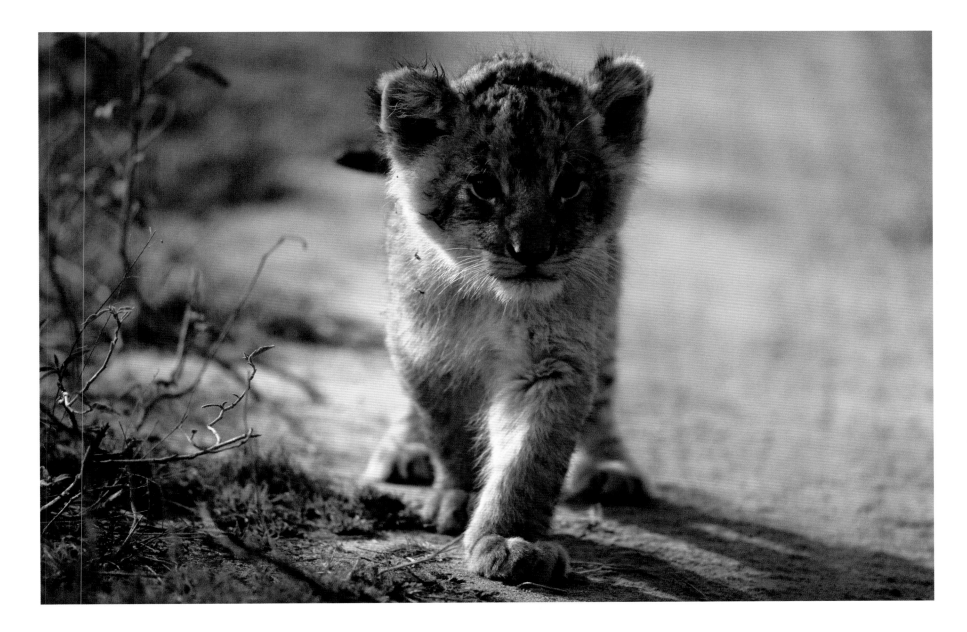

An eager member of the River Rocks pride ventures towards the Land Rover on Northern Section Golf Course.

Social
Groupings

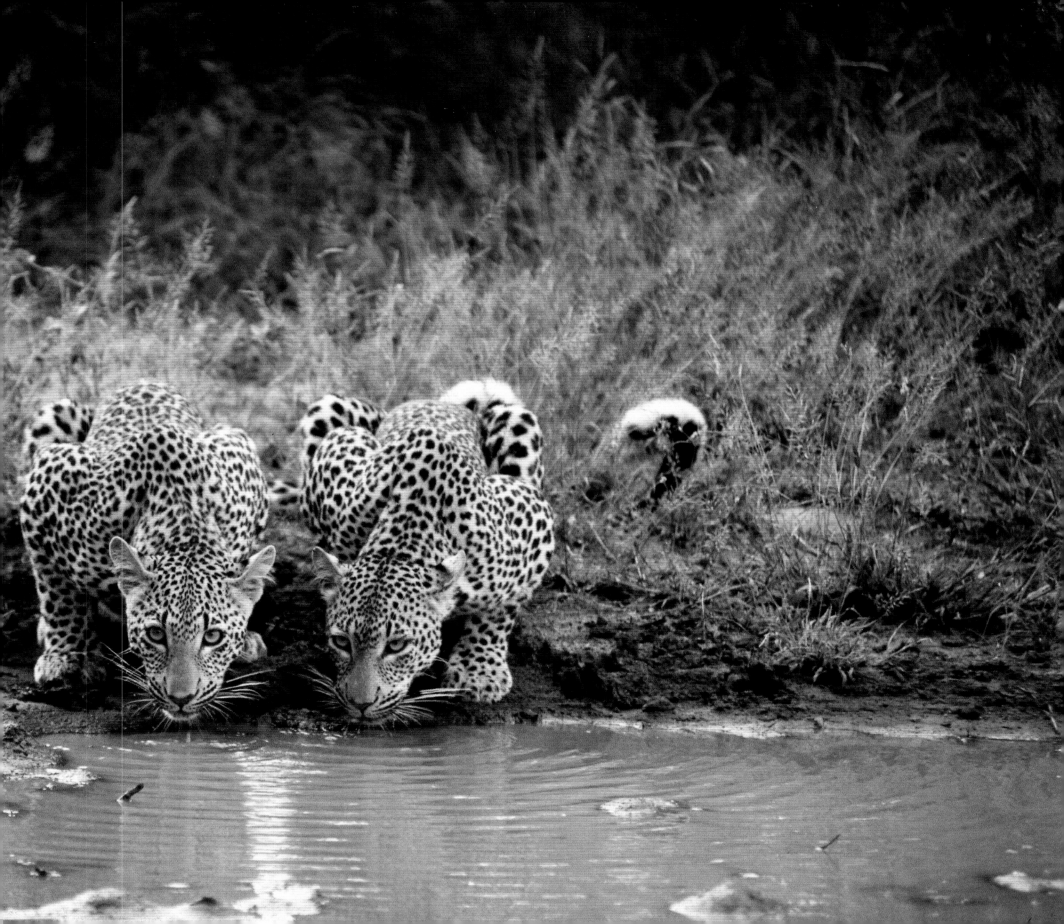

THE SOCIAL GROUPS FORMED BY THE DIFFERENT TYPES OF ANIMALS AT MALAMALA are fascinating, both in their distinctiveness and complexity. As visitors, we are given the opportunity to view them in a wholly natural and unguarded state. Indeed, it is as if we have been granted access to a window through which we can see how animals structure and secure their communities, families and, ultimately, their survival.

A number of animals serve as excellent examples of the intricate or simple patterns and hierarchies of each animal species. Lions mate, then separate. The opposite of this behavior can be found in jackals, which mate for life. Matriarchal elephants possess a strong sense of kinship, and it is common for female elephants to form a life-long bond with their daughters and their daughters' progeny. On the other hand, cheetahs, when past their early years, are solitary animals with no strong familial or community attachments. From the spirited gesturing and vocalizations one can easily observe between baboons, it should come as no surprise that they are strong communicators with social groupings of up to 150 members. Conversely, leopards, like cheetahs, communicate subtly and lead an essentially lone existence. Obviously, male and female leopards need each other to mate, but beyond that, their relationship is decidedly unfriendly. Then, of course, there is trans-species interaction; for example, the red-billed oxpeckers, who enjoy grooming rhinos and Cape buffaloes.

When observing these social groupings among animals, one finds it difficult not to ascribe to them qualities applicable to human group dynamics. One sees the maternal protectiveness between a lioness and her cub, the way in which impala seem to move as a group (rather like survivalist peer pressure), and the aloof independence of the cheetah. Mongooses enjoy company, and elephants possess a sturdy solidarity and sense of purpose in their own family clusters. The cacophony of the birds suggests that they have their system of communication all worked out, even among different varieties of birds.

As visitors, we are fortunate to have the opportunity at MalaMala to observe these alternative behaviors. Whether animals are solitary or part of an enormous herd, whether they are fiercely territorial or flexibly nomadic, whether they mate for life, or for three days, it is clear that distinct differences between their social groupings exist. Despite these significant disparities, however, all these animals share a common goal: survival of the species on common ground, the Eden of MalaMala.

RIGHT: Giraffes have an intricate vascular system, enabling them to graze and drink without the blood rushing to their heads.
PREVIOUS PAGE: The Toulon female leopard and her cub (left) drink from a pan off Harry's Access. Aware of their admirers' presence, their movements never betray a sense of nonchalance.

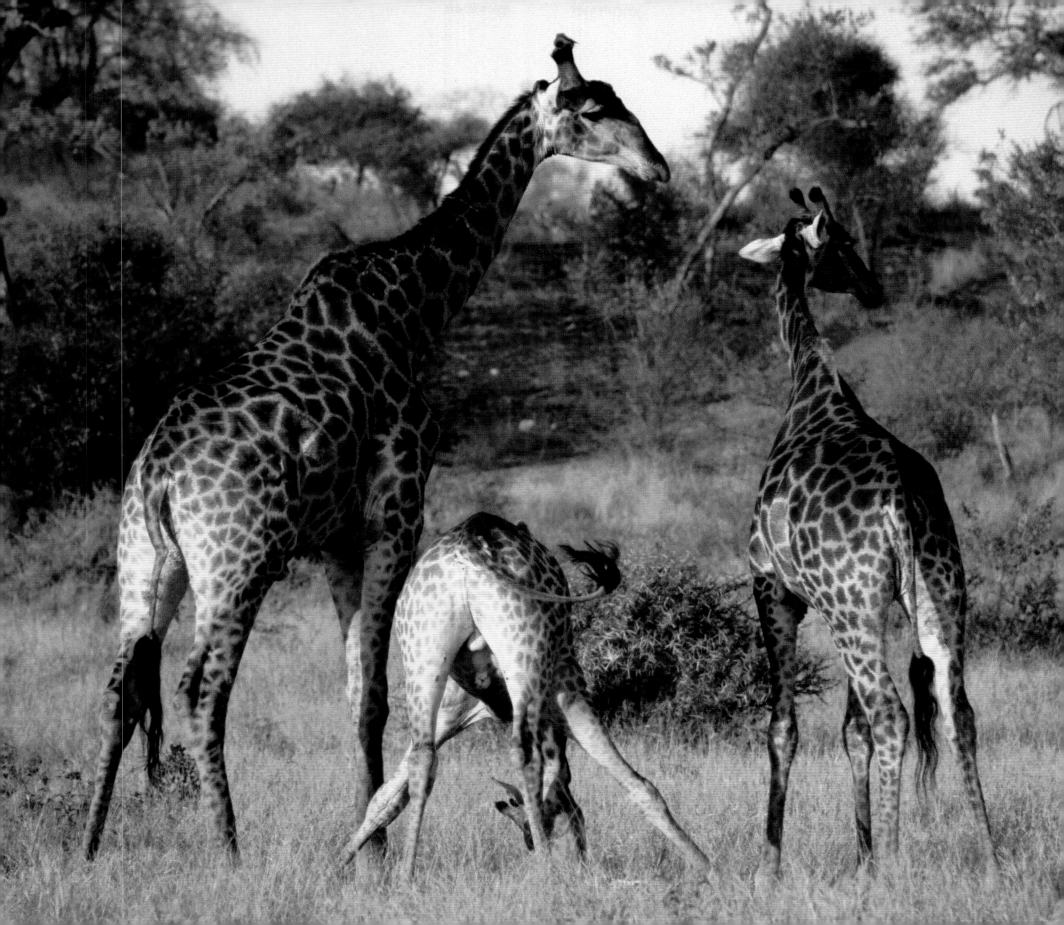

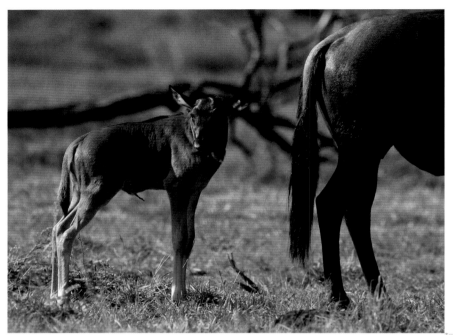

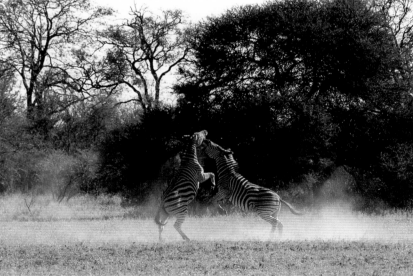

ABOVE: Wildebeest calves need to get mobile shortly after birth to keep up with the herd and avoid predators.
RIGHT: Zebra fights can be fierce, as they bite with their chisel-like teeth.
OPPOSITE: The first and last few hours of daylight are the busiest for feeding.

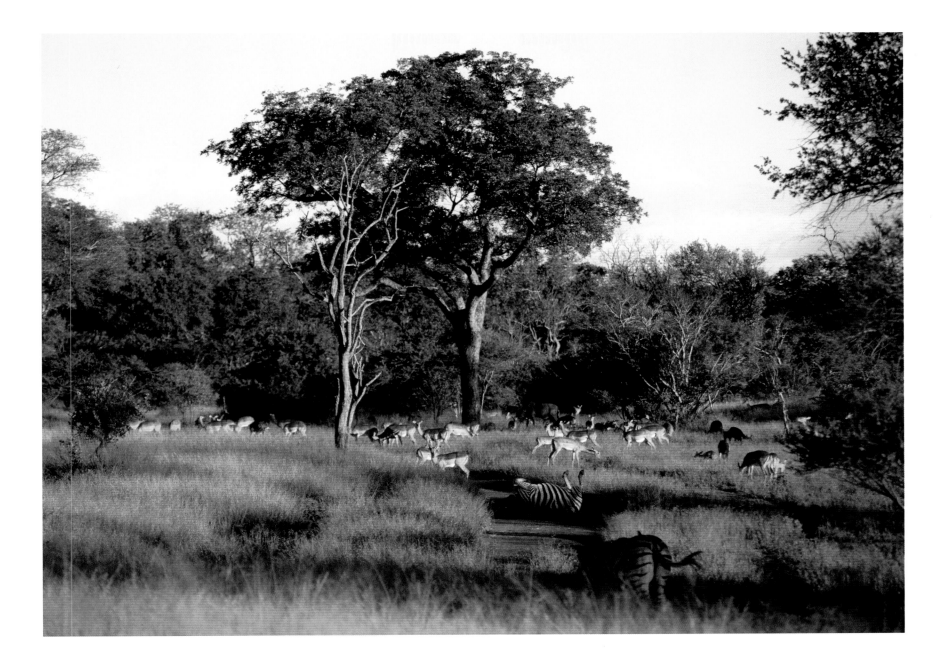

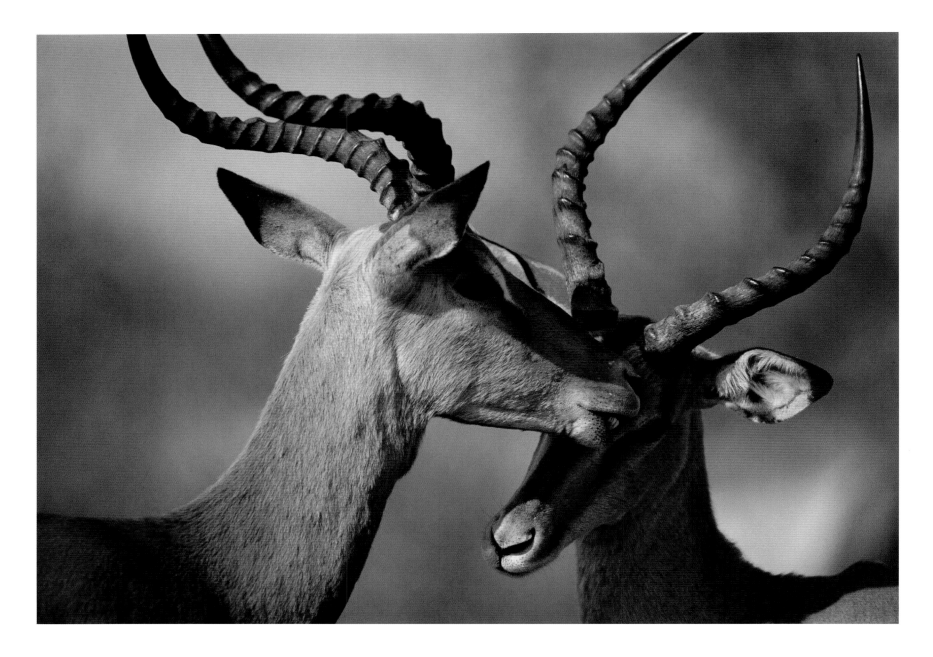

Reciprocal grooming between two impala rams.

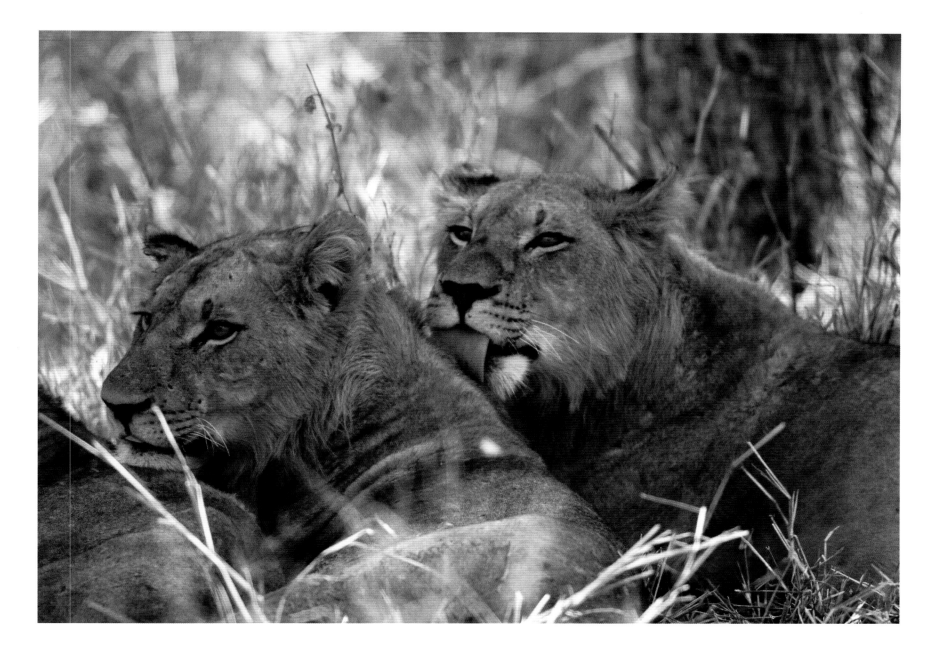

Male littermates from the Styx pride. They will probably stay together after leaving the pride and later compete for territory as a team.

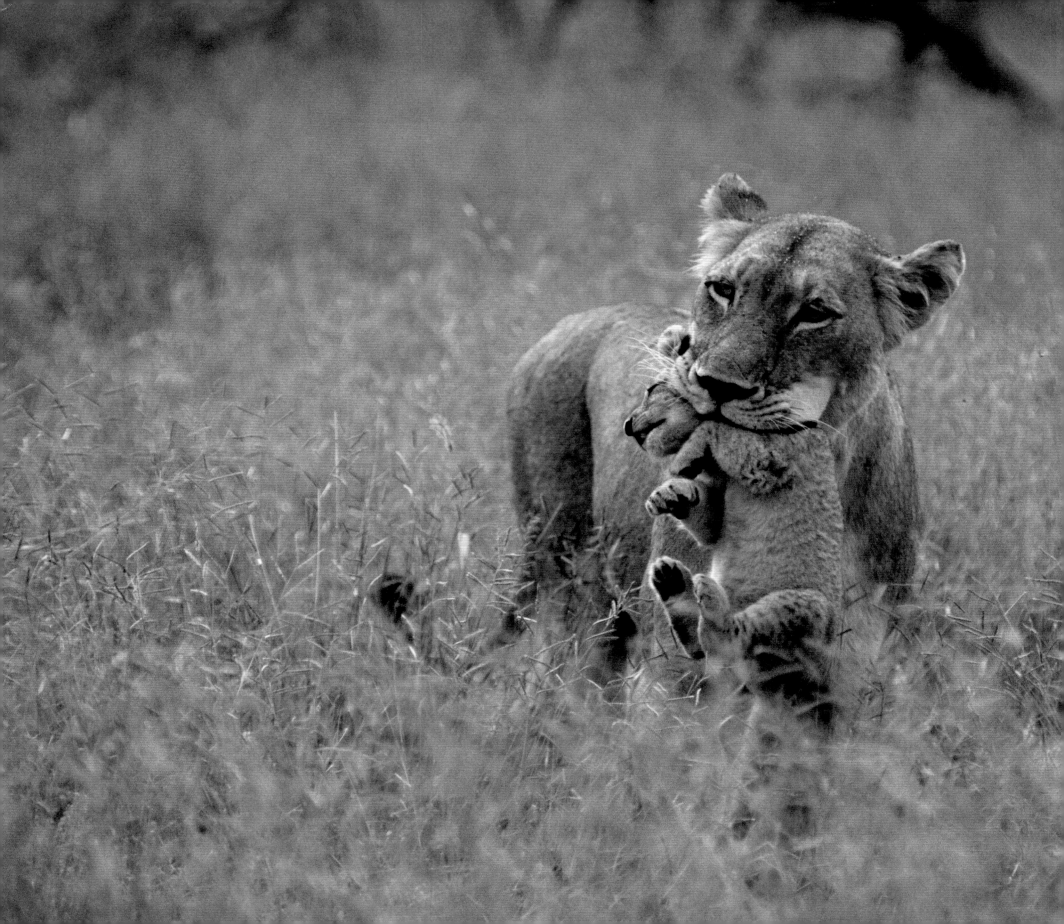

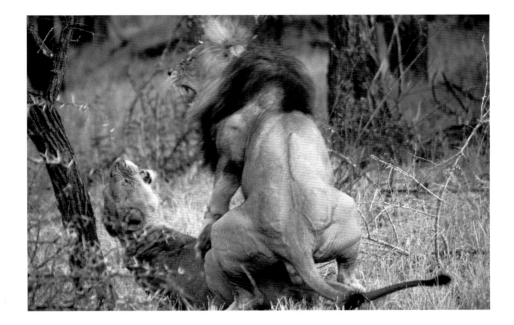

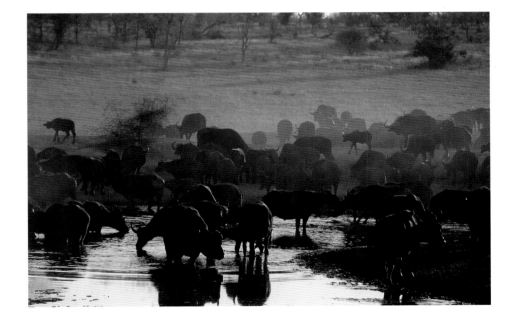

ABOVE: Buffalo are highly sociable. Herds include males, females, and young.
TOP: Mating lions can be quite an agressive affair.
LEFT: One of the Styx pride females gently carries each of her cubs between the Campbell Koppies.

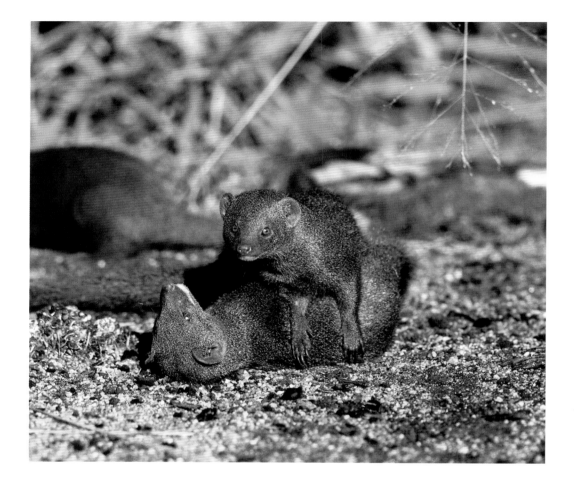

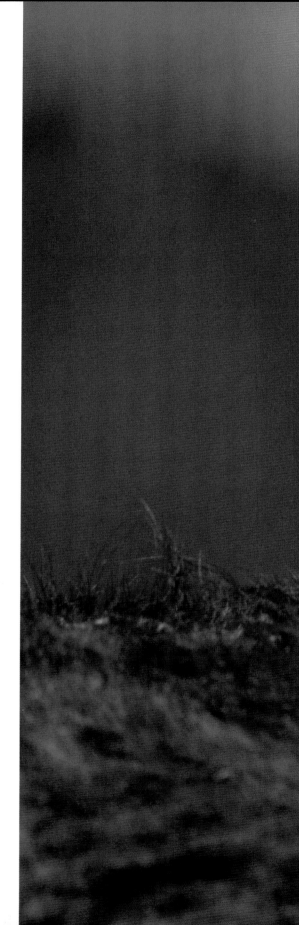

ABOVE: Dwarf mongooses wrestling on Old Borehole Road
RIGHT: Redbilled oxpeckers and buffaloes have a symbiotic relationship. The oxpeckers feed on the ticks and parasites that annoy the buffalo.

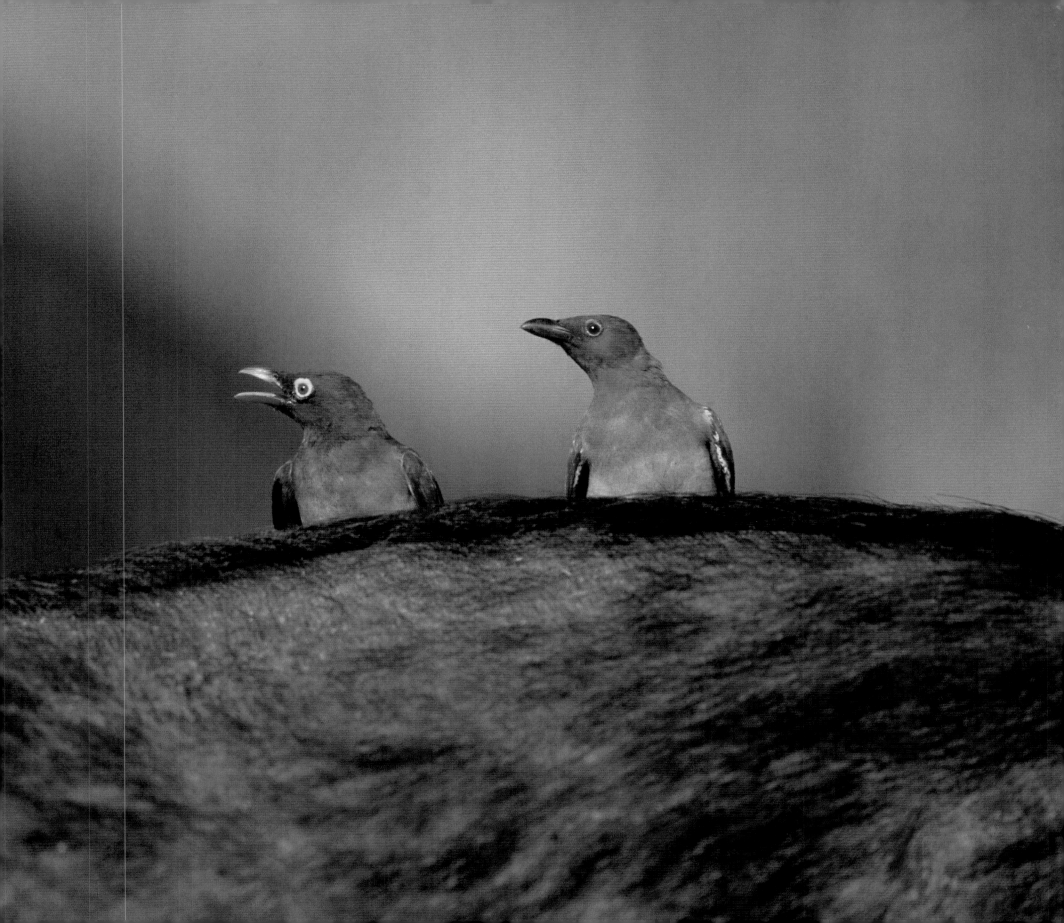

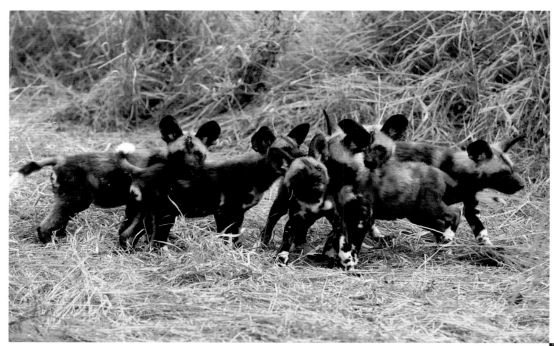

ABOVE: Wild dog pups are truly one of the most special sights at MalaMala.
RIGHT: The feeding frenzy of vultures after lions have finished with a buffalo carcass.
OPPOSITE: Since rhinos were reintroduced after hunting devastated the population, they now thrive at MalaMala.

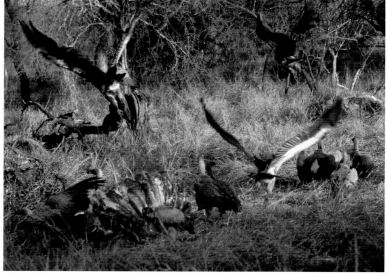

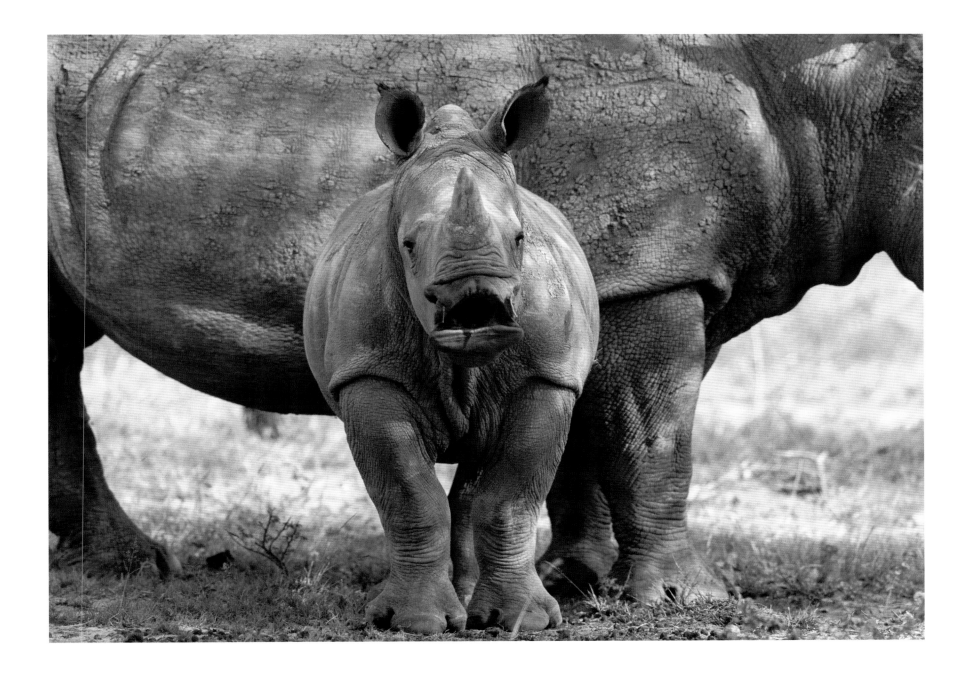

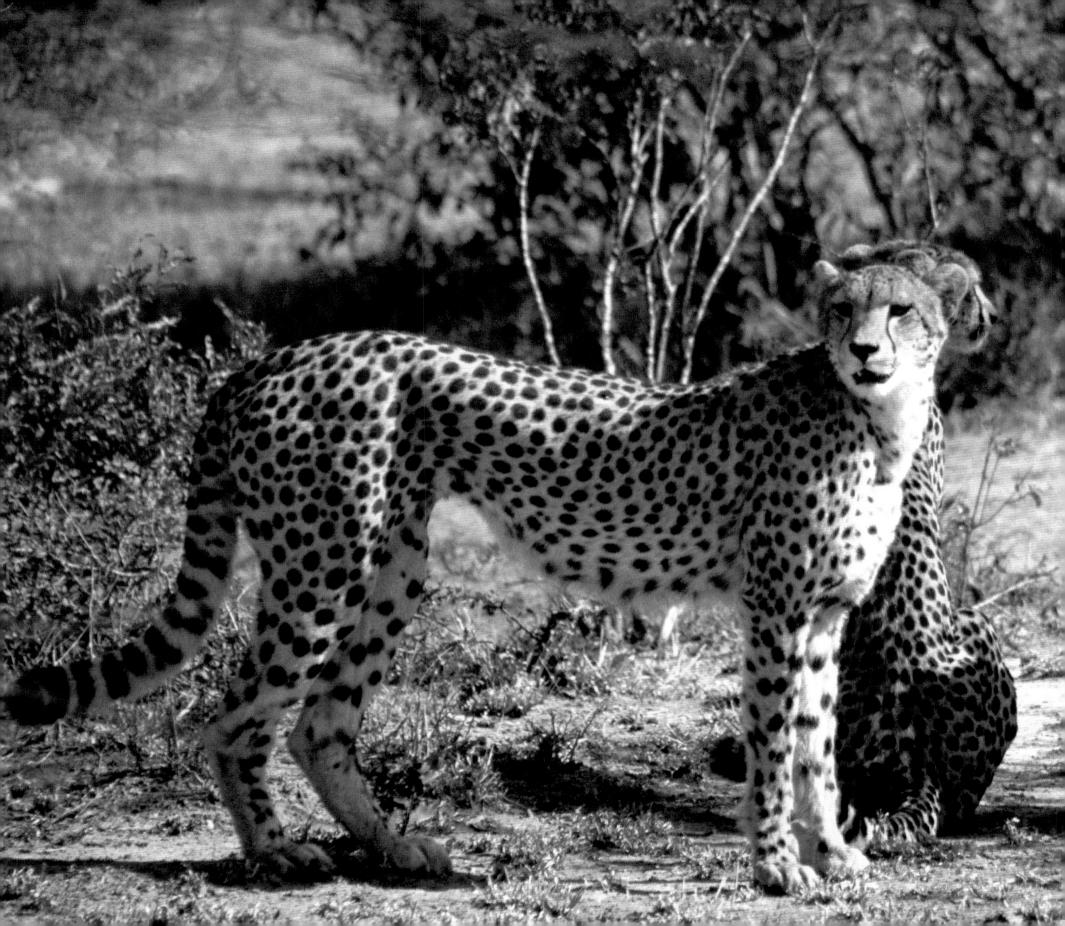

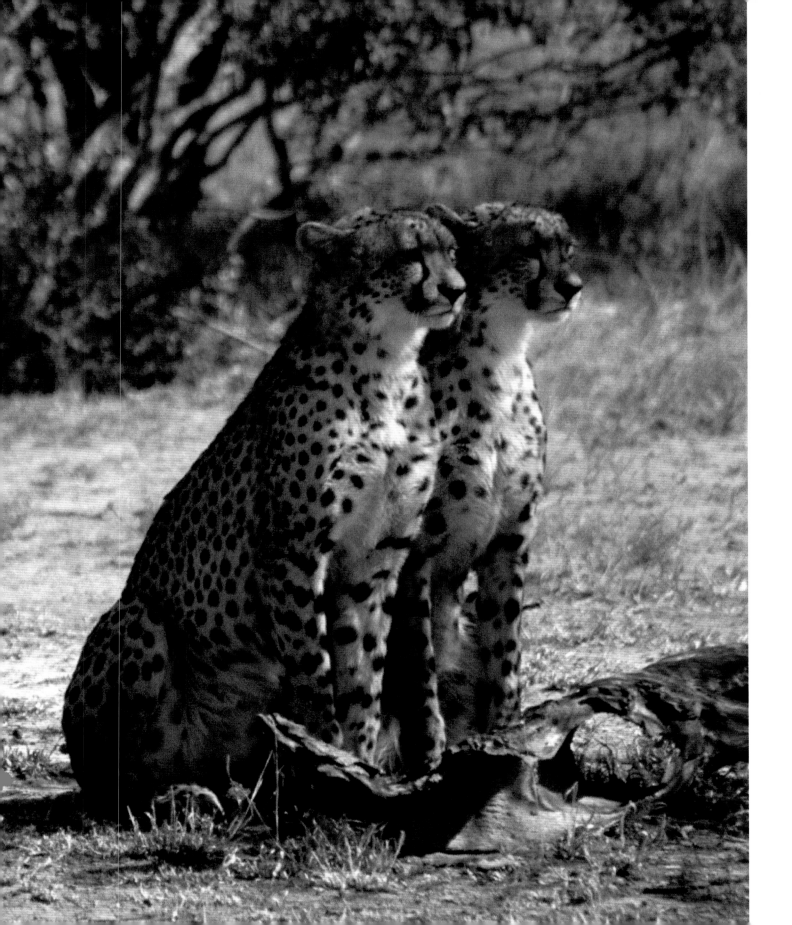

A cheetah and her cubs
have approximately an
eighteen-month rela-
tionship before they
part company. The cubs
usually stay together for
a few months thereafter.

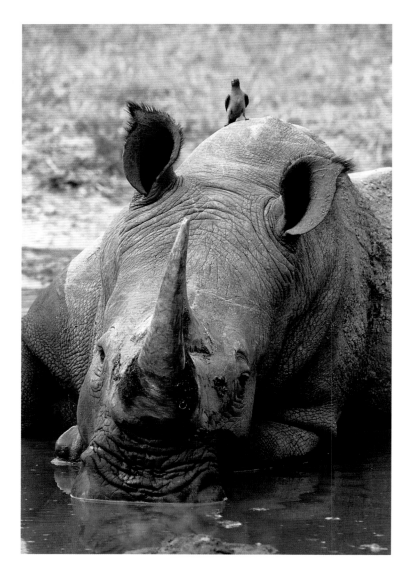

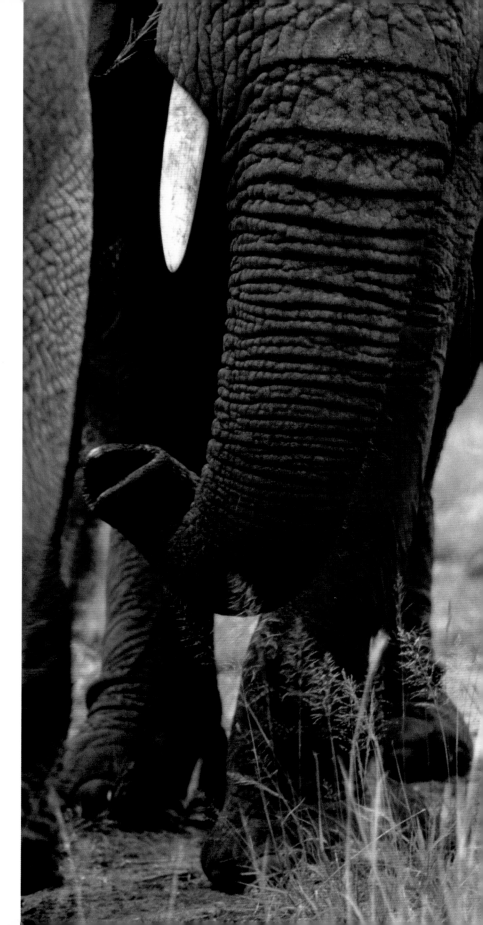

ABOVE: A bull rhino cools off in Matshapiri Open Area. A Bull does tolerate sub-adult males in his territory as long as they avoid his females.

RIGHT: Elephants illustrate probably the highest degree of bonding. Mother-daughter relationships are usually lifelong.

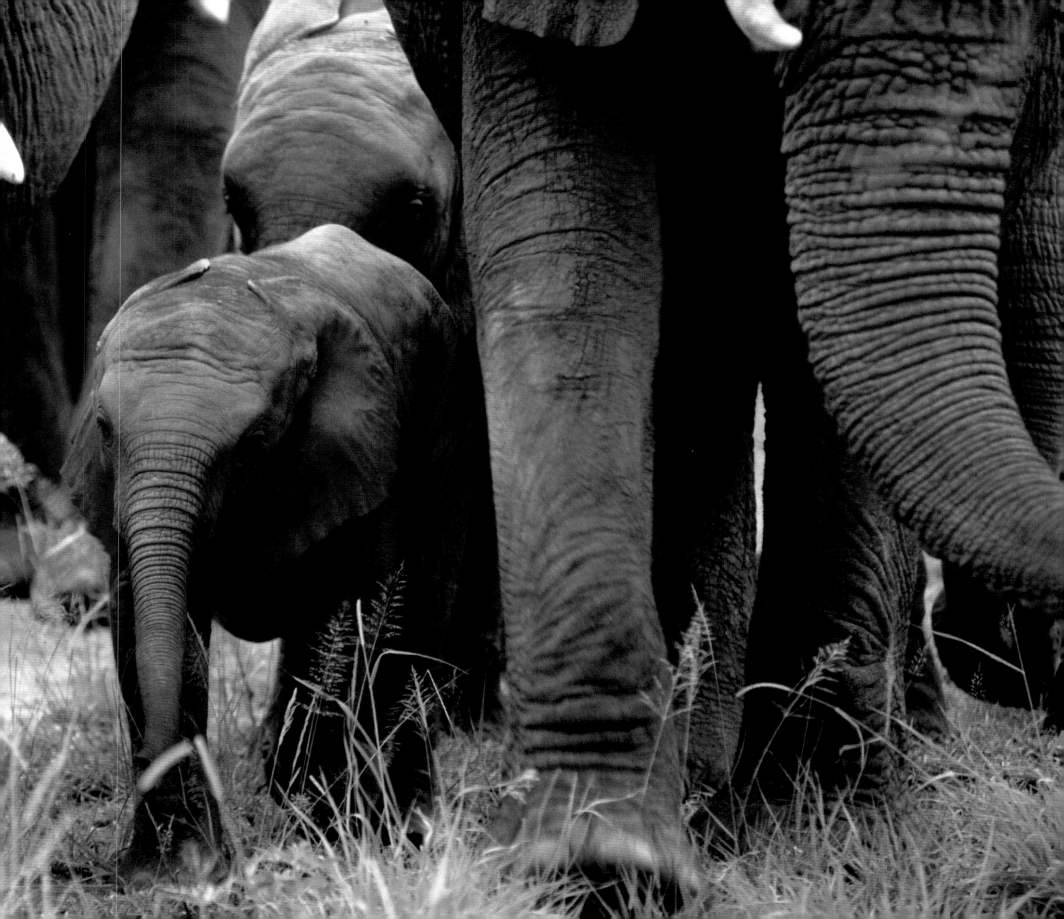

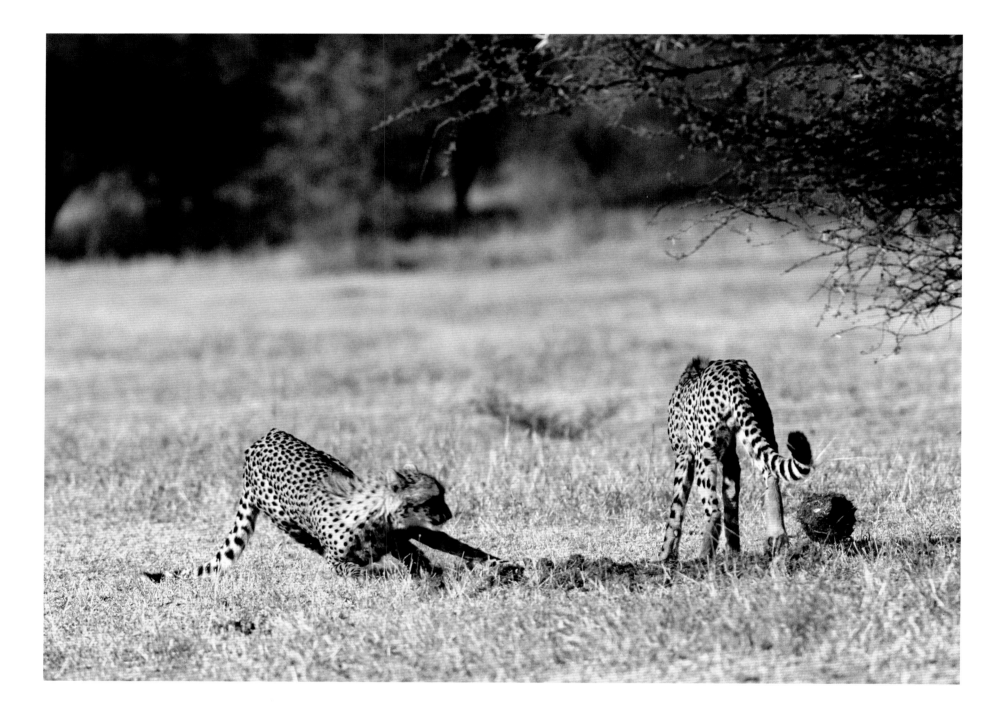

Two cheetahs playing with a ball of elephant dung on the old airstrip.

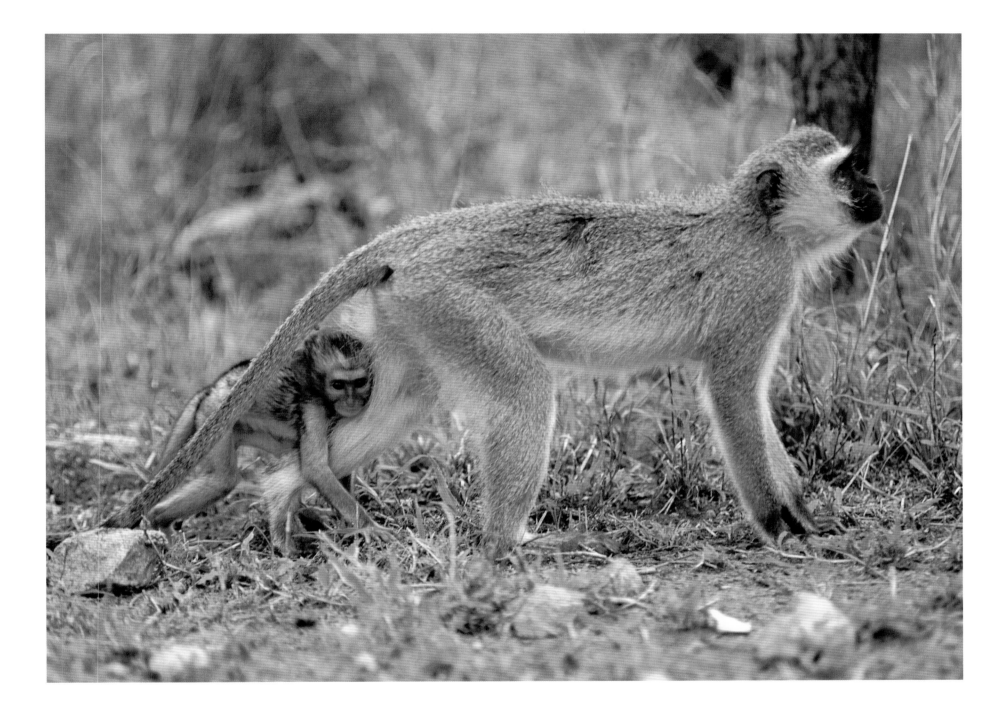

Vervet monkeys average between twenty and twenty-five animals in a troop. They use a high degree of visual and vocal communication.

*Rocky Koppies
and Dried
River Beds*

*T*HE SCRUB OF THE BUSHVELD AND SWEEPING SAVANNAS OF MALAMALA ARE PUNCTUATED by the crags and upsweeps of numerous rock formations known as koppies. These koppies are similar in appearance to the buttes that exist in the American West, but instead of sandstone they are comprised of granite. In addition to providing aesthetic drama to the MalaMala landscape, these koppies are well-used by certain animals. They provide a safe haven for lions and leopards, especially when these animals are nurturing their young. Not only can approaching danger be viewed from the koppie's elevation, but the cubs can be concealed and protected in its many nooks and crannies as well. Another animal who thrives in the rocky terrain of the koppies is the klipspringer, a type of antelope who makes its home there. Klipspringers are intensely territorial and are equipped with specially adapted hooves which enable them to leap swiftly from rock to rock.

As a visitor to MalaMala, a person can also appreciate these natural formations. The koppies provide an unsurpassed spot for viewing spectacular sunrises and sunsets and the surrounding vistas. Sunrise is nowhere more dramatic than when viewed from high atop Campbell koppies, where one can watch first the rosy glow, then the golden rays peeking over the crest of the hills, and finally the radiant orb of sun emerging from the thin boundary between earth and sky. Sunset is another unforgettable experience, with its vivid and intense burnished gold and brilliant yellow which fades, as the sun dips below the horizon, into a muted, dusky pink afterglow.

The dried river beds provide contrast to the koppies. The Sand River has five major tributaries on MalaMala: the Manyelethi, the Mlowathi, the Matshapiri, the Kapen and the Tjellahanga rivers. These tributaries are virtually always dry, except for perhaps a few days during extreme wet periods, when the water rises swiftly and just as swiftly recedes. As a result, these dried beds provide popular routes for animals. Often, such predators as lions and leopards will lie among the reeds, enjoying the cool shade while waiting for their prey to pass by. Elephants frequent the banks of these river beds and occasionally dig down with their trunks to the subterranean water that runs beneath the sand.

These dried river beds are also used by the rangers as a means of navigation, as roads often run on either side of the beds. Consequently, if a ranger is knowledgeable about the river beds, he will always be able to orient himself at MalaMala. They are also, quite simply, fascinating and beautiful to explore, as their banks are rich with lush vegetation and rock formations, not to mention a variety of animal and bird inhabitants.

The koppies and the dried river beds add a visual element of primitive drama to the landscape of MalaMala. In a land where much of the terrain is grassy or covered with brush, these areas of rocks, boulders and sand stand in sharp contrast. However, it is only their appearance that is stark and inhospitable. Like the rest of MalaMala, they are burgeoning with life, and their distinct kind of beauty contributes to the diversity of the MalaMala experience.

RIGHT: These rocks along the Mlowathi River bed are often used by the resident female leopard as a lair for her cubs.
PREVIOUS PAGE: Klipspringers are often found in the koppies and in the rocks along the dried river bed of the Mlowathi River.

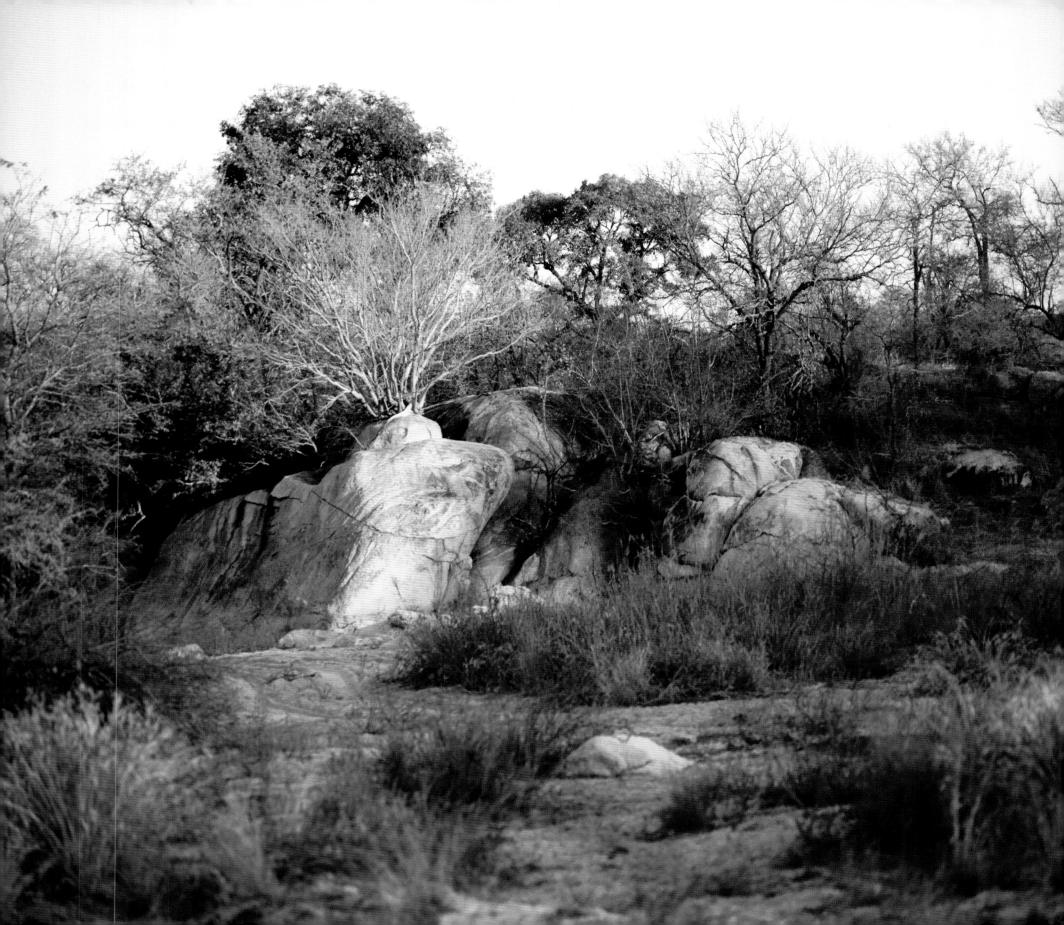

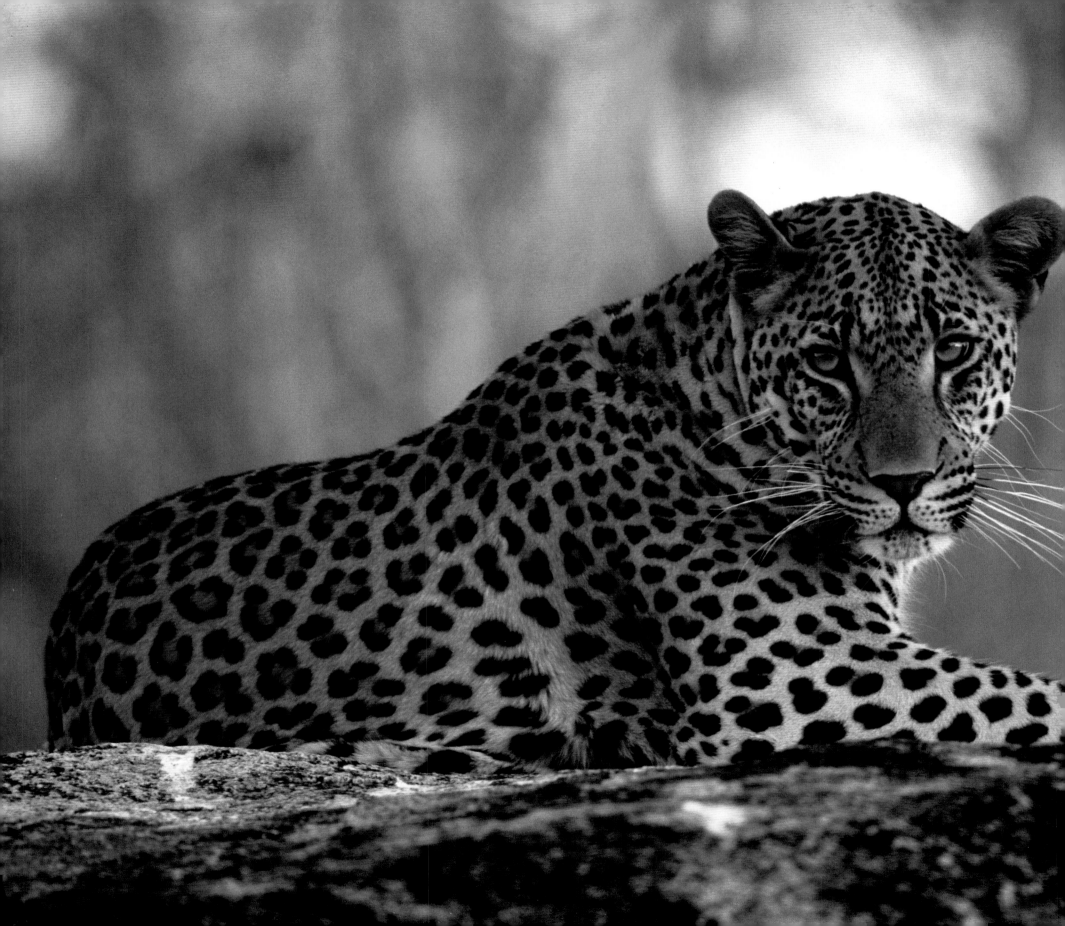

ABOVE: Campbell Koppies, like all the koppies, are of granitic origin.

LEFT: Leopards on rocks are particularly photographic. Males can be easily distinguished from females by their larger heads.

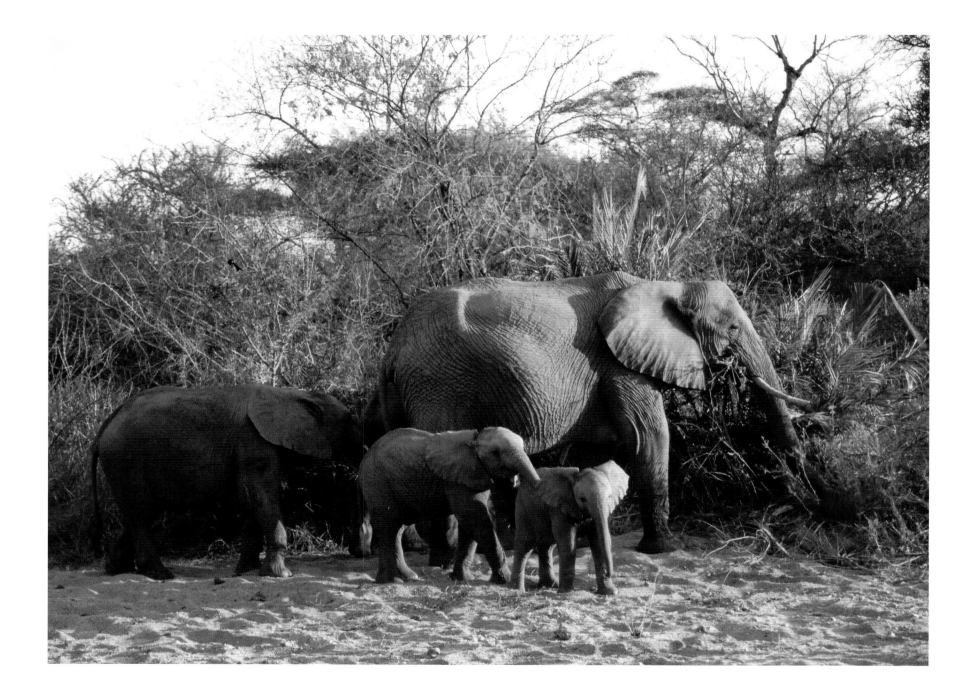

A herd of elephants moves slowly upstream in the Manyelethi River.

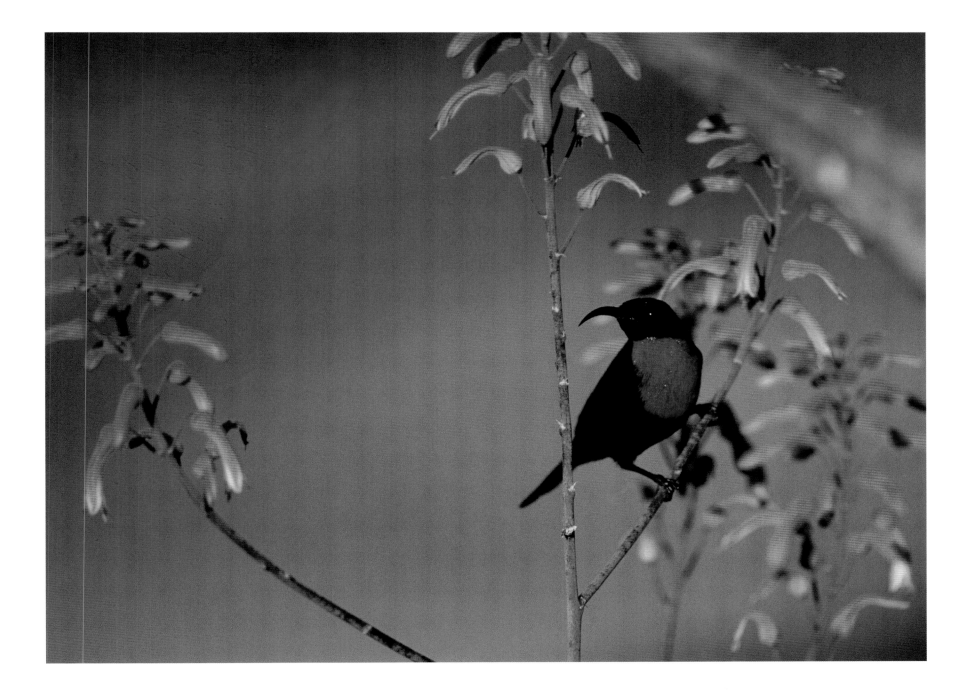

The scarlet-chested sunbird adds some vibrant color to the koppies.

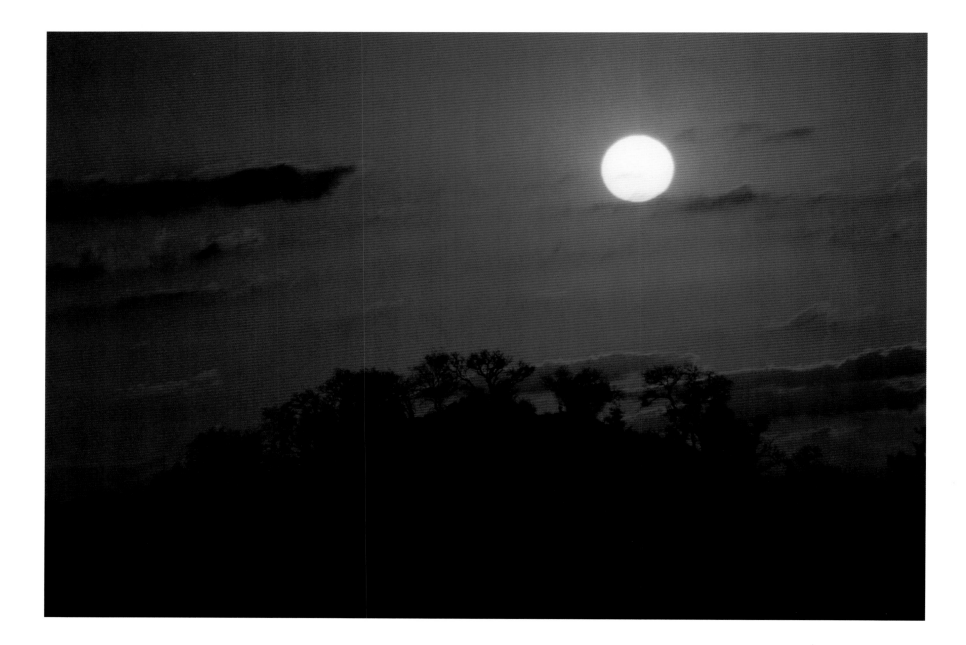

ABOVE: The eastern koppie of Campbell Koppies just shortly after dawn.

RIGHT: Campbell Koppies are a regular haunt for these klipspringers, which pair for life.

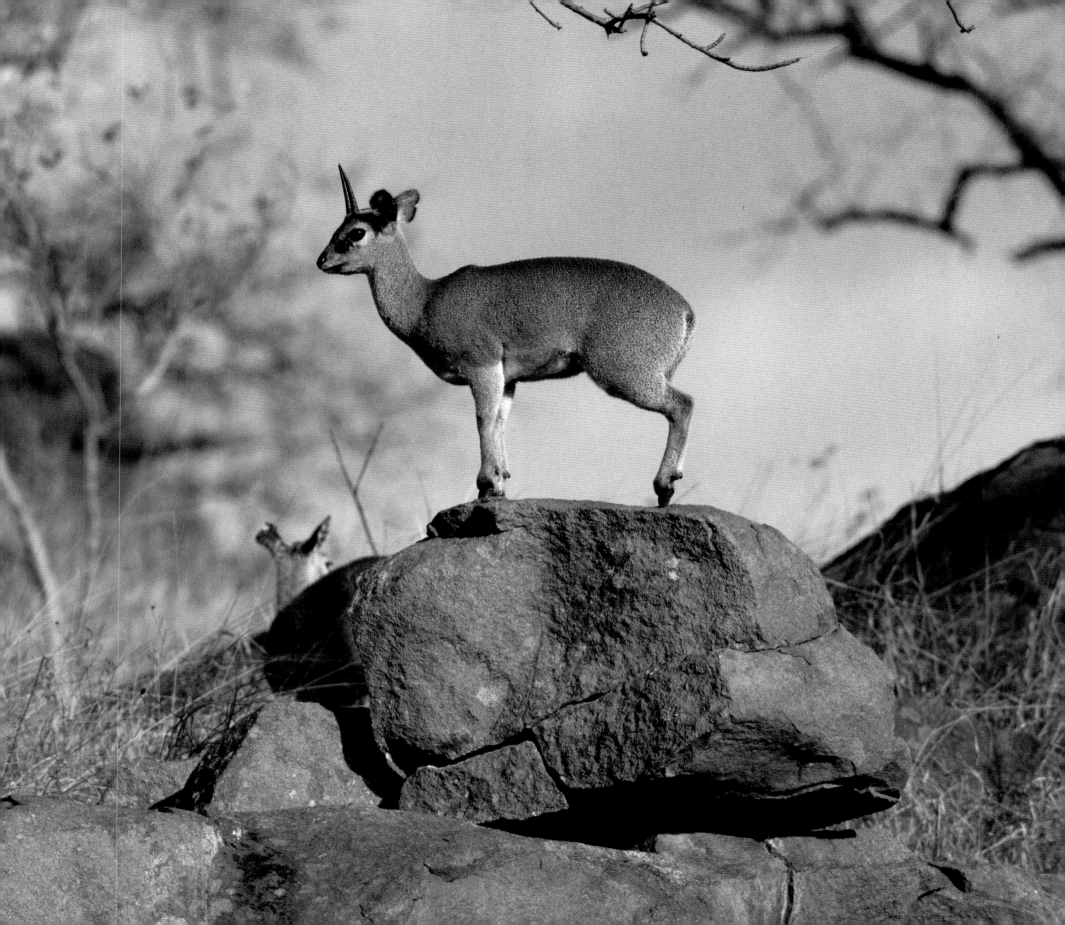

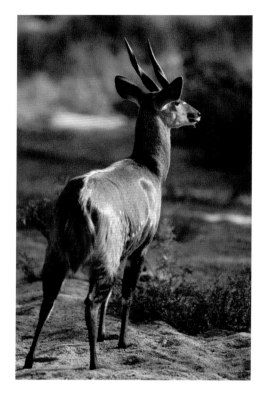

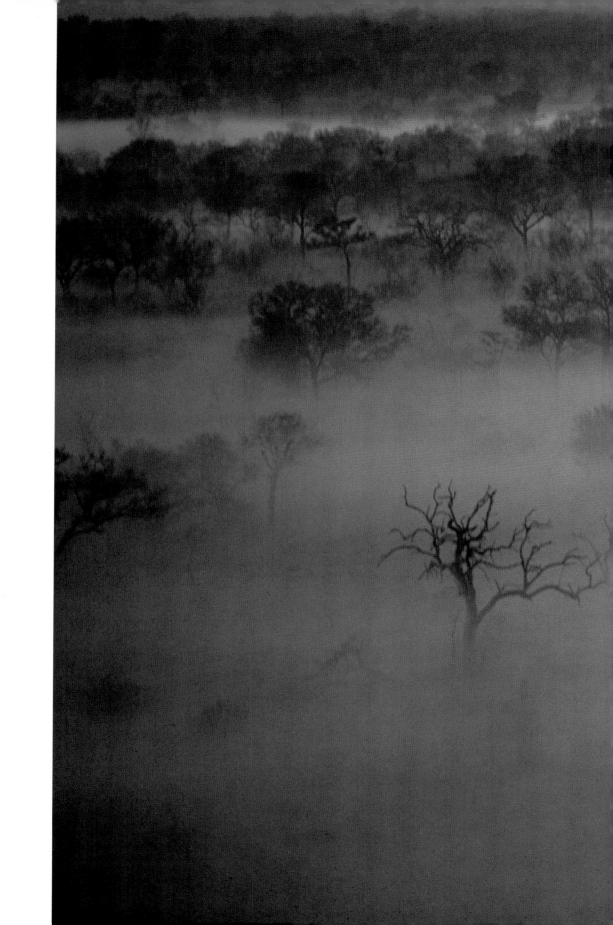

ABOVE: An adult male bushbuck tests the air, ready to dart off with piercing dog-like alarm barks.

RIGHT: Mist occasionally fills the valleys and covers lower ground in winter only to dissipate after sunrise.

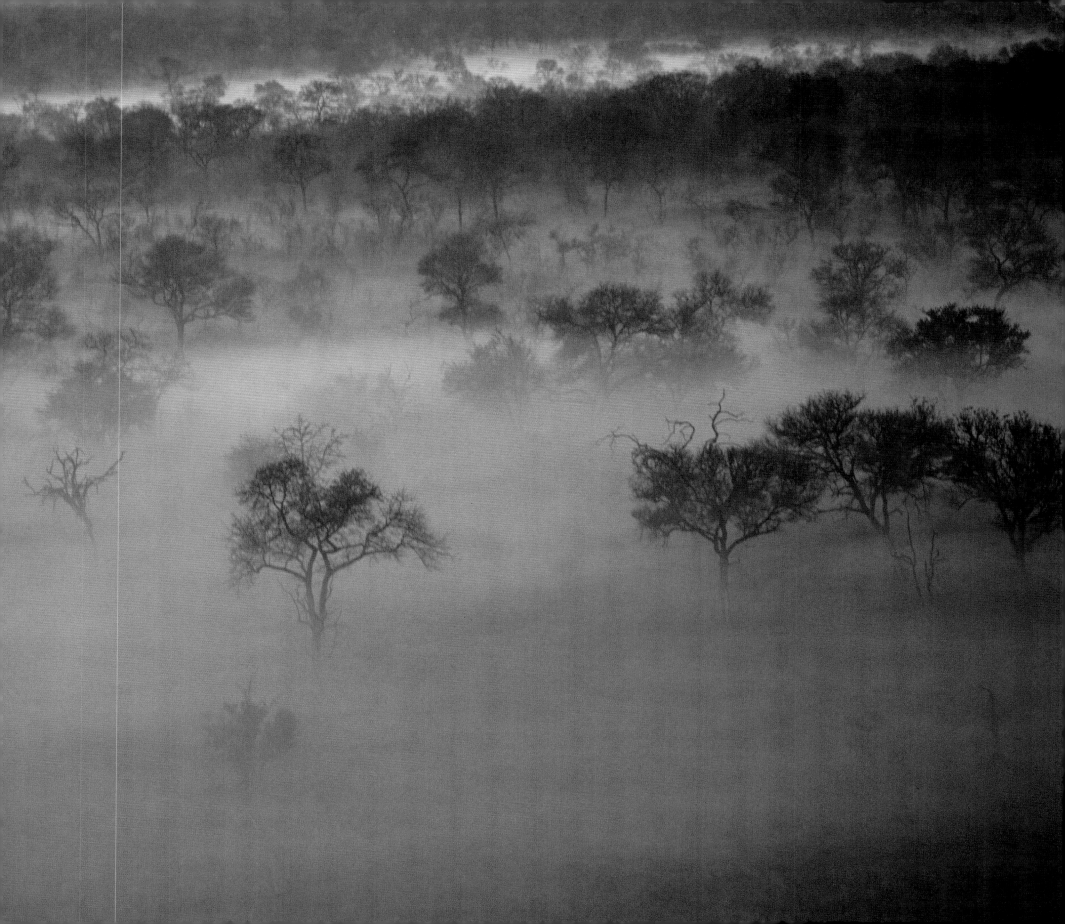

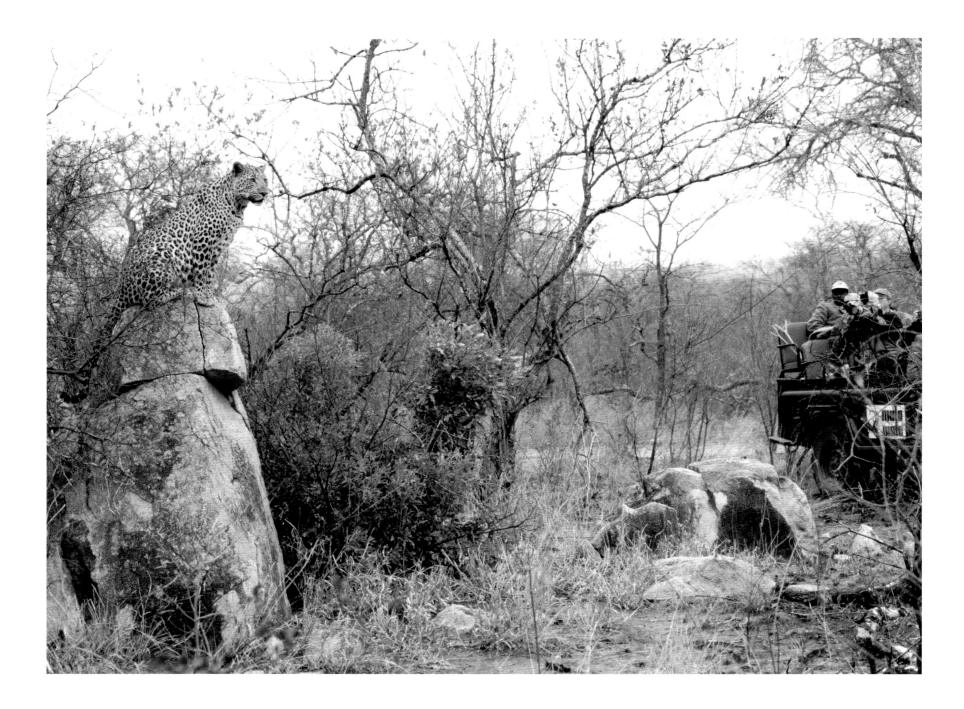

LEFT: The Mhlabatini female's cub uses some rocks for elevation while hunting.
RIGHT: Euphorbias are an interesting sight around Stwise and nearby koppies.

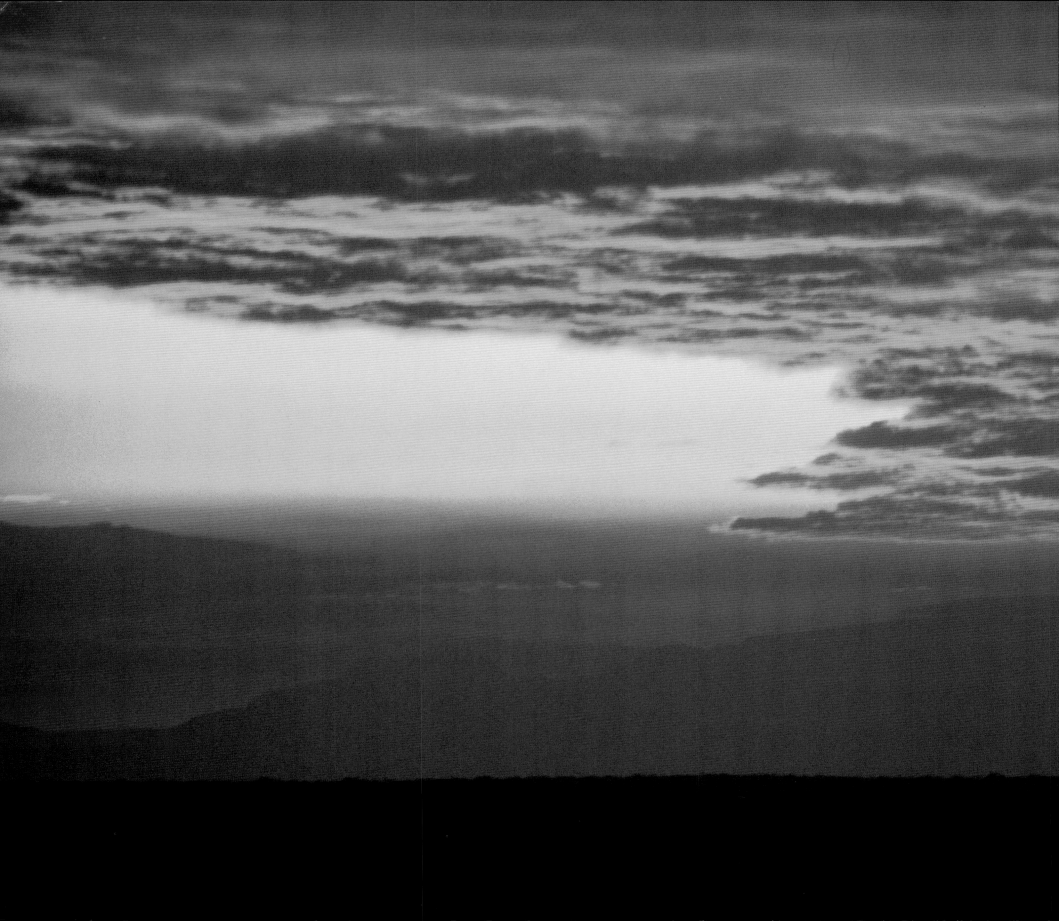

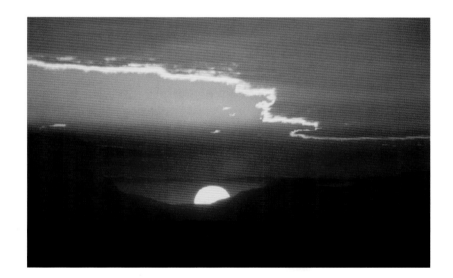

ABOVE AND LEFT: Sunset over the escarpment of the Mpumalanga
Drakensberg is spectacular from Stwise.
TOP: Ranger and tracker admiring the vista from Stwise.

At
Camp

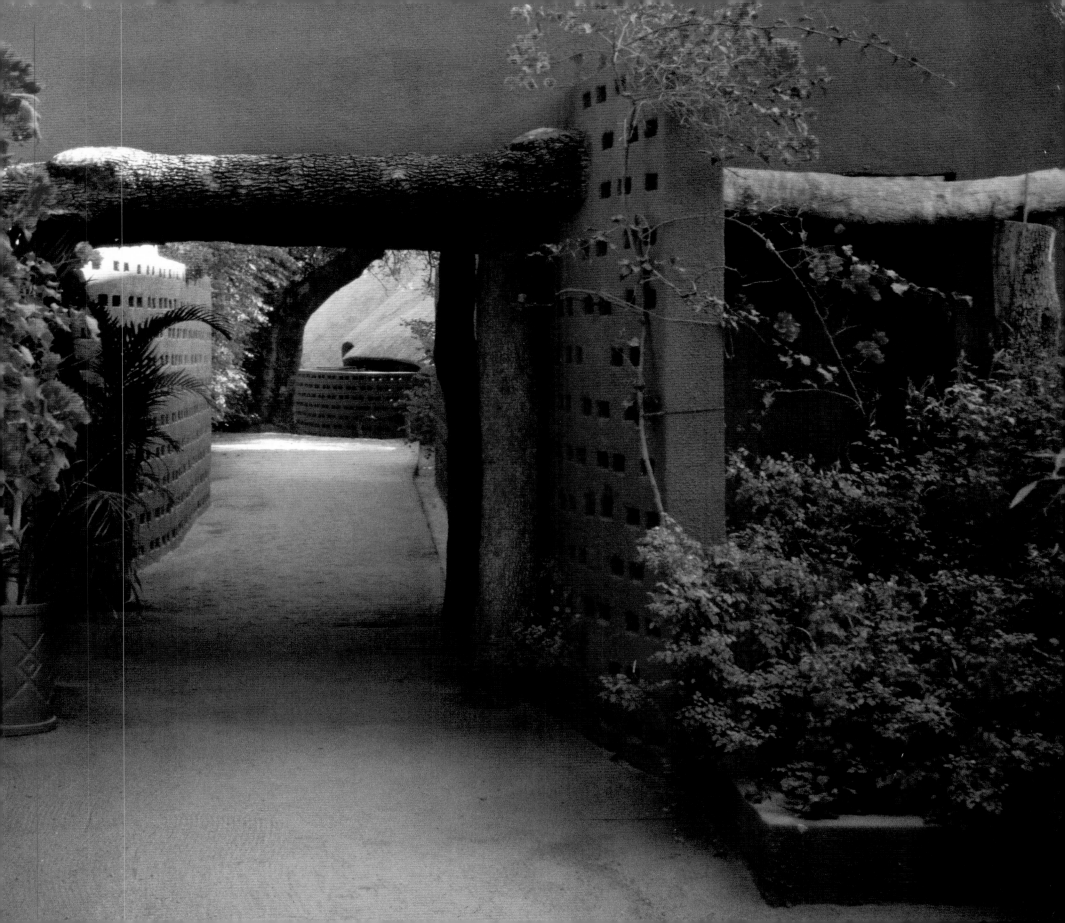

WHEN WAC CAMPBELL BOUGHT MALAMALA IN 1929, THE CAMP WAS LOCATED where the Mlowathi River flows into the Sand River. Campbell soon realized that the summer rains made the river difficult to cross at that location, and in 1930 the camp was moved across the Sand River to its present site. At that time, it was used exclusively in winter as a base of operation from which to hunt game. During that same year, four concrete rondavels (round hut structures with thatched rooves) were erected, with a layout and construction similar to that of buildings used in nearby Kruger National Park. This rondavel construction is the basic design for the bungalows as they exist at MalaMala today, and they are a beautiful sight: burnt sienna in color, integrated perfectly onto the river bank and set like gems amongst the stately shade trees. The boma, a rustic open-air setting for the evening meal, was constructed of enormous reeds, built in a circle, underneath a giant jackalberry tree. The boma still stands today, virtually unchanged in both appearance and function.

A half-hour away, within the same tract of land and also part of Rattray Reserves, is Kirkman's Kamp, named after Harry Kirkman, who was the manager of the southern part of MalaMala during cattle farming years in the early 1920s and '30s. It is a restored Colonial homestead, retaining the charm of the past while providing modern comfort. Harry's Camp is also located in the southern part of the reserve; however, it was to be replaced.

Back at the Main Camp, a stroll might take you first to the commodious Buffalo Lounge, where animal trophies, tribal artwork, books and periodicals on Africa, and other objects of interest can be found and examined. The lounge is also an elegant yet comfortable place to relax with friends over a drink or simply to read quietly after a full day in the bush. Just down the hall is the warm and intimate wood-paneled bar, with its nostalgic safari memorabilia and chalk scoreboard prominently displayed. Each animal spotted on a game drive is worth a fixed number of points (the rarer the animal, the greater the number of points), and it is great fun to join up with the rangers and fellow guests at the end of the day to tally up the collective points of the daily sightings. Breakfast and lunch are served in the sun-filled dining room, which is graced by an unobstructed view of the Sand River and any passing wildlife, though you may opt to dine on the spacious elevated wooden deck, which affords the same excellent view of the river. The thrill of dining alfresco with unfenced elephants, hippos, baboons, and warthogs mere yards away is indescribable. The evening meal is served in the boma, and dinner service is heralded by the beating of African drums. An enormous bonfire burns in the center of the boma, and low tables are arranged around it in a convivial circle.

At some point you are compelled to seek sleep in order to be alert for your morning game drive the next day.

RIGHT: Bougainvillea, which was planted by Mrs. Campbell during her first visit to MalaMala in the 1930s, provides a ubiquitous spray of color throughout the seasons.
PREVIOUS PAGE: Archway leading from the Buffalo Lounge to room seven and beyond.

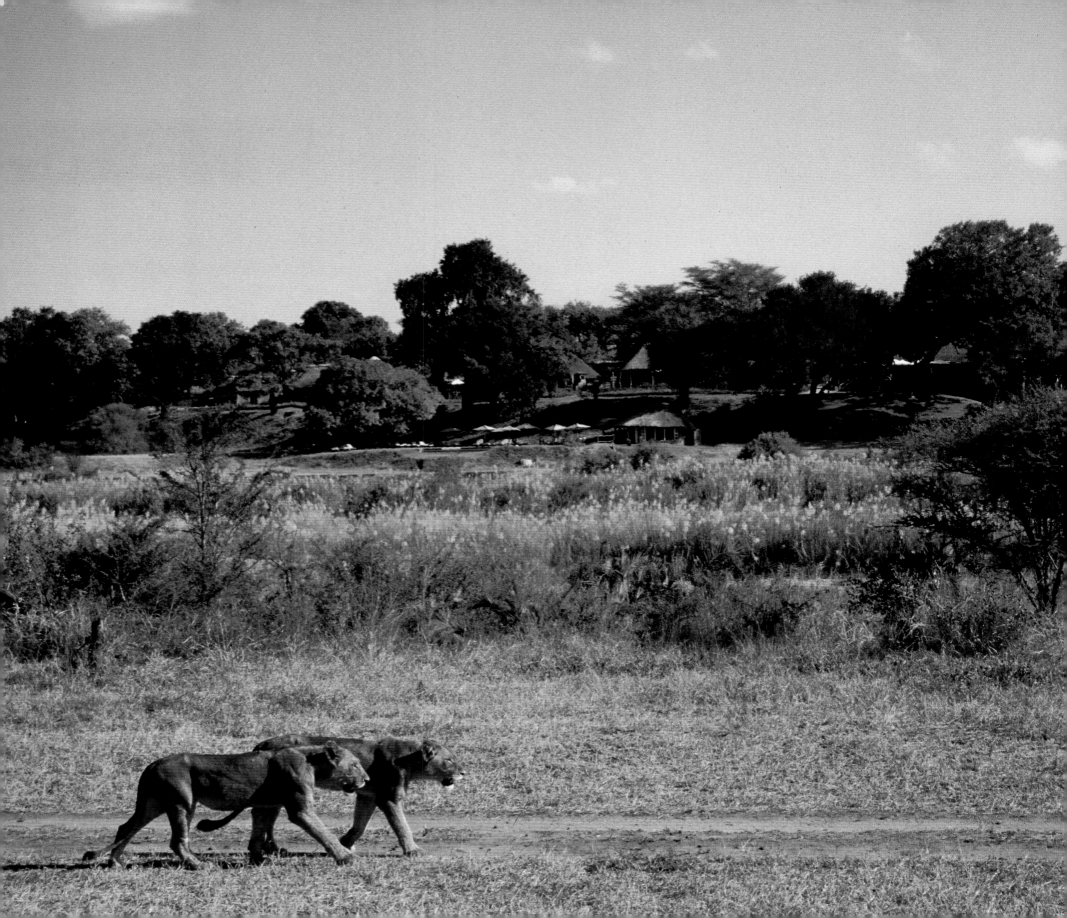

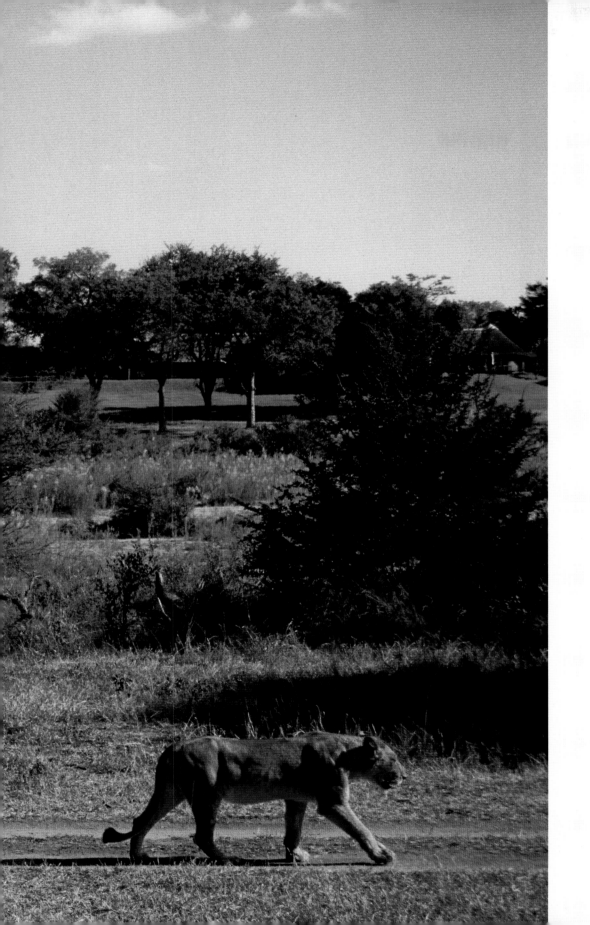

Your ranger walks you to the door of your bunga-
low, just in case some animal denizen of
MalaMala decides to take an evening stroll
around the premises. As you sink gratefully into
your comfortable bed, you are lulled to sleep by
the sounds of the bushveld at night. Is that a lion
off in the distance? Probably, but nestled within
the sturdy walls of your bungalow, you feel safe.

 This, then, is MalaMala. Here, simple
beauty merges with extravagant comfort, and
unstintingly provides the perfect resources for
body and soul to relax, recharge and reawaken.

Lions from the Styx
pride seen on the hunt
directly across from the
main camp.

LEFT: Flapnecked chameleons are fairly common but well camouflaged.
BELOW: The original thatch rondavel design is still evident, only they are much bigger and more luxurious.
OPPOSITE: A number of animals can be seen at the camp perimeters, some dangerous, so don't walk off the short cut grass.

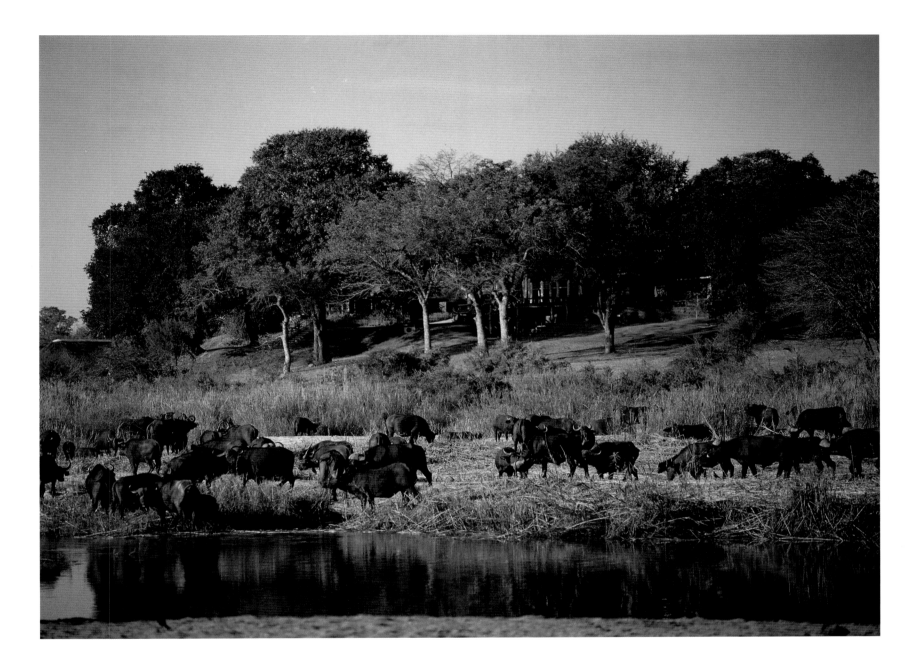

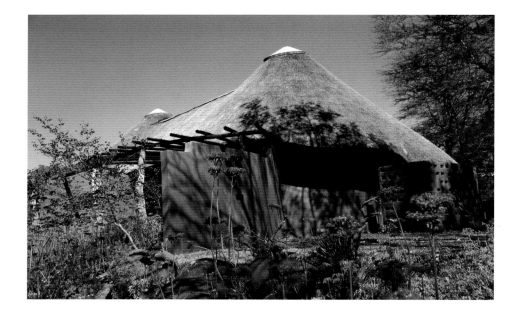

ABOVE: Kirkman's Kamp viewed from Kirkman's Crossing.
TOP: Many plants in camp flower in winter.
RIGHT: Fever trees were planted in the camp. They have a distinct yellow and green bark.

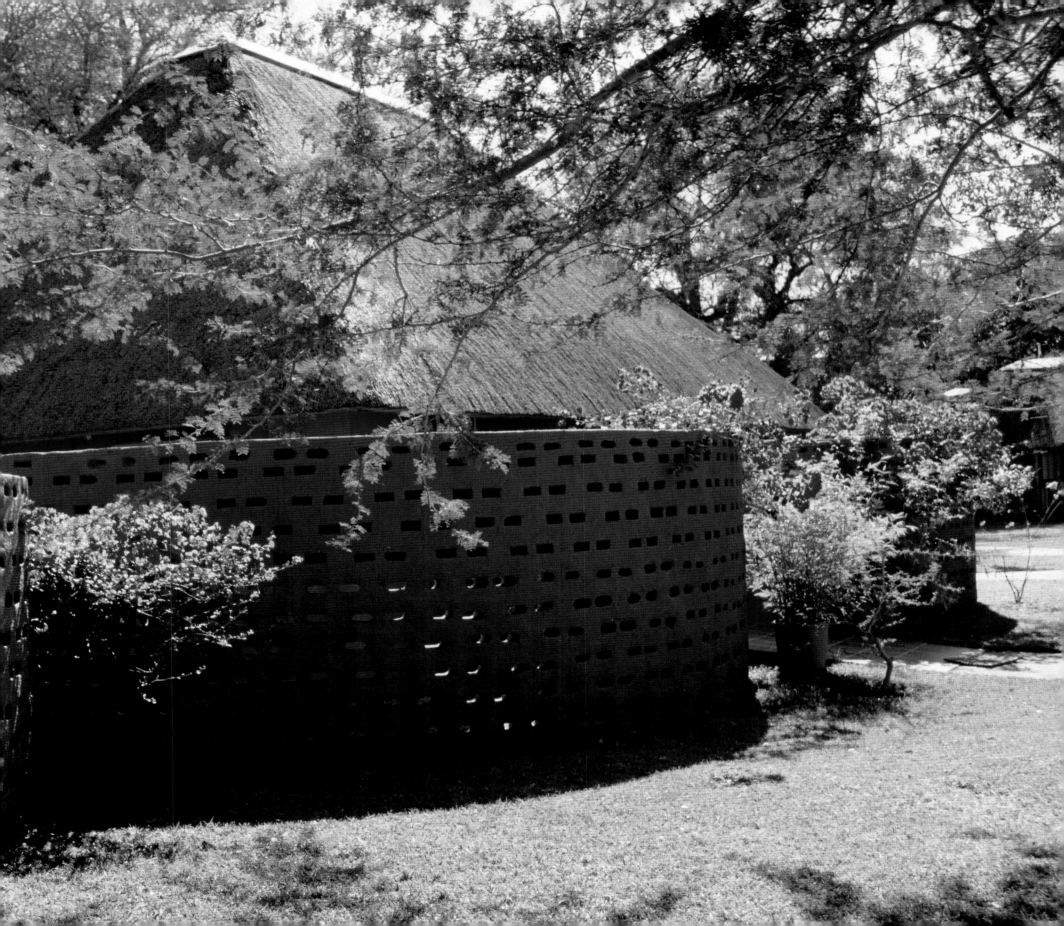

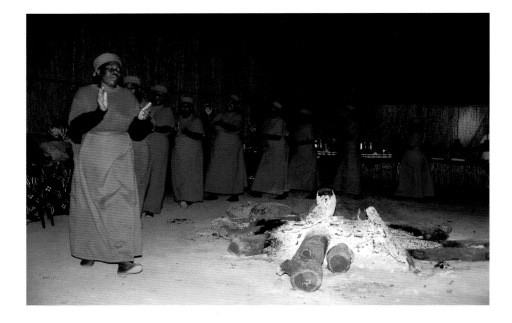

ABOVE: At night some of the staff entertain guests with traditional songs of love, praise, and thanks.

RIGHT: Growing in abundance in the rivers are reeds, also called elephant grass.

OPPOSITE: Made of tightly bundled reeds, the boma, where guests enjoy a smorgasbord dinner around a blazing fire under the open sky, offers protection from the elements.

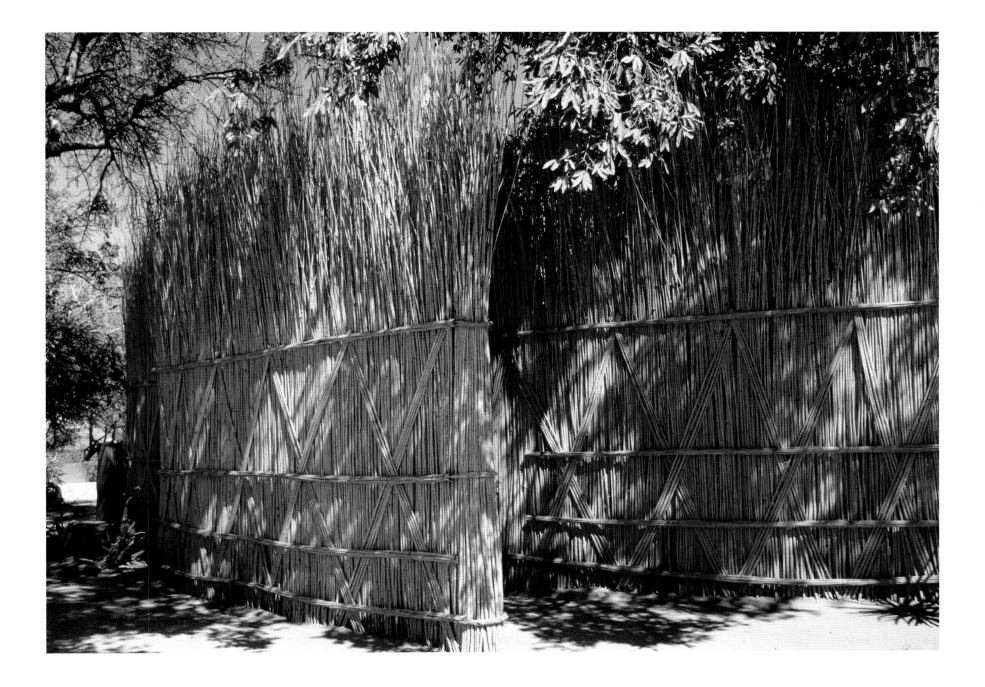

16ᵗ. lions in this pride.

Dr ~~Roca~~ Lubke shot one of two small lionesses weighing 200 lbs These two young lionesses had been trying to catch Warthogs which had taken refuge in and old ant heap - evidently the lionesses had been patrolling round the ant heap for some time. On poking into the hole with a long thorny stick the 4 hogs came out with a rush

Pendock also had a shot at a leopard in the open but unfortunately missed it

Game weights

	Animal	Hunter	Weight	
	Wildebeest Cow	Wac	432 lbs.	
	Sable Bull	"	523 "	
	Wildebeest Bull	Pendock	526 "	
	Waterbuck "	Starling	605 " 34" Horns	
	Wildebeeste "	King	420 "	
13ᵗʰ.	Lion (Starling)	Starling	419 "	
14ᵗʰ	Lion	Wa Campbell	477 "	
15ᵗʰ	Lion	Noel H. King	435 "	
16ᵗʰ	Loness	Dr O Lubke	200 "	
17ᵗʰ	Kudu Bull	"	635 " 45" Horn	
17ᵗʰ.	Young Impallah	Wac.	112 lbs.	
17 "	Kudu Bull	Wac	622 lbs. 52" Horn	
17 "	Lioness	E H Pendock	189 lbs	
19 "	Wildebeeste	"	635 "	
19	Kudu	R. James	592 " 51¾	
17	Baboon	Wac		
19ᵗʰ	"	Wac	Teeth 2"	
21	"	Wac	76 lbs.	
21	Lioness	Andree	407 lbs.	

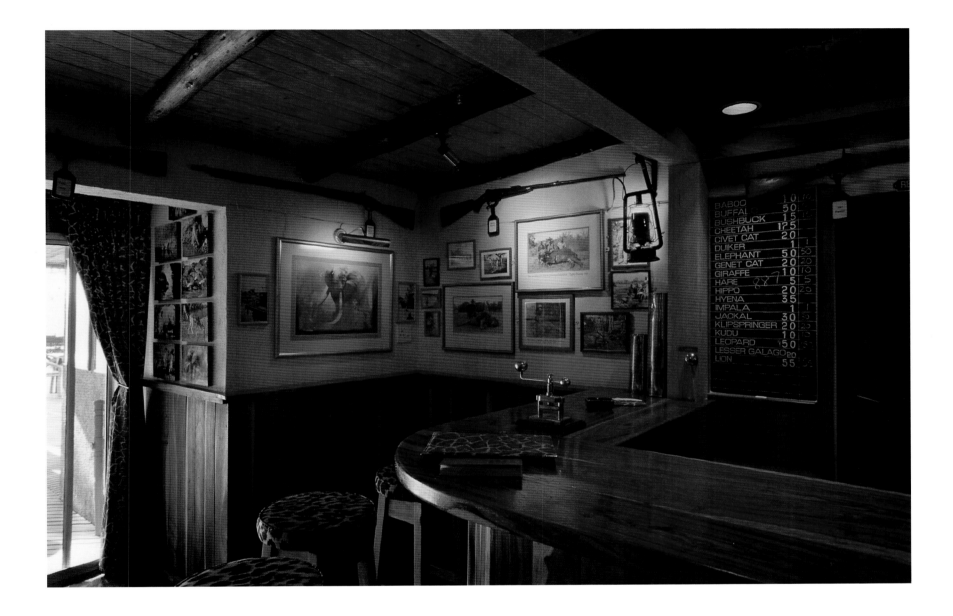

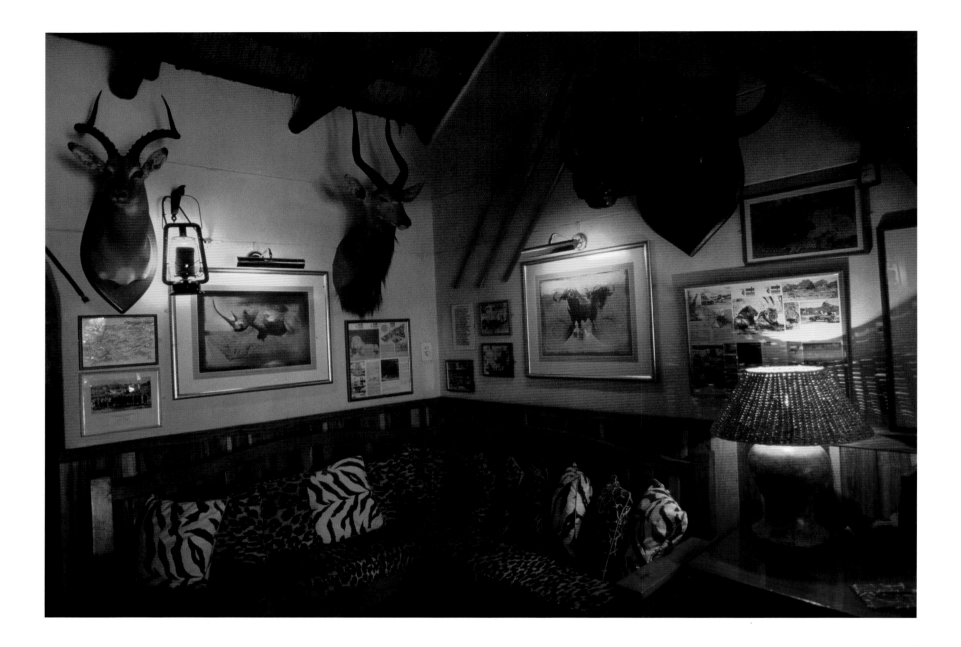

With walls adorned with trophies, old photographs, and other memorabilia, the Buffalo Bar offers a taste of the old hunting days.

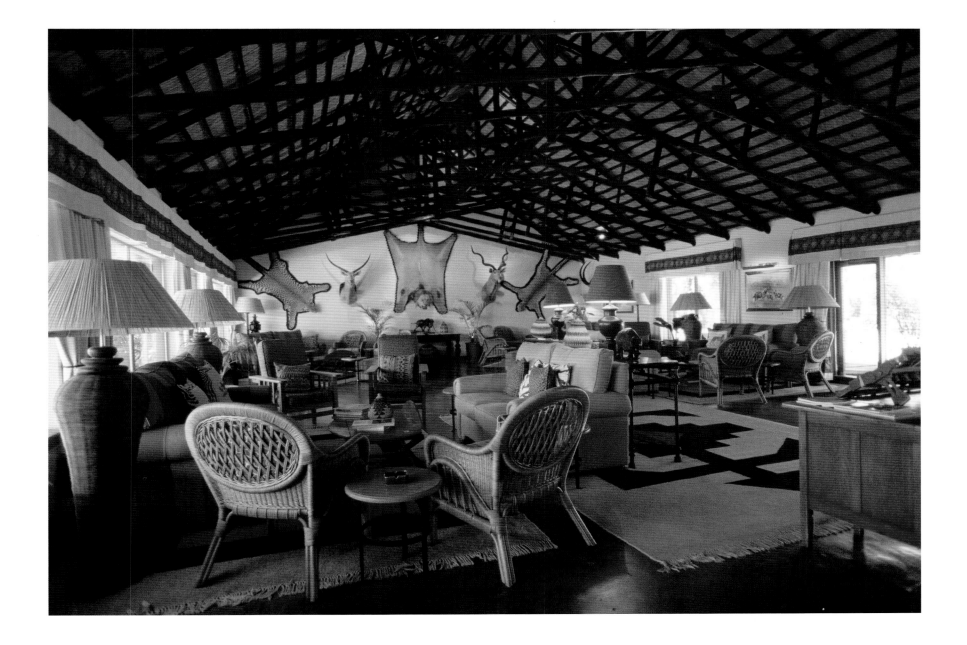

Warm colors invite you into the Buffalo Lounge, where you can relax, have a drink, and enjoy the reading material.

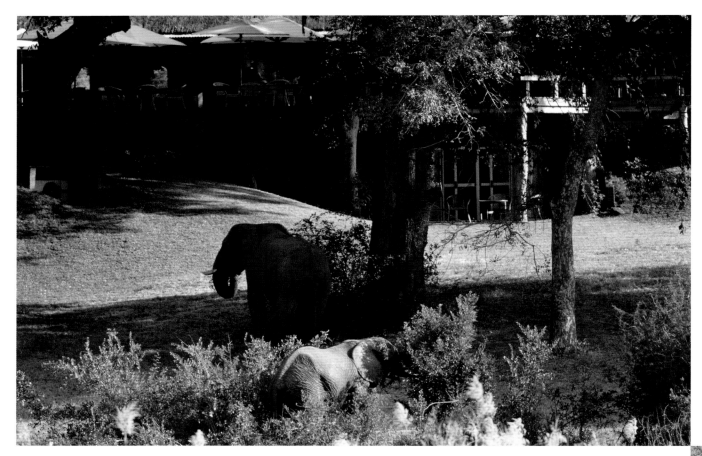

ABOVE: Elephants go about their business of eating in front of the main camp's dining room, seemingly unaware of their proximity to civilization.
RIGHT: A warthog is not shy about showing up for lunch on the deck.
OPPOSITE: The pool at the luxurious Sable Unit.

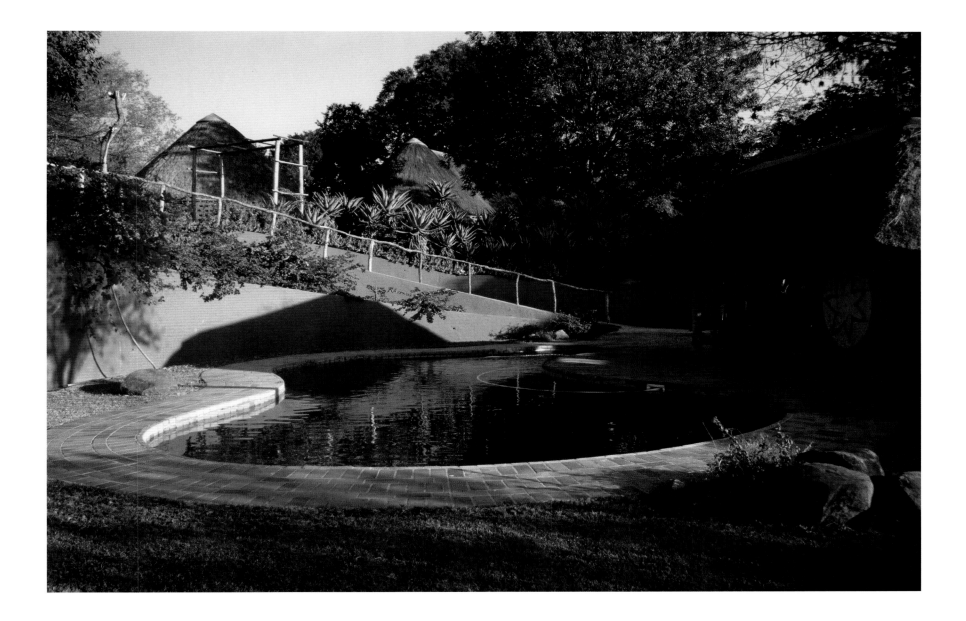